S0-CAL-749

EXPLORE
M·U·S·K·O·K·A
·LAKES·

EXPLORE
M·U·S·K·O·K·A
·LAKES·

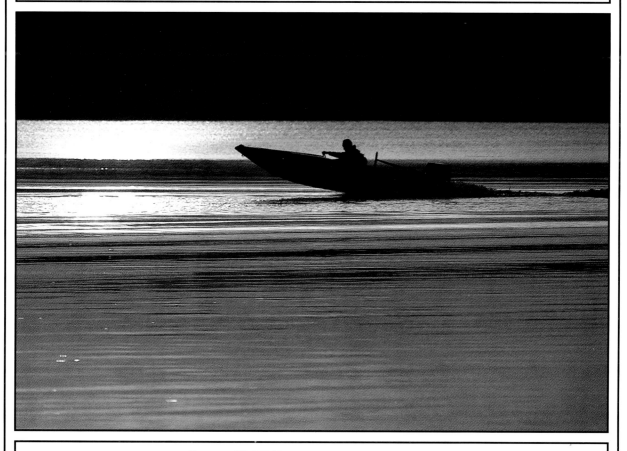

by SUSAN PRYKE
Photographs by G.W. Campbell

THE BOSTON MILLS PRESS

OVERLEAF: *An early morning spin at Foot's Bay.*

CANADIAN CATALOGUING IN PUBLICATION DATA

Pryke, Susan, 1952-
 Explore Muskoka Lakes

Includes bibliographical references.
ISBN 1-55046-010-2

1. Boats and boating - Ontario - Muskoka
(District municipality) - Guide-books.
2. Muskoka (Ont.: District municipality) -
Description and travel - Guide-books.

GV776.15.M8P78 1990 917.13'16044 C90-093884-6

©Susan Pryke, 1990

Edited by Noel Hudson
Designed by Gill Stead
Map illustrations by Mary Firth
Typography by Lexigraf, Tottenham
Printed and bound in Canada

Published by:
THE BOSTON MILLS PRESS
132 Main Street
Erin, Ontario N0B 1T0
(519) 833-2407
Fax: (519) 833-2195

Winners of the
Heritage Canada
Communications Award

American Association
for State and Local History
Award Winner

We wish to acknowledge the financial assistance and encouragement of The Canada
Council, the Ontario Arts Council and the Office of the Secretary of State.

Cedar-strip canoe, Lake Muskoka

Contents

Acknowledgements

This book would not have been possible without the assistance of those people who opened their homes and cottages to me, took me out in their boats, found time to talk about the past, searched through their attics for pictures, and so on. I would also like to acknowledge the assistance of the Ontario Arts Council in this project and the fine work of photographers Glen Campbell, Fred Schulz and Alldyn Clark. I am especially grateful for the generosity extended by Fred Schulz in providing, virtually at no cost, copies of photos from the Gravenhurst Archives. I will mention, too, the assistance of Mr. R.J. Boyer in reading the manuscript to make sure the names, places and dates were accurate. And a special thank you to Russ Brown, of the Muskoka Lakes Navigation and Hotel Company, in allowing me to hop aboard the RMS *Segwun* for research trips. The confidence of my publishers, John Denison and Jean Filby of The Boston Mills Press, is always appreciated. My husband, David Pryke, continues to provide emotional support and constructive criticism. Without him, the book would not have become a reality. The following people all helped to make this book possible, and I thank them.

Shirley Barlow
Elaine Bell
Mark Binnington
Robert J. Boyer
Arthur Brackley
Linda Brett
Russ Brown
Robert Bonnis
Glen Campbell
Hugh Clairmont
Alldyn Clark
Marion Colwill-Maddock
Bill DeForest
Donna Denison
Cyril Fry
Marion Fry
James Goodwin
Barry Gonneau
Betty Gordon
Bill Grand Jr.
Bill Gilmore
Wendy Gilmore
Mary Hardy

Mary Hare
Bruce Hatherley
Verna Hatherley
Lindsay Hill
Isobel Ingram
Sylvia Hurlbut
Lorne Jewitt
Barry Kearns
T.B. King
Gary Long
Evelyn Longhurst
Chris Lusty
Jean MacDonald
Dave MacDonald
Hugh MacLennan
Jane MacNaughton-
 Stoneman
Jean McCrea
Doug Marshall
Norman Miller
Bruce Mitchell
Phyllis Kaye Moore
Andrew Murie

Doug Myers
Nancy Nevala
Oscar Purdy
Edna Ramey
Father Gordon Rixon, S.J.
Betty Salmon
Fred Schulz
Bill Snider
Sister St. Norbert
Ian Turnbull
Iris Wallace
Bernice Willmott
Elizabeth Wilson
Henry Wilson
Carol Wiser
Emily Wood
Norman Yan

The staff at the Bracebridge and Gravenhurst public libraries and the staff at the Ontario Fire College.

Preface

About the Book . . .

In many ways *Explore Muskoka Lakes* is a child of my previous book, *Explore Muskoka*. At that time, the idea of writing about points of interest along the byways of Muskoka, *and* providing a map to identify them, generated considerable comment. "Great work," readers said. "Now all we need is a similar book for the things you can see when you're on the water."

So I spent a glorious summer. It was no hardship to travel up the lakes on those hot, still days in July, stopping every now and then to dive into the water or to munch on plums with my feet dangling over the back of the boat. I saw the lakes at their best, but also at their nastiest. In the lead-grey days when the water roiled, I got wind-burned and wet and bounced in my seat like a jackhammer.

Explore Muskoka Lakes is a reflection of those experiences — the knowledge, the wonder, and the respect that came from living with the lakes for the season. As in the previous book, I felt an urgency to get down both the stories and the history. This book is an attempt to freeze the shorelines for a moment.

What The Book Does . . .

Explore Muskoka Lakes gives shore-dwellers and lake visitors a guide to exploring the nooks and crannies of the lakes. But the book is for landlubbers, too, as it attempts to put into words the Muskoka ethos (the lakes, after all, are what make Muskoka, Muskoka).

The book mentions points of interest that I've found intriguing or beautiful, or both, and pinpoints them on maps. And here I draw a distinction between maps and charts. THE MAPS INCLUDED IN THIS BOOK ARE FOR LOCATION ONLY AND SHOULD NOT BE USED FOR NAVIGATION.

· LEGEND ·

④ Point of interest	⌂ Park	🚹🚺 Toilet
⑬ See detail map	⚊ Picnic spot	Wreck
◀ Boat launching ramp	Public dock	Water tower
⛪ Church	Swimming	Lookout

A *quiet spot on the Muskoka lakes.*

What the Book Does Not Do . . .

Explore *Muskoka Lakes* does not pretend to tell everything about the Muskoka lakes. Instead, it takes the reader on leisurely cruises and concentrates on aspects of shoreline history. Part of the interest in the Muskoka lakes is the knowledge that a good many VIPs spend their summers here — movie stars, publishers, the heads of corporations. But you won't find out where the celebrities stay by reading this book. They've come to Muskoka to escape the limelight, after all.

Information about the cottages in this book comes from previously published accounts, or journals, or by permission of the owners. The *Segwun*'s classic cottage cruises also opened a door or two. While there are many noteworthy homes not mentioned in the book, those that are mentioned speak eloquently for their neighbours.

— Hydrographic Charts —

There's nothing more exhilarating than following your nose around the peninsulas and islands, but do it with your charts in hand. (Until you've experienced that rush of adrenalin when a nest of big rocks rises under the boat from what appeared to be perfectly deep water, you can't imagine what all the fuss over charts is about.) Hydrographic charts are put out by the Canadian Hydrographic Service, 1675 Russell Road, Box 8080 Ottawa, Ontario, K1G 3H6 (613) 998-4931. The Lake Muskoka chart is number 6021, lakes Rosseau and Joseph are number 6022. These are large charts, big enough to paper the wall with. Their unwieldy nature led to the publication of the smaller, laminated version on sale at some bookstores and marinas throughout Muskoka.

— Safe Boating —

The rules of navigation include more than a basic understanding of which side of a red or green buoy your path should take. (Believe it or not, some boaters have stopped the Ontario Provincial Police marine patrol to ask what the red and green "sticks" in the water were!) As on the highway, you must understand the "road" signs, know who gets the right of way, and what equipment you're expected to have on board. A good publication is the *Safe Boating Guide*, put out by the Canadian Coast Guard. The Ministry of Natural Resources also has pamphlets on water safety, boating restrictions and regulations. By far the best idea is to take a navigation or boating safety course. In Muskoka, the Power Squadrons in Bracebridge and Gravenhurst have a basic boating course that starts in the fall. The fee (around $100 or $110) includes an intensive 20-week course and instruction book.

- Bracebridge Power Squadron
 Box 2372
 Bracebridge, Ontario
 P0B 1C0

- Gravenhurst Power Squadron
 General Delivery
 Gravenhurst, Ontario
 P0C 1G0

— Buoys —

The buoyage system in Canada includes buoys of various shapes — spars, conicals, cans and pillars. On the Muskoka lakes the spar-type buoy is most prevalent.

Port Buoy (green): keep green buoy to your port (left) side when proceeding in the upstream direction.

Starboard Buoy (red): keep red buoy to your starboard (right) side when proceeding in the upstream direction.

Bifurcation Buoy (red and green bands): pass on either side when proceeding in an upstream direction; the top colour indicates the preferred channel (if red on top, keep buoy to your starboard side; if green on top, keep the buoy on your left side to follow the preferred channel.)

Cautionary Buoy (yellow): *don't even think of going through the channel* — the danger may be shallow water, or an underwater line — consult your chart for details.

For a complete understanding of the buoyage system, please consult the *Safe Boating Guide*, or *The Canadian Aids to Navigation System*, put out by the Canadian Coast Guard.

— Speed —

Fast boats have been a problem on the Muskoka lakes almost from the time the power boats made their appearance. The issue of "high speed boats" found its way on the agenda of the Muskoka Lakes Association meeting as early as 1921. And this wasn't the first time the topic had come up. Today, speeding continues to be one of the most annoying and dangerous problems on the waterway.

While it's been said before, I'll say it again: Be courteous. Think about the other guy. Think about what you are doing. The law says you must slow down to a speed of 9 km/h when your vessel is travelling within 30 metres of the shore, a dock, pier, raft, float or a vessel that is anchored, moored, or under way.

Muskoka chairs, Lake Joseph.

Fairyland

"To me it was paradise, the nearest approach to a dream come true I had yet known. The climate was dry, sunny and bracing, the air clear as crystal, the nights cool. In the moonlight the islands seemed to float upon the water and when there was no moon, the reflection of the stars had an effect of phosphorescence in some southern sea."

Algernon Blackwood
Episodes Before Thirty

It's a hot, July morning, under a paintbox-blue sky. The *Segwun's* taking on passengers and puffing like a runner on an uphill climb. You rest your elbows on the wooden railing and find yourself breathing with the rhythm of the idling steam engines, in and out, *whoosh-a-a-a, whoosh-a-a-a.*

Then the ship slips away from the dock and glides across the bay. The water is as smooth as syrup. On sleepy islands, cottagers stand with cups of coffee on their docks, watching a loon fish for its breakfast.

If asked to recommend the best way to see the Muskoka lakes, this would be it: just you and your camera (and a tube of good sun block) aboard the RMS *Segwun* on a calm summer day.

But then you'd miss the lakes when they're wild, when the wind's whipping up waves like egg whites and you're in an aluminum fishing boat heading up the reach, your hands clenched on the gunwales, your bottom bouncing on the seat, the water the colour of lead, and just as cold when it sprays over the side. These are the times when two sweaters and a windbreaker are not enough and you wish you had mitts, even though it's June.

These are lakes of the Canadian Shield, characterized by rocky shorelines and islands piled with pine trees. The beaches, when you find them, lie under the water like vast golden thresholds honeycombed with sun lines. Writer Algernon Blackwood summed up the charm of the lakes when he called them a fairyland. Even now, when the cottages are dishwasher-efficient and lined up shoulder to shoulder like suburbia, there's something magical in the clean, rugged landscape, some solace to be found walking down to the dock, feeling the tree roots under your bare feet and breathing in the smell of pine. Here life is uncomplicated. The wave-washed rocks hold memories of happy days: floaters and fishing poles; a kiss stolen on the end of a dock; falling asleep to the lapping of water, on a cot on the verandah on a too-hot night in July.

While there are over 1,600 lakes in the district, this book deals with only three: lakes Muskoka, Rosseau and Joseph. People persist in calling them The Muskoka Lakes, as if they are the only ones that matter. Even though the other lakes hold charms of their own, there's no denying that lakes Muskoka, Rosseau and Joseph have a certain aura, a pedigree based not only on their inherited beauty, but on what they've done with themselves over the years.

Together these lakes form the largest stretch of lake surface in the district (covering 236 square kilometres or 90 square miles). In early days, their sheer size and connectedness meant easy access to the town centres and to neighbours who might be hours away by land. This is where steam navigation began, where the first rail links were made, the first tourist resorts built.

While all Muskoka's lakes were born of the Ice Age, the glacial imprint on the Big 3 proved fortuitous in that it left them "joined at the hip," as it were.

Beaumaris Yacht Club

A million years ago the glaciers rolled over Muskoka, gouging out the pockets of softer rock and leaving the harder rock behind as ridges and islands. About 12,000 years ago the ice-front began melting. It took its time, mind you, wasting away at a rate of about 130 to 140 metres (425-460 feet) per year. At the melting edge, Lake Algonquin formed. The shoreline of this ancient lake was roughly parallel to, and east of, Highway 11. From here it stretched west, swallowing up what we know as Georgian Bay and Lake Huron.

When the glacial freshet subsided, and the land rebounded after being relieved of the weight of the glaciers, hundreds of lakes were left high and dry. This geological process left lakes Muskoka, Rosseau and Joseph almost as one, separated only by a small chute on the Joseph River and rapids on the Indian River. With very little trouble these constrictions could be opened, and the lakes used in a navigation network. Lakes like these were just what the explorers were looking for when they came to Muskoka in the 1800s.

With military strategies in mind — namely an alternative route from the Ottawa River to Georgian Bay — explorers chanced upon Lake Muskoka, then Lake Rosseau. But it was David Thompson who first mapped all three lakes, in 1837, giving them poor grades as a possible supply route, but good grades for water power and settlement opportunities.

The forests of the district made quite an impression on the explorers, however. Soon lumbermen were driving rafts of logs down the Moon and Musquash rivers to Georgian Bay, and from there to sawmills in Collingwood or Midland. With the construction of the Muskoka Road and influx of settlers in the late 1850s, the focus of lumbering began to shift from the Moon and Musquash to the lakehead: Gravenhurst roared into existence in the whir of the sawblades.

One of the first to see the potential of Muskoka Lakes was A.P. Cockburn. He could see a vast commercial network opening up, if only efforts were made to make all three lakes accessible to steamboat travel. A navigable waterway was the key to settlement and the ready flow of goods and resources. As a man with influence in the right sectors of government (at various times he represented Muskoka in the provincial government and House of Commons), Cockburn set about to make the dream a reality. He lobbied for the construction of a lock at Port Carling and a cut at Port Sandfield. He also worked to get the railway to Gravenhurst and advocated the promotion of Muskoka as a tourist destination. Of course all this fostered the growth of his own enterprise, the Muskoka Lakes Navigation Company.

Being a finite resource, the lumber industry soon devoured itself, leaving the land pock-marked with stumps and cinders. In the meantime the settlers battled the uncompromising landscape and grew just a little tired of the effort it took to keep food on the table. For settlers used to the rolling hills of the Old Country, or even the gentler landscapes of southern Ontario, the Precambrian Shield came as a bit of a shock. To these settlers the dawn of tourism was a welcome relief. They gladly offered sportsmen a meal and found places for them to stay overnight. It meant a few extra dollars and a better existence all around.

From this beginning came the hotels that attracted the clientele that made Muskoka *the* place to be in the summer. And in the cradle of the lakes, the summer visitor and the year-round resident nurtured each other. The people of Muskoka found an occupation in tourism, an occupation that embraced not only the resort business, but also the care and upkeep of private summer homes, growing produce, selling groceries, building boats, pumping gas, peddling kitchen stoves.

Lakes Muskoka, Rosseau and Joseph are, in many ways, the heart of Muskoka, not only pumping life into the district, but also epitomizing her spirit as the Land of Clear Skies and Many Lakes — The Greatest Lakes.

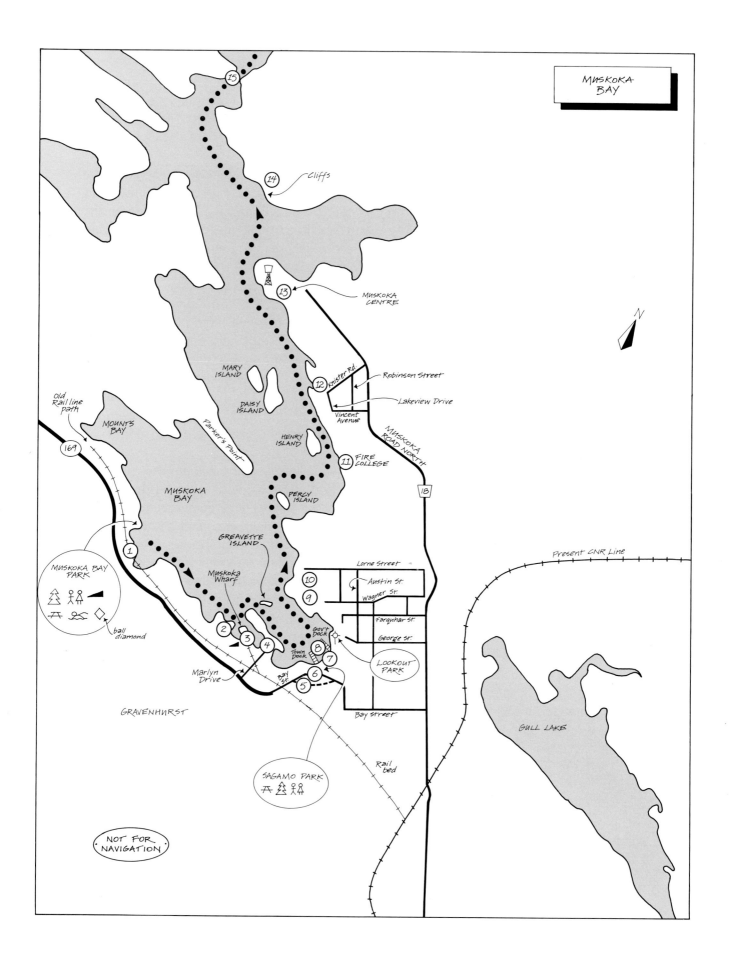

MUSKOKA
BAY

Cliffs

Muskoka Centre

Knister Rd.
Robinson Street
Lakeview Drive
Vincent Avenue

Old Rail line path

MOUNTS BAY

Parker's Point

MARY ISLAND

DAISY ISLAND

HENRY ISLAND

FIRE COLLEGE

Muskoka Road North

MUSKOKA BAY

PERCY ISLAND

GREAVETTE ISLAND

Muskoka Wharf

Present CNR Line

Lorne Street
Austin St.
Wagner St.

Farquhar St.
George St.

Gov't Dock

Town Dock

Lookout Park

MUSKOKA BAY PARK

ball diamond

Marlyn Drive

Bay St.

GRAVENHURST

Bay Street

GULL LAKE

SAGAMO PARK

Rail bed

NOT FOR NAVIGATION

Muskoka Bay

"Another class of city cynics told me that Muskoka was a barren wilderness, and that I could not get enough soil on the rocks to plant potatoes in, till I had saved up a year's tea leaves and floor dust to clothe the rock."

W.E. Hamilton
Muskoka Sketch

Muskoka's rocks are the stuff of legend — great hulks of billion-year-old bedrock that scared the stuffing out of some of the early settlers. Early reports tell of newcomers "closing their eyes" to the rocks, or packing their bags and leaving when they found the rocks "staring them in the face." Still, there were those who, like Thomas Robinson, looked between the rocks and exclaimed, "There's enough good land for me. We'll go not further."

Robinson himself chose to settle near some of the most spectacular rock cliffs on the Muskoka lakes, those of Cliff Bay. From here he embarked on his explorations of the lakes, mostly to seek provisions, but also as a tour guide. So it's fitting that a book that sets out to explore the Muskoka lakes should start with Robinson's Muskoka Bay. Its shorelines were indelibly etched on the minds of hundreds whose journeys to their new homes or summer retreats took them from the road or rail connections at Gravenhurst via steamboat up the length of Muskoka Bay. Their passage led them out of the industrial mess of the Gravenhurst waterfront, with its sawmills, shipyards and boatbuilding factories, past the groomed grounds of the sanatoriums, the cliffs that plunged into the water from great heights, to Shantyman's Point and The Narrows. In size, Muskoka Bay is a tiny fraction of Lake Muskoka, but the comings and goings along these shorelines left a lot to talk about.

GRAVENHURST WATERFRONT

Today it's difficult to tell exactly where the rock outcrops are. The trees have softened their edges. Rooftops have blocked out their stark grey colour. But in the lumbering era the rocks rose out of a bed of boathouses, rusting machinery and rail lines, like the bald heads of inanimate earth-gods who were frowning on the ruin of the waterfront.

Gravenhurst was the railhead then. From 1875, when the railway arrived, to the 1910s and '20s, when lumbering declined, most of the timber left Muskoka via the Gravenhurst terminal, Muskoka Wharf. It's difficult to say how many sawmills operated around the bay at any given time. Certainly there were six within hailing distance of each other on Rogers' 1879 map: two where the *Segwun* docks today, two more in the vicinity of the National Potash towers, and two in West Gravenhurst. By the 1890s early mill names like Cockburn, DeBlaquiere, Tait, Taylor and Brown had given way to the big names in the business: Rathbun, Mickle-Dyment, and Snider.

At times the bay was chock full of sawlogs. So many, in fact, that a fellow could walk *across* the bay to see his girlfriend on a Saturday night. And there are reports that steamboats could be held up here in a logjam for six to seven days.

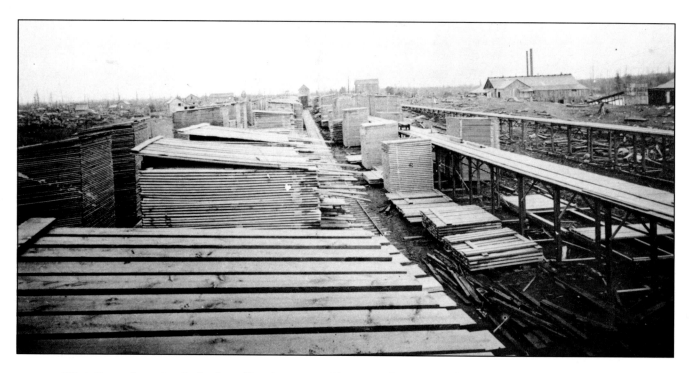

West Gravenhurst in the heyday of lumbering. Freshly cut timber was stacked in piles as tall as houses. The Snider mill, in the background, was situated behind the present-day Jug City, Hill Street. G.W. Taylor built the mill and ran it until 1890. The Snider Company operated it until 1908. (Gravenhurst Archives)

The logs were such a scourge in the spring and early summer (before they were cleared out and sawn into lumber), that some of Gravenhurst's well-to-do citizens purchased water lots to keep the area in front of their boathouses free of logs; they not only owned the land where their boathouses sat, but 800 feet out into the water as well. There were at least four such water lots in the vicinity of the government dock.

The bottom of the bay is still littered with big logs that have not deteriorated, but the expense of retrieving them would make the cost of the salvaged lumber too high to compete with the products that are readily available at the local lumberyards.

WEST GRAVENHURST

Today a ball park is the most distinguishing feature of West Gravenhurst shoreline. In the lumbering era, though, the big mills dominated the lakefront. It was wall-to-wall lumber from the Hill Street area, where the Snider's Mill was located, right round to today's Sagamo Park. Stacked two to three storeys high, the piles of freshly cut wood actually looked like houses, hundreds of them, built shoulder to shoulder like tract housing.

Snaking between the piles of lumber were about 32 kilometres (20 miles) of railway track, counting the sidings and the main lines together. Overhead tramways hauled the lumber to the tiptop of the piles. To get to West Gravenhurst from Gravenhurst you had to work your way through the maze of lumber on a road made of wood shavings. Just about every day, there would be a fire somewhere in the yard.

The mills burned their refuse in a large burner which lit the sky at night. Some of the sawdust accumulated along the shore and built up into a "bridge" which was strong enough to hold a horse, if the rider didn't mind a spongy ride. According to Effie Groh Beiers in *The Light of Other Days*, "This log and sawdust bridge squished water every time a horse trod on it, and timid persons breathed a sigh of relief to be over safely."

1 FIRST MICKLE-DYMENT MILL AND SHINGLE FACTORY

The Tait family had established a mill at the south entrance to West Gravenhurst by 1877. In 1878 Charles Mickle Sr. joined forces with Andrew Tait to operate Tait's sawmill, later buying Tait out. Mickle formed a new partnership with Nathaniel Dyment in 1884, creating what was to become a giant among lumbering companies in the province. A fire destroyed the Mickle-Dyment mill in West Gravenhurst in 1889 or 1890. The mill sat on the residential lot that now has an arched bridge to a dock. The little island in front of the property held the mill's refuse burner, and the flames from the refuse burner provided a primitive style of street lighting for the citizens of West Gravenhurst.

2 MICKLE-DYMENT MILL

The Mickle-Dyment sawmill operation outlived all others in Gravenhurst and is quoted as being "one of the most extensive and successful lumber firms in the country." An 1890 business directory listed the company as owning two sawmills and a shingle factory, and employing about 100 men. The company's second mill was built here, by Muskoka Wharf, in 1886.

Mickle ran such a large operation that it became a suburb of the town. Mill hands took up accommodation nearby, and the area became known as Mickletown. Life in Mickletown was tuned to the mill whistle, but that whistle fell silent in 1936.

The mill had been winding down its operation for some years prior to its closure. Mr. Mickle Sr. had seen the writing on the wall and expressed his thoughts about the ending of the lumber era on the occasion of his 50th wedding anniversary in 1926. "It is a history that can never be acted over again, for all the great stand of virgin timber in the old parts of the province are gone."

Today the Silvaplex plywood plant sits on land once taken up with extensive piles of lumber from the Mickle-Dyment mill. The land has been reclaimed from the original shoreline by years of sawdust accumulation.

3 MUSKOKA WHARF

It's hard to imagine the Muskoka Wharf site as an important historic landmark. It's lost in the backlot of a plywood factory, an ugly landfilled jetty held in the clutch of some ghastly aluminum boathouses. Piles of broken concrete and asphalt have been dumped here and there. Some tough-looking grass has grown through the cinders, and if you kick through it you can find the old rail line.

In early days the line ran right down to the end of the wharf. If you stood at the base of the wharf, you'd see a long station-house complex, similar to the restored station building in downtown Gravenhurst. It had a large waiting room, telegraph office and a restaurant, all under one roof, with a canopy that extended over the rail lines right to the end of the wharf. Oscar Purdy, who has been around Gravenhurst for a good many years, describes the scene at the old Muskoka Wharf this way: "At train time there might be a couple of trains in at once, and four or five steamboats at the dock. A purser stood outside each boat and the people would be running, running, from one place to the other. Just a madhouse. Everybody on the tear."

The line reached Muskoka Wharf in 1875, connecting passengers to the Muskoka Navigation Company steamers. For years, more people and products came and went through Muskoka Wharf than any other terminus in Muskoka. In the hierarchy of railway stations, Muskoka Wharf was the ruling monarch.

At the foot of Muskoka Wharf, on the east side, the hulk of the steamer *Sagamo* is buried under a pile of concrete rubble. It's an inglorious end to a steamer which was once the flagship of the Muskoka Lakes Navigation Company. The lavishly appointed steamer was pulled out of active service at the end of the 1958 season. It served for a short time as a floating restaurant, complementing the *Segwun*, which had become a floating museum. In 1969 a fire razed the steamer, and its burned-out hull was towed to this location and buried.

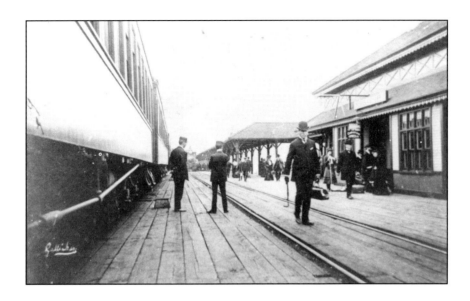

Muskoka Wharf
(Gravenhurst Archives)

THE RAILWAY STORY

Getting the railway to Muskoka Wharf was probably the most important event in the history of Muskoka. Having the railway meant business, new settlement, a better life. Not having the railway meant loss of industry, trade, and exodus of settlers to more prosperous areas. That's why, in 1869, representatives of the organized townships of Muskoka, which had only been opened to settlement ten years before, invited the officers of the Northern Railway Company for a visit, with a view to obtaining a railway extension to Muskoka. The Northern Railway was at that time operating a line from Toronto to Barrie.

The president of the railway, along with other officials, businessmen and journalists, received a warm Muskoka welcome in September 1869, stopping in Bracebridge, then Gravenhurst, before carrying on to Parry Sound. In December of that year the Toronto, Simcoe & Muskoka Junction Railway was incorporated.

But the railway had some rough terrain to cover, both physically and figuratively, before the line made it to Gravenhurst in 1875, where it was stalled for ten years. The problem hinged mostly on funding. In the winter of 1871 rumour had it that if the line made it to Severn Bridge, it would stop there. The line had been pushed through that winter from Orillia to Rama. It was terribly cold and the workmen were complaining. What's more, the company was low on cash. So the manager, Frederick Cumberland, issued an ultimatum to the municipalities north of the Severn. They had to come up with the necessary funds or the railway would stay were it was.

In a meeting with municipal representatives in February 1871, the provincial government had agreed to a provincial grant of $4,000 a mile to take the rail line from Washago to Bracebridge. The railway was giving $10,000 a mile, and the district was asked to come up with about $2,000 a mile for about 25 miles — a total of $50,000, a hefty sum for an area where settlement was just nicely getting started.

To be on the safe side, the railway decided to space out the construction on a go-as-we're-paid basis. What with the funding problem and the difficulty getting the line across streams and rivers in the area, it took four years to get the railway from Rama Township to Gravenhurst.

So it was with great fanfare that the citizens of Muskoka greeted the arrival of the first train to Gravenhurst on September 28, 1875. People arrived from all points to see the train. Hotelkeepers rolled kegs of beer into the street and the town whooped it up.

The spur was extended to Muskoka Wharf in November 1875. The tracks connecting the Gravenhurst station (at the south end of town) to Muskoka Wharf station were so steep that the passenger trains had difficulty making the climb. For several decades the railway kept a wood-burning locomotive in the yards to help the passenger trains up the grade. Some old-timers will remember the shunter engine, with its classic funnel smokestack. It was called "Ruby" and they say it was the first engine to come to Gravenhurst.

In the course of the construction of the line, the Toronto, Simcoe & Muskoka Junction Railway merged with the North Grey Railway to become the Northern Extension Railway, which in turn was absorbed by the Northern Railway. Later the Northern became part of the Grand Trunk Railway, and still later, the Canadian National Railway.

4 DITCHBURN BOAT MANUFACTURING COMPANY

From the water, you can see the tall smokestack a long way off. On closer inspection, you'll find a rambling brick building that straddles the peninsula. This is the second plant. The first one burned in 1915, and some of its salvaged timbers were installed in the ceiling of Sloan's Restaurant in Gravenhurst.

It was the location that brought the Ditchburns to Gravenhurst in the first place. Most of the vacationers to Muskoka passed through Muskoka Wharf on the way to their summer retreats, so it was an ideal place for a boatbuilding and boat rental business.

Henry, William, John and Arthur Ditchburn came from England to Rosseau in 1869. They were descended from a long line of boatbuilders and seafaring men. A 1929 company advertisement reads: "The Ditchburn family have been building boats for 500 years. At the time of the Spanish Armada, William Ditchburn was one of the naval advisors to Queen Elizabeth and 300 years later his descendants were the pioneers in the construction of the first iron ship. Henry Ditchburn, founder of the present industry at Gravenhurst, Muskoka, sailed as a midshipman on the Blackwall frigate, Cospatrick, between London and the Orient for nine years before coming to Canada."

The Ditchburns set up depots to cater to tourists at Port Carling, Port Cockburn and Gravenhurst. Gravenhurst proved to be the preferred location and became the company headquarters around 1890. After some experiments with gasoline launches in the early 1890s, the Ditchburn company began building motorboats in earnest in 1898. Henry's nephew Herbert had joined the firm and by 1904 was running the Gravenhurst operation. The incorporation of the H. Ditchburn Boat Manufacturing Company in 1907 heralded the coming of the golden age of boatbuilding, an era when boatbuilding in Muskoka would gain nationwide recognition.

To this point, the company's mainstay had been the production of sailboats, rowboats and canoes. By 1921 the focus had shifted to the large motor launches, the luxury line especially. These were showcase boats, 60 to 70 feet long with gleaming hulls, polished brass, leather upholstery, and enough levers and dials to make you feel like an admiral.

The plant covered one and a half acres. It was a massive boatworks with, at one time, five marine railroads running into the lake: two at the front, two at the back, and one by the CNR line to facilitate the loading and unloading of heavy boats from water to flatcar or vice versa.

Two of the marine lines ran right through the buildings, from the bottom floor, where repairs were done, to the second-storey paint shop, then back out into the lake at the other end. With this system, the boats could be moved in and out of the building easily. At the Muskoka Wharf side of the plant there was a large glassed-in showroom, with a handsome boat on display.

By 1923 the company's Gravenhurst plant was bursting at the seams with orders, many of them for boats too large to be accommodated at the Gravenhurst plant. A new boatworks was set up in Orillia, where, with access to the Trent-Severn Waterway, boats could be delivered anywhere on the Great Lakes.

At its height, the Ditchburn Boat Manufacturing Company employed about 130 men in Gravenhurst and Orillia, an operation that was larger than anything else in the country at that time.

Then the Depression settled in, stifling the demand for launches. Having invested heavily in expansion in the late 1920s, Ditchburn's found itself in a precarious position. In May 1932 the company declared bankruptcy. In the following years Herbert Ditchburn tried to resurrect the company with a less expensive product, but that failed as well.

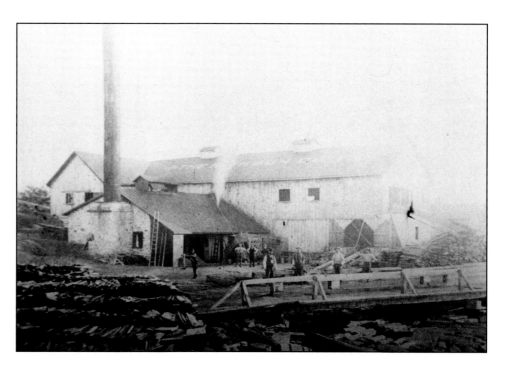

Rathbun Lumber Mill
(Gravenhurst Archives)

5 RATHBUN LUMBER MILL/GREAVETTE BOATS

Lumbering characteristically gave way to boatbuilding on the shores of Muskoka Bay. At the Greavette site the observation is correct not only in the general sense, but also literally. Isaac Cockburn had a large sawmill operation at the base of the ridge many years before Greavette's boatworks was established here. Cockburn received a listing in an 1890 Business Review which said he ran a lumber, lath and shingle business employing about 60 men. By 1904 the Rathbun Lumber Company had purchased the holdings.

The Rathbun mill became part of the National Potash Corporation and Gravenhurst Crushed Granite Company around 1920 and burned when the plant exploded in 1925. Tom Greavette then built a large boat-manufacturing plant on the site, locating his main building just to the right of where the sawmill had been.

Researchers believe Greavette's was the first assembly-line boatworks in Canada. Founder Tom Greavette had been in on the ground floor when Henry Ditchburn began making motor launches in Gravenhurst. He left Ditchburn's employ in 1929 with a view to setting up his own operation. His backers were former Ditchburn customers who believed in his assembly-line idea. The plant was built in November 1930 and work began the following April. It ran day and night, turning out a boat a day.

Starting a business in the Depression was a risky undertaking, and Greavette's ground to halt for a few years, but in 1933 the company was reorganized with the emphasis on custom-built designs.

During the Second World War, Greavette's built boats for the air force and the upper structures for the Fairmile patrol boats, which were being built in Toronto. The company also made the race-winning *Little Miss Canada* speedboats for Harold Wilson. In 1933 *Little Miss Canada* III won the first World Championship 225-Class race held at the Canadian National Exhibition. Wilson won again in 1934 with *Little Miss Canada* IV.

Tom Greavette died in 1958. The MacNab family operated the company for a number of years after that, then Bruce Wilson took over Greavette's and moved the plant to Port Carling in 1978. The Gravenhurst building became a marina, and was torn down in 1987. Today it is the rock itself that is of prime real estate value. A new condominium project called Bayview Ridge is planned for this location.

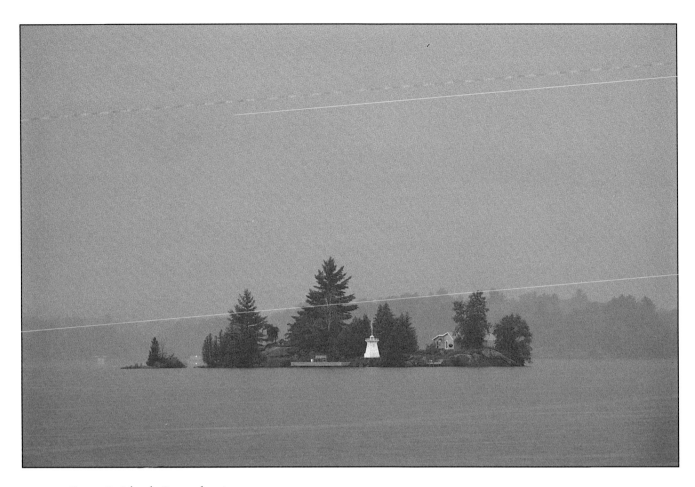

Greavette Island, Gravenhurst.

6 NATIONAL POTASH CORPORATION AND GRAVENHURST CRUSHED GRANITE COMPANY

As landmarks go, the towers are unique. For years they sat on their own, looking like refugees from some derelict mining operation. They seemed to have no business on the waterfront. As it turns out, "no business" was endemic from the beginning. The idea behind the construction of the manufacturing plant was one of the get-rich-quick schemes that took advantage of wartime patriotism. When founding the company in the early years of the First World War, the owners had it in mind to crush granite, extract phosphate and produce potash. They put out a flowery booklet that decried the "worldwide German monopoly" on potash, which could be ended, it suggested, by buying into the Gravenhurst potash company.

After a year of operation it was a guessing game as to who had control of the company. In 1924 the town seized the plant for back taxes and unpaid power bills. These were paid, but the company quickly fell into arrears again.

Then, on June 20, 1925 the plant burned to the ground. The fire was spotted by the crew on the *Segwun*, who sounded the alarm. But the fire ignited barrels of blasting powder, and the ensuing explosion demolished the plant and showered the bay with embers. People climbed to their rooftops to beat out the sparks. The nearby Ditchburn home was saved, but not the barn. And the landmark Rathbun Mill, which made up a large part of the plant, was destroyed. The towers remained. In more recent years an artist built a studio around the towers. Work crews demolished the studio in the summer of 1989, making way for a realignment of Highway 169, but there are plans to preserve the towers as an attraction in Sagamo Park.

21

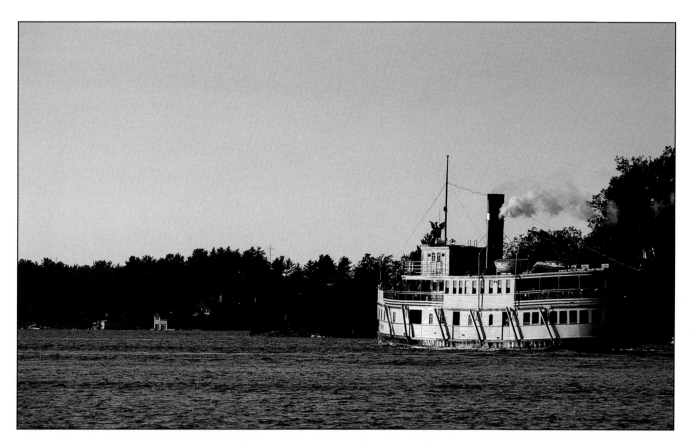

The Segwun departing Gravenhurst

7 SAGAMO PARK/MUSKOKA NAVIGATION COMPANY.

Sagamo Park, named after the steamer *Sagamo*, encompasses what were the navigation company yards. In steamboat days this was a swampy bit of ground littered with old tin sheds, marine rail lines, and discarded machinery. As the waves washed the shoreline, dozens of weather-beaten sawlogs rolled back and forth, the flotsam and jetsam from nearby sawmilling operations.

The landscaped Sagamo Park, officially opened in 1986, is a successful attempt at reclaiming the waterfront for the people to enjoy. Gone are the scruffy boathouses and the hodgepodge of docks. The clipped lawns and neat boatslips give the park a yacht-club atmosphere, with the showpiece, of course, being the refurbished *Segwun*, moored at the government wharf.

The *Segwun* and *Sagamo* were sister ships, two of the last steam vessels to operate on the Muskoka lakes.

The *Sagamo*, which means "Big Chief" in Ojibway, lived up to her name. She was the biggest and most richly appointed steamer in the Muskoka Navigation Company fleet. She was so big, in fact, that many of the docks around the lakes could not accommodate her. Going up the Muskoka River was impossible in the *Sagamo*, and she wouldn't fit under the bridges on Bala Park Island. That knocked both Bracebridge and Bala off the list of the steamer's ports of call.

She was the first navigation company steamer to burn coal (instead of wood), the first to have steam steering and electric lights, and probably the first with an on-board septic tank. But most remember the *Sagamo* as the 100-Miler. The 100-Mile Cruise took tourists on an all-day excursion of the three lakes, starting at Gravenhurst, then cruising up lakes Muskoka, Rosseau and Joseph to Natural Park, at the top of Little Lake Joseph.

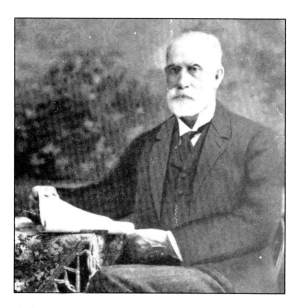

A.P. *Cockburn*
(Gravenhurst Archives)

To many of the cottagers on the lakes, the *Segwun* and the "Sag" epitomized the Muskoka experience. Just watching the tall white giants gliding by, with smoke billowing from their stacks, was magic. And if you ran down to the dock and waved for all you were worth, you might get the captain to blow the whistle. And that was the best of all.

It was a sad sight to see the two steamboat sisters moored permanently at the dock at the foot of Bay Street. There were two attempts to turn the *Sagamo* into a floating restaurant (circa 1962-63 and 1968-69), a complement to the *Segwun*, which since 1962 had been operating as a floating museum. The *Segwun* got a new lease on life in the 1970s, when a group of interested citizens decided to see if they could get her back into operation. The *Sagamo*, sadly, caught fire and burned in 1969, but her name lives on in the pretty little waterfront park.

MUSKOKA NAVIGATION AND HOTEL COMPANY

Alexander Peter Cockburn, the originator of steam navigation on the Muskoka lakes, visited the Muskoka area in 1865, while he was reeve of Eldon Township in Victoria County. He was especially taken with the possibilities of opening up the district via water navigation on the chain of lakes comprising lakes Muskoka, Rosseau and Joseph. He mentioned the idea to Darcy McGee, a minister in the pre-Confederation government, saying he'd put a boat on the Muskoka lakes if the government would build a lock to by-pass the Baisong Rapids on the Indian River.

The idea fired the imagination of both the government and the Cockburn family, who packed up and moved to Gravenhurst. A.P.'s father and brother set up a lumber business, while Alexander opened a large general store and stagecoach service.

In 1866 Cockburn had the paddlewheeler *Wenonah* built, the first of a fleet of steamboats that made the navigation company an integral part of the history of the district. By the 1880s Cockburn had three steamboats operating on the Muskoka lakes: the *Wenonah*, the *Nipissing* (1871) and *Muskoka* (1881). (The *Waubamik*, Cockburn's second steamboat, had been taken off Lake Rosseau and sold to a man on Lake of Bays.) It was in 1881 that the collection became an official "line" under the title: Muskoka and Nipissing Navigation Company.

In 1889 the company changed its name to the Muskoka and Georgian Bay Navigation Company. In 1901 it was the Muskoka Lakes Navigation Company, and by 1903 the Muskoka Lakes Navigation and Hotel Company. The addition of the word "Hotel" was a result of the company's interest in the Royal Muskoka Hotel, the splashiest accommodation on the lakes to that date. The building, designed by Lucius Boomer of Waldorf Astoria fame, was the type to wow the who's who of any continent with its massive central rotunda, mansion-like wings and towers, not to mention verandahs that stretched to extravagant proportions. At the time of A.P. Cockburn's death, in 1905, the navigation company owned eight steamships and the grandest hotel on the lakes. It was the largest operation of its kind in North America.

The Royal Muskoka Hotel, the jewel in the company's crown, turned out to be a gem set in fool's gold. During the Depression, the cost of a holiday at the Royal Muskoka went beyond the reach of many. What profits the steamboats made were eaten away by the debts of the hotel. The motor car had arrived, too, and road transportation began to cut into the steamboat trade. Still, in spite of the setbacks, the company managed to make it through the Dirty Thirties and at the end of the decade was one of the few steamboat lines still operating in Canada.

The company rallied a little during the Second World War, when gasoline rationing restricted the pastimes of vacationers and made the steamboats popular again. After the war, however, it was evident that the steamboat was a tortoise in a hare's world. Also, repairs to the vessels were costly, and finding experienced men to run the boats was getting harder and harder each year. In 1952 the Royal Muskoka Hotel burned, and in 1955 the Muskoka Navigation and Hotel Company sold the steamship line to Morgan Cyril Penhorwood, who created a new but short-lived firm, Gravenhurst Steamships Limited.

The navigation company was out of business, although it retained a paper identity to sell off portions of Royal Muskoka Island. It was officially dissolved in November 1970, but has been resurrected to identify the management company which operates the *Segwun* for her owners, the Muskoka Steamship and Historical Society.

Gauges on board the Segwun.

8 RMS *Segwun*

The *Segwun* makes a perfect picture sitting in the summer sun, and you will usually find several photographers clicking their cameras at her from various vantage points along the shore. The Muskoka lakes are made even more special by the presence of the RMS *Segwun*. She's a grand old girl, the real McCoy, saved from the fate of her sisters by the dedication of those who wanted a living reminder of the steamboat era.

The name *Segwun* is the Ojibway word for "springtime," and it's a fitting name when you consider the "rebirths" in the *Segwun*'s background.

She started out in 1887 as a paddlewheeler called the *Nipissing* II. At that time she was the flagship of the fleet, and the first iron-hulled vessel on the inland waterways in Ontario. Her predecessor, the *Nipissing*, had burned in 1886 at Summit House, at the head of Lake Joseph.

Because the second boat had arisen from the ashes of the first, the captain of the Nipissing II, George Bailey, carved a wooden phoenix rising from flames and placed the emblem on the wheelhouse. The Nipissing II continued in service until 1914, then sat at the Gravenhurst dockyards for the next ten years, looking more down-at-the-heels with each passing season. But in 1924 the navigation company wanted to expand its fleet, and the Nipissing's iron hull was sound enough to justify converting her to a twin-propeller vessel, called the Segwun. The phoenix on today's Segwun is a replica of the original, unveiled in a special ceremony in the summer of 1987, the Segwun's 100th birthday.

The Segwun and Sagamo sailed out of active service in 1958. In 1959 they were sold to two Gravenhurst businessmen who had plans of scrapping the Segwun and turning the Sagamo into an entertainment centre. But before the Segwun could fall under the wrecking ball, the citizens of Gravenhurst rallied to save her and have her made into a floating museum. The businessmen, Jack Vincent and George Morrison, sold the steamboat to the town for $1.

The museum opened in 1962 and continued till the early '70s, when it became clear that the Segwun was deteriorating and in danger of sinking. She had not been out of the water since 1955.

Since 1969 a group of steamboat lovers had been touting the idea of putting the ship back into operation as a living artifact. A massive fundraising effort got under way in the following years, with the Ontario Roadbuilders' Association coming forward in 1973 with an offer to sponsor the rebuilding of the ship.

The hull was removed in sections and shipped to Collingwood to be replated while a local woodworker repaired the superstructure. The Segwun was officially relaunched by then prime minister Pierre Trudeau on June 1, 1974. But it took a few more years before the engine, boiler and electrical system were refurbished. In fact, it wasn't until June 1981 that the restored steamboat made her maiden voyage up Lake Muskoka. The Segwun is now into her second century of service.

9 MINNEWASKA HOUSE/SANATORIUM

Today there's not much to see on the Minnewaska House property, just a large cement footing or two, traces of a foundation, and a drainage spillway that looks like something out of an old city sewer system, complete with rusting valves, grates and a holding tank half covered with decaying timber. There's an ominous dripping sound emanating from the pit of the tank that lets you know it's both deep and dangerous.

By 1899 the Minnewaska House summer hotel had found a prominent place on area maps. By all accounts, it was an ambitious undertaking for its time, with steam-heated rooms, electric lights, and a drainage system. The site, atop a rocky headland, takes your breath away these days, but at the turn of the century, visitors would no doubt have found a less edifying horizon, one cluttered with sawmill roofs.

About 1908 Doctor Charles Parfitt took over the property and converted the hotel into a private hospital. Dr. Parfitt came to Muskoka as physician-in-chief when the Muskoka Free Sanatorium (Fire College location) was established. He was born in Delaware, Ontario, and took his medical training in Toronto and Europe. With a career that included lecturing at Cambridge and working at John Hopkins Hospital in Baltimore, Parfitt held considerable standing in the medical community when he fell victim to tuberculosis himself on his return to Toronto. His stay at the Saranac Lake sanatorium revived him, and he went on to work exclusively in the field of tuberculosis treatment, for which he received the King George V Jubilee Medal for devoted service.

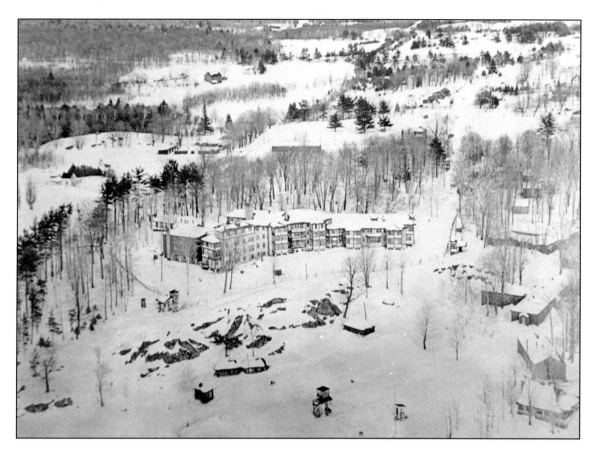

German Prisoner of War Camp, formerly Calydor Sanatorium. (Gravenhurst Archives)

Parfitt operated the Minnewaska as a sanatorium until 1916, at which time his new hospital, Calydor, opened on the adjacent grounds. Minnewaska was torn down about 1922.

The Minnewaska's rocky headland is as dramatic as it always was, but the once well-tended grounds behind it are choked with regrowth and odd piles of modern rubbish.

10 CALYDOR SANATORIUM/GERMAN PRISONER OF WAR CAMP

In a woodsy part of Gravenhurst, bounded by Lorne Street and Muskoka Bay, there's a rusty fire hydrant standing in the brambles and an asphalt driveway that seems to run nowhere. If you wandered in here unawares, you'd stumble on the remains of a chain-link fence, snipped off at its concrete base, find the ends of bed springs "growing" out of the ground, and discover some meticulous stonework that once bordered the gardens. The building that stood here housed patients, then prisoners, then folks up for vacation.

The story starts in 1913, when Dr. Charles Parfitt and his associates began raising money to set up a private sanatorium for the treatment of tuberculosis. The Calydor opened in 1916. In 1924 a local paper described the hospital as "a sanatorium of exceptional character for people who can afford to meet their own expenses."

The facility proved popular and a waiting list soon developed. Patients doubled up in rooms, or stayed in tents on the property when there was an overflow. One Hamilton family, the Haltons, moved their summer cottage from Lake Rosseau to Muskoka Bay to be closer to the Calydor. Dr. Parfitt was Mrs. Halton's physician. (The Halton cottage is the lovely brown-shingled home you can see opposite the government dock in Gravenhurst.)

During and after World War I, there were always some ex-servicemen in residence for periods of convalescence arranged by the Government of Canada.

The Calydor ceased operation in 1935 and stood idle for some years. In 1940 the federal government took over the hospital and converted it to a prisoner-of-war camp. About 400 to 500 prisoners of the British government were sent to Gravenhurst by train and interred at the Calydor facility. This particular camp was set up for high-ranking Nazi officers. Townsfolk remember them as an arrogant bunch who often spat at the guards when they passed. The exercise yard rang with the clicking of heels as officers saluted one another.

This was not Stalag 13 by any stretch of the imagination, in spite of the chain-link fence. While the prisoners did have to put in time on the work crew, they also had opportunities to set up an orchestra, play volleyball and tennis, or go for swim. The camp had barbed wire strung out into the water, and the prisoners were to stay inside the fence — although it was not unusual for a local resident to find a prisoner rowing outside the confines of the fence while his guard sat inside watching him.

Of course, the local people were quick to rub the prisoners' noses in their predicament. When the steamboats went by, for instance, the pianist on board played "There'll Always Be An England." They say the prisoners became so accustomed to the tune that they began humming it to themselves.

The prisoners were on their honour not to escape, although some tried, unsuccessfully. Several dug a tunnel that opened into a nearby cornfield; others tried to escape in trucks or packing crates. If a break occurred, the whistle at the Rubberset plant in town sounded an alarm.

It's ironic that the building which housed the Nazi prisoners of war became the Jewish-run Gateway Hotel after the war ended. The Gateway was a popular spot, especially for entertainment. In the declining years of the hotel's history, it operated as a children's camp, then stood idle. It burned in 1967.

While many Gravenhurst citizens take walks through the property and dive from the rocks along the shore, this is actually private land. Records at the Town of Gravenhurst (1989) show parcels of the Calydor and adjoining property belonging to U-4 Developments, c/o Alan Eagleson (a name many hockey buffs will recognize).

11 MUSKOKA FREE HOSPITAL FOR CONSUMPTIVES/FIRE COLLEGE

The Muskoka Free Hospital for Consumptives was the second sanatorium established in Gravenhurst. "The Free," as it was called, was built in 1902 for those who could not afford tuberculosis treatment. Charitable donations and a weekly grant from the province of $1.50 per patient kept the hospital running. Later the province took complete responsibility for the maintenance of the hospital. The free sanatoriums in the province were deliberately planned to get the tuberculosis patients out of crowded homes and into an environment where there was plenty of bed rest, fresh air and good food.

The patients' accommodation (called shacks) were long, unheated pavilions with the beds lined up like deck chairs in verandah-like corridors. Even in the middle of winter the windows were swung open to let the fresh air (and snow) inside.

In 1908 the Muskoka Cottage Sanatorium (Muskoka Centre site) and the free hospital were brought under one medical management. The combined operation became known as the Muskoka Hospital, or "The San." A fire in November 1920 destroyed the main building at the free hospital. Following the fire, patients were housed at the cottage hospital and the free hospital became a residence for staff.

The provincial government purchased the free hospital property in 1957, and a year later opened the Ontario Fire College, the first residential fire college in North America. The college provides year-round advanced training for firefighters from municipal fire departments, as well

as weekend courses for volunteer firefighters. Fire departments from across Canada and around the world have sent firefighters to the college.

From the water you can see the modern students' complex, built in 1984. Before the new residence was built, students were accommodated in the old free hospital infirmary, which had escaped the fire in 1920. To the right of the residence is a pretty, turn-of-the century residence called Staff House. In the sanatorium days it was Fulford Cottage, built with funds provided from the municipality of Brockville for use of patients from that part of the province. It later became a doctors' residence and now houses the instructors' offices at the fire college.

Two cement-block towers are prominent on the shoreline. Viewed from the water, the tower on the left is used for training students in scaling techniques. The tower on the right is regularly set ablaze to give the students practice in putting out fires. Straw is scattered about inside the building to start the fire. The shallow pit to the right of the smoke towers is filled with oil or gasoline and set on fire to give students practice extinguishing flames.

TAKING THE CURE

While it is hard for us to imagine today, the word "tuberculosis" at one time engendered such fear in people that they shunned victims of the disease. The fear was very real, as there was, in the beginning, no medicine to cure the highly infectious disease and no institution in the country willing to accept tuberculosis patients for treatment. In 1895 Gravenhurst offered Canada's recently formed sanatorium committee $10,000 to locate a sanatorium (Muskoka Cottage Sanatorium) near the town. It was a bold step, considering the mind-set of the era against exposure to TB.

If there ever was truth to the saying "if it doesn't cure you it will kill you," the fresh-air regimen for tuberculosis patients was it. Historian Herbert Irwin describes winter at the sanatorium this way:

Patients went to bed typically more than fully dressed, wearing two or three sweaters over heavy underwear and pyjamas, bathrobes, toques, scarves and socks. Each tried to acquire eight blankets on top and eight below. Five times in 24 hours, two-gallon earthenware jugs were filled with hot water, and two were placed in each bed, one at the foot and one halfway up the bed, tucked under the covers. The moisture created by these containers gradually seeped through the mattress and froze in the manner of a stalactite, eventually reaching the floor in a column of ice about eight inches in diameter. Bed patients were given a hot water bottle on their laps while eating. The temperature would drop to -30°F (-22°C) and often snow blew in, covering the floor between the beds. Sufferers were exposed to the elements like this under the assumption that it was the best way to arrest this chronic and smouldering disease."

East Georgian Bay Historical Journal Vol.2, 1983

The cure was a drawn-out affair lasting anywhere from one to ten years. When the fever subsided and the coughing diminished, patients embarked on a gradual course of exercise with activities such as canoeing and water sports in the summer, and sleigh rides and snowshoeing in the winter. Patients on the mend were dispatched to the pavilions, where they virtually lived outdoors. The central washrooms were heated, but the long verandahs were open to the elements.

The sanatorium had the best-equipped operating room north of Toronto. Chest re-section was the common treatment of the day. The early therapies included heliotherapy, with natural sunlight and ultraviolet light. Doctors also tried gold injections and electrical treatments. But it was not until the 1940s, with the discovery of the antibiotic streptomycin, that clear inroads began to be made. In the '50s and '60s chemotherapy did not completely cure the disease, but it allowed radical surgery without fear of spreading the disease. In time antibiotics eliminated the need for surgery altogether, and sanatoriums, as a place of isolation and bed rest, were no longer needed.

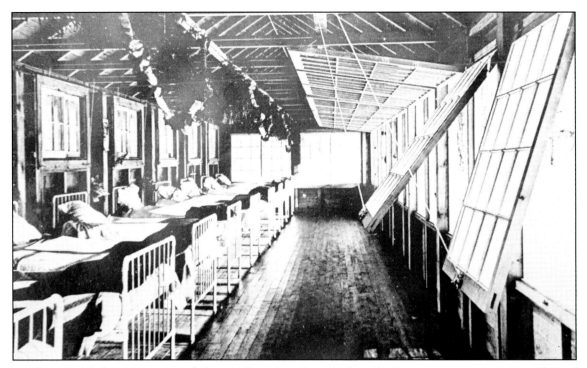

Fresh air and bed rest were part of the cure for tuberculosis in the early days. Even in winter the windows of the sanatorium pavilions were opened wide. Notice the Christmas garlands hanging from the ceiling.
(Gravenhurst Archives)

12 ROBINSON HOUSE

> The little wife was on the shore to direct us to a landing and to tell us that a very welcome supper was waiting at the house; the first meal ever served to tourists in Muskoka which is now the summer home for thousands.
>
> Thomas Robinson
> "A Voyage in Search of Free Grant Lands"

I wish there was something on the shoreline to shout out that this spot, the ninth residential lot up the shoreline from the fire college, is where Thomas Robinson built his home. It's not just the historic importance of the setting, which sheltered the first tourist establishment in Muskoka, but the man's story itself that makes this a special location.

In 1860 Robinson took a trip to Canada to find out about the free grants of land that had been publicized in England. He originally set out to see the grant lands offered along the Opeongo Road, but a newspaperman in Toronto suggested that Muskoka was closer.

Robinson made his way to Lake Muskoka, borrowed a birchbark canoe and paddled up the shoreline to this spot. What attracted Robinson, besides the stretch of good land and healthy trees, was the sandy beach with "water enough for a wharf for large boats." Robinson had an affinity for the water and was very likely the "old English man" mentioned in Joseph Brock Jr.'s memoirs as " a great man for taken [sic] baths winter and summer and people who knew him said he kept a hole in the ice where he used to drop into every morning for his bath all winter."

Having found his dream location, Robinson worked his passage back to England, and returned in 1861 with his wife. Together they set about carving their niche in the wilderness. "At last I was ready to move our belongings to our new house: our home! and to invite my patient partner to our new home. My inexperience detracted in some degree from my efficiency,

yet with a sailor's persistency and my wife's untiring help, we pulled through many tasks that would have been hopeless under other circumstances," Robinson writes.

Robinson found employment running Hugh Dillon's boat from Washago to Orillia. On the boat Robinson met the two passengers who had been the first tourists to Muskoka, university students John Campbell and James Bain. They'd first visited Muskoka in 1860 and had started coming back on an annual basis. In June 1862 they hired Robinson to guide them on an exploratory trip around the Muskoka lakes, using a boat they'd brought with them from Toronto. It was during this trip that Mrs. Robinson served the meals to the first tourists.

Following that summer adventure, things began to come together for the Robinsons. The birth of their son prompted Thomas to look to his future. He bought a boat and began building another one. This was the start of a boatbuilding and charter service. He became a councillor for the townships of Morrison and Muskoka, and built "a larger and better" house on the property, necessitated by the demand for accommodation for tourists.

Truly the Robinsons had made a success of it as pioneers. He'd taken an office in the division court, was well known and, in his modest way, had obtained a modicum of security. Ironically, it was about this time that Robinson spoke of regret at the turn of events:

> About or near this time [1896] I sold, against my conviction, some part of my land to the National Sanatorium Association on option, which I regretted since, although I had acquired more land in lieu of what I sold. All my untoward misfortunes were crowned by the death of my eldest and youngest daughters and, to crown all, the death of the partner of all my joys and griefs; this followed by my serious illness and an ultimate operation in hospital.
>
> I see now how much happier I could have made life in my late years, and better and more pleasant for myself and family, if I had been wiser, but that implied knowledge came rather too late to be useful.

Some of Gravenhurst's older citizens can remember Robinson's big yellow frame house when it was boarded up. They say it was left as if someone had just turned the key and gone. There were hundreds of books in the house, thrown about on the floor by kids who'd gone in and smashed things up. Down at the dock there was an big sailboat, also full of books.

The Flowers family later purchased the home and it became the Three Flowers Inn, so named for the three Flowers: Mr., Mrs. and Maudie. The inn is gone, but tucked in behind the trees is the Knisters' home, a white brick ranch house built where the Three Flowers Inn used to be.

13 MUSKOKA COTTAGE SANATORIUM

In the late 1800s, at a time when tuberculosis cut across all social and economic barriers as the number-one killer, a man named William Gage took the plight of the suffering to heart. No Canadian institutions accepted tuberculosis patients, the closest treatment centre being Saranac Lake in the Adirondacks, in New York State. Gage, a Toronto book publisher with a year of medical studies in his background, set up a special meeting of the National Club in Toronto on June 27, 1895, to discuss the problem of the disease (he was later knighted for his efforts in obtaining better treatment facilities), and he and his friends formed a committee to build a sanatorium. Of particular importance in choosing the site was its spa-like atmosphere. They were looking for a retreat with good, clean air and an invigorating climate. That, thought the town fathers of Gravenhurst, was just what Muskoka had to offer.

The National Sanatorium Association was incorporated in April 1896, and that same year work began on the Muskoka Cottage Sanatorium, on a point of land purchased from T.M. Robinson.

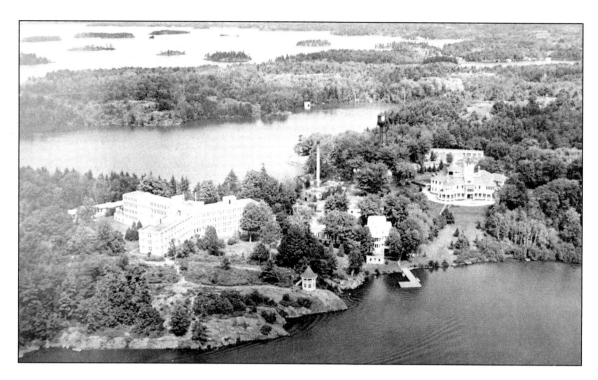

Muskoka Cottage Sanatorium (Gravenhurst Archives)

The hospital was the prettiest institutional building Muskoka has ever seen, with its rounded wings, pillars and slim central tower. Inside was a red-and-white-tiled foyer with a huge fireplace and sweeping stairway to the conservatory. In keeping with the style of the place, patients were required to dress for dinner. One writer called it "a jewel of Victorian frame construction." What a picture it must have made on opening day, July 13, 1897, sitting there amongst the stumps on the roughly cleared ground. With time, however, the grounds took on a more civilized appearance, and a sprinkling of trim, summery-looking "cottages" grew around the main building, affectionately referred to as The Main.

The cottage sanatorium originated as a private treatment facility. Patients paid a rate of $6 per week. By 1908 the sanatorium and the adjacent Free Hospital for Consumptives came under the same administrative blanket. When a fire destroyed most of the free hospital, the board of directors called for the construction of another treatment centre, called the Gage Building, in honour of Sir William Gage. The yellow brick building at the end of the peninsula now dominates the site. Lady Gage laid the cornerstone on July 5, 1922. The operating room was perhaps the best-equipped facility north of Toronto, a boon to local doctors, who took advantage of the X-ray department and outpatient facilities before new hospitals were built in their towns.

The original sanatorium building became the administrative centre of the complex. Here you could find the business offices, the switchboard, the post office, and a store — until 1958, when The Main received its notice of termination. In June of that year workmen razed the old building and Gravenhurst lost one of her prettiest structures.

In 1960 the Ontario government purchased the sanatorium as an extension of the Huronia Regional Centre in Orillia. The Muskoka Centre currently provides a live-in training environment for developmentally handicapped residents.

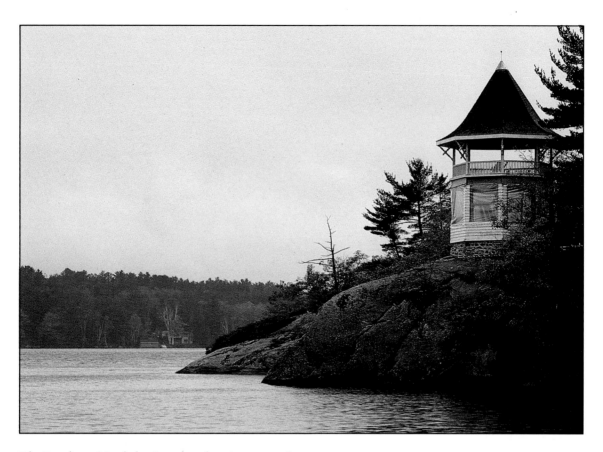

The Gazebo at Muskoka Centre undergoing renovations.

THE WATER TOWER

The centre's water tower, once emblazoned with the TB symbol, is a real navigational beacon to boaters on the Muskoka lakes. The centre still has its own water and sewage systems, and provides waste water treatment for the fire college. In this regard, the two facilities are still tied together by their sanatorium ancestry.

THE GAZEBO

After two restorations, the second in 1988-89, the two-storey gazebo is still a landmark on Muskoka Bay. It's been there since the early days of the sanatorium, outliving even the magnificent main building. Patients of the sanatorium called it the josh house because it looked like a pagoda. (The term *josh house* is an anglicized version of *joss house*, a Chinese temple.) The gazebo held a special place in the hearts of the patients, as going to the sun pavilion usually meant you were making strides in your fight against TB. Today it looks out on the bay with a fresh face, having been mostly rebuilt rather than restored. A special dedication ceremony in August 1989 designated it a historic site.

14 CLIFF BAY

You couldn't think of a better name for this feature of Muskoka Bay. The cliffs are quite spectacular. From the water they stretch 21 to 23 metres (70-75 feet) straight up. You have to wonder at cottagers building along the top. It's a great view, but getting down to the water is something else again. That's why you see the crazy combinations of steps and ladders bolted to the cliff face. The dock platforms are also bolted on.

15 THE NARROWS/SHANTYMAN'S POINT

A newcomer may be excused for thinking a right turn is the wrong direction to take if you're looking to get out to the main part of the lake. At first glance it appears as if you're heading into a small inlet. Then the tiny passageway appears. If you're aboard the *Segwun*, you feel there's no way she'll squeeze through the gap. In the steamboating days the navigation company built cribwork along the shoreline to keep the ships from scraping against the rocks on windy days. Although it looks narrow, the channel is 24 metres (80 feet) wide and 6 metres (20 feet) deep. In earlier days the bottom was obstructed on the west side by an underwater ridge. After the navigation company put the steamer *Sagamo* on the lakes in 1906, construction crews blasted the ridge to make the passage safe.

The name Shantyman's Point dates back to the lumbering era when great booms of logs had to be put through The Narrows. The Rathbun Lumber Company kept a float here. On board was a 9-metre (30-foot) bunkhouse and cook shack for the men who worked the logs through. In *Through the Narrows on Lake Muskoka*, Joyce Schell writes: "Many of the logs were put through at night to avoid any hold-up with the passenger and mail boats. Some men worked all day in the mills and after dark until two or three o'clock in the morning at The Narrows."

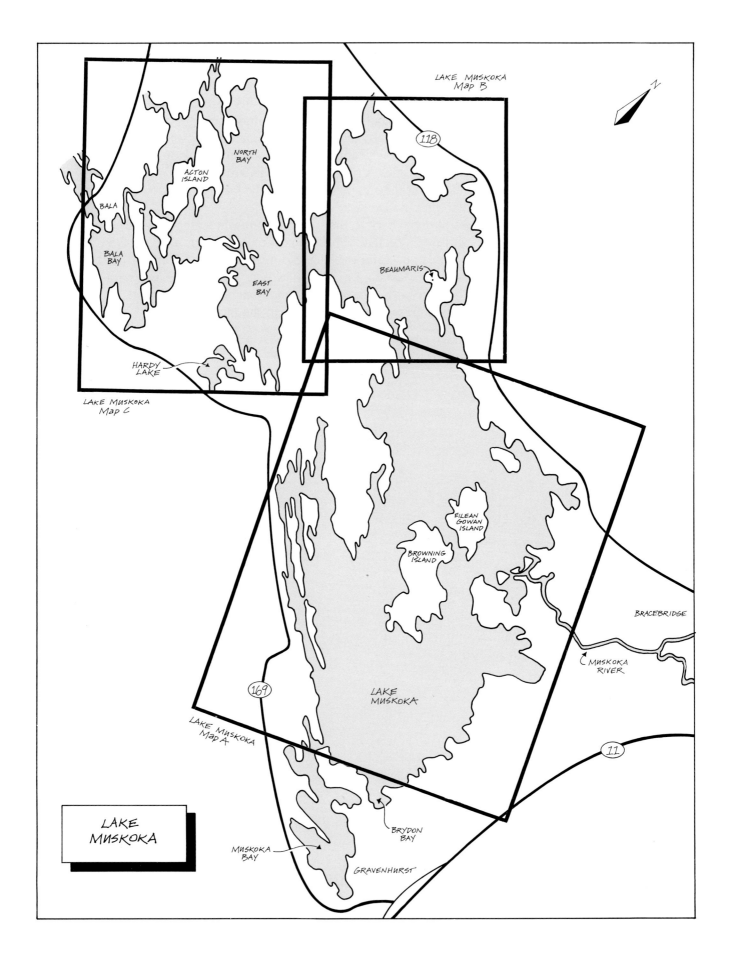

Lake Muskoka

"A spirit of merry madness seemed upon us, and without thought of fear the girls sat up to windward with glowing, waterwet faces, and laughing eyes framed with blowing, tangled, spray-soaked hair. On we dashed, past Sandy Point, with its white tents and huge dinner bell . . . On still on! past Shaw's and Bassett's and into the steamer channel, where the waves boil angrily around the Kettles, half submerged in menace to the unwary."

J. Edward Maybee
"Muskoka Wanderings"
Field and Stream, 1897

Life is played out on a grand scale on Lake Muskoka. It is the largest lake of the Big 3. It has the largest natural islands (Acton being the largest, Browning the second largest). Within its confines are some of the most looked-at million-dollar cottages in the district. Lake Muskoka is the big-town lake, with Gravenhurst at the bottom end, Port Carling at the top; to east, there's Bracebridge; to the west, Bala. It is a convenient lake, a busy lake, a lake that's harder to love.

It is also the lake that harbours the hauntingly beautiful Eleanor Island bird sanctuary, and the curious Kettles rock formations. And from these shores you can explore the largest stretch of undeveloped land accessible to the general public from the water. Hardy Lake Provincial Park, off East Bay, makes a great picnic destination and one of the only spots where you can tie up the boat and take a serious hike inland.

Lake Muskoka is the big sister of the lakes — grown up, citified, at times a pain, but also a charmer when she wants to be.

1 LIGHTHOUSE ISLAND

Lighthouse Island is perhaps the most photographed spot on the lake. The Department of Marine and Fisheries erected the first beacon here in 1884. The "light" at that time consisted of a coal-oil lamp hoisted up a mast. A shed beside the mast held supplies and provided shelter for the keeper, David Schell, who rowed out to the island each night to light the lamp. On foggy nights he operated a foghorn which could be heard far out on the lake.

In 1894 William Readman took over as keeper of the light, often conscripting his son, Charles, into duty. The distance from the Readman home in West Gravenhurst to the island was some 3.2 kilometres (2 miles) Charles rowed out and back each night to light the lamp and polish the glass, then repeated the trip in the morning, before school, to extinguish the flame.

The lighthouse (No. 2210) was built in 1905 and operational by 1906. The government gave the tender to George Brown, who had to move the mast to the side so that the new lighthouse could be erected exactly where the old light had been. With the new lighthouse came a new lighthouse keeper, Isaac Barnes. Mr. Barnes remained as lighthouse keeper until his death in 1950. He was succeeded in this duty by his son Wilfred. Wilfred kept the light until 1967, when the lighthouse was put on a service contract with the other lights on the lakes.

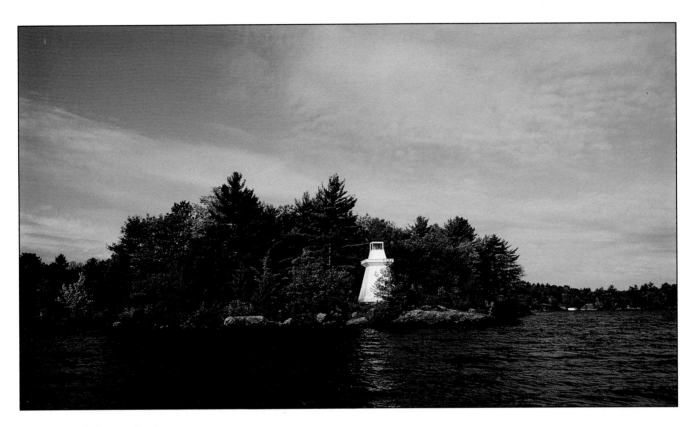

Lighthouse Island

2 MUSKOKA SANDS INN

Things have always been done up in style at the Muskoka Sands or, as it was originally called, Muskoka Sands Beach. Unlike the majority of family-run, family-operated resorts around Muskoka, The Sands was a "company" hotel from the beginning. In October 1926 the directors of the Muskoka Beach Company, which included businessmen and officials from the Gravenhurst area, announced their plans for the site. Frank Kent, the president of the Toronto company said, "A no more ideal spot in Canada could be found for the development." Certainly, the point had a wonderful view, sandy beach and bathing area, and sunsets that "defy description." A golf course was laid out along the Hoc Roc River (originally spelled Hock Rock), and the river itself was to be illuminated with electric lights. Construction of the 200-room hotel got under way in the spring of 1927. Everything was up to date with electric lights, telephones and steam heat. The reception area was big enough for a balcony orchestra and was dominated by a large fireplace.

From the onset The Sands was to be a year-round operation — a novelty at that time on the south Muskoka lakes. Not that Muskoka hadn't experimented with the winter vacation concept before The Sands. Gordon Hill's Limberlost Lodge, northeast of Huntsville, had skiers and snowshoers in residence since 1921. It seemed, however, that The Sands was setting out to make winter holidays the "in" thing. There were skating parties under lights on the Hoc Roc River, the thrills and chills of a toboggan ride, an ice carnival. And the fun did not stop at sunset. The nights were alive with dancing and jazz bands.

The plan was to make The Sands an international destination. The modern adventurer could fly into the resort in a four-seat Vickers. While the other world-class resorts in Muskoka (Bigwin Inn and the Royal Muskoka) had their reputation steeped in upper-class elegance, The Sands fairly crackled with fun.

In 1932 Warren Doan purchased the resort. Following his death, in 1957, the main lodge burned and Mrs. Doan sold the property to a co-operative trust company from western Canada. In 1984 the resort changed ownership again. The Renaissance Leisure Group from Toronto embarked on a major renovation project. They closed the resort completely from October 1986 to May 1987 and came back into business with a dramatic reception area, dining room, new pool, conference rooms and kitchen. The new time-share units dominate the point now, overpowering the landmark Boathouse Lounge, long a popular whistle-wetting spot for summer boaters.

3 ELEANOR ISLAND

No, the island is not covered in white paint. It's guano that makes it stand out like a white billboard on the horizon. Eleanor Island is a blue heron and gull rookery. It makes an eerie sight in June when the herons are nesting. The dead pine trees are bristled with nests that resemble chimney brushes. The herons sit vulture-like on the bare branches, eight or more to each tree. The trees themselves are ghostly white from the drizzle of guano that has accumulated over the years. It's a scene set for witches and goblins, but it is inhabited instead by pristine white gulls and their fat grey babies, who weave unsteadily on their webbed feet and occasionally topple off into the water. While the herons sit stealthily on their perches, sometimes pushing themselves into the sky, their long legs dangling, the gulls continuously swirl around the island.

The island is a national wildlife area and migatory bird sanctuary administered by the Canadian Wildlife Service. Muskoka Township offered the island to the Canadian government in 1970 in an attempt to give the bird sanctuary the official protection of the Dominion of Canada. In 1977 the government designated Eleanor Island a national wildlife area.

The habitat is a precious one, already stretched to its limit in providing a nesting area for the hundreds of gulls and herons that return here each year. In 1983 the Canadian Wildlife Service reported 23 blue heron nests and in excess of 200 herring gull nests. The nesting activity of the great blue herons has killed almost half of the white pine trees on the island.

The sensitive nature of the habitat means strict enforcement of a no-entry regulation. Conservation officers with the Ontario Ministry of Natural Resources have the authorization to enforce federal legislation if anyone is caught setting foot on the island.

But that doesn't mean you can't go bird-watching if you stay offshore. The island is one of my favourite places on the lakes, but I admire it from a discreet distance in a quiet, slow-moving boat.

4 BROWNING ISLAND/BIG ISLAND

The island is named after the Browning family, who figure prominently in the history of Bracebridge. They came from Newcastle-upon-Tyne, England. Andrew Browning ran a store and post office at Alport.

The 1872 *Gazetteer and Directory of the County of Simcoe and District of Muskoka* lists Andrew and James Browning as owners of the southwest half of Big Island, as it was called. They also owned land in Monck Township, near the mouth of the Muskoka River, on the north side. James, a solicitor, took the reeve's chair when Monck Township became a municipality in 1869, but gave it up after a few sessions. Andrew, whose esteem in the community is evidenced by the title "Esquire" after his name, took James' place as reeve.

Another member of the family, Robert Mortimer Browning, brother of James, studied law in Toronto and Hamilton, later returning to Bracebridge to work in James' law practice. Robert Browning is remembered in the R.M. Browning Memorial Hall on Mary Street in Bracebridge. When Robert died, in April 1903, he was probably the richest man in the town, owing to the success of a real estate and insurance business.

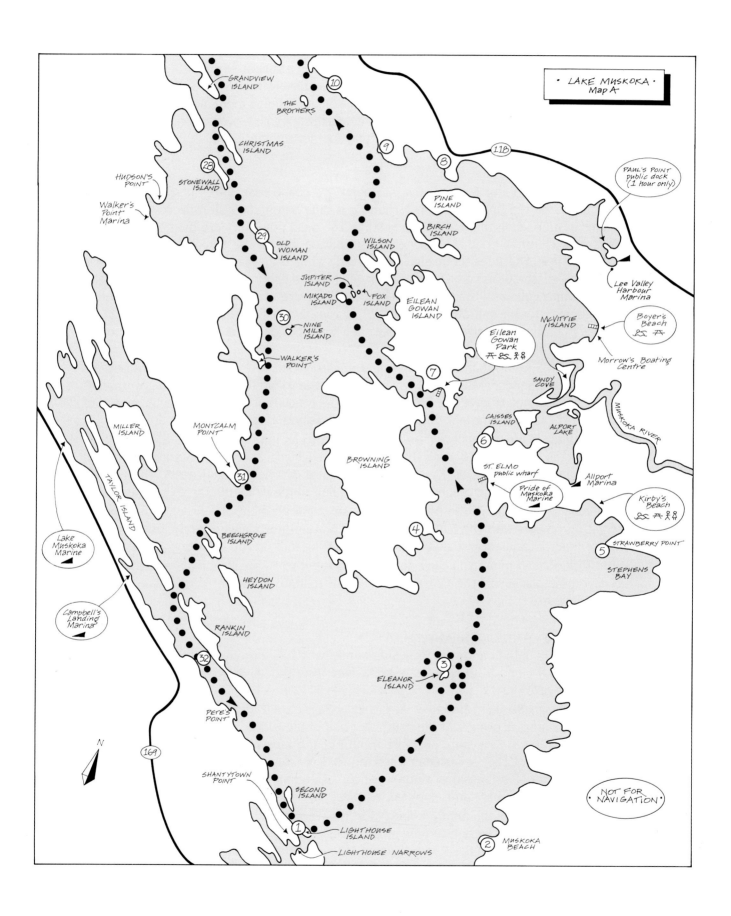

Captain Wesley Archer, whose family were early settlers at Stephen's Bay, purchased farmland on the east side of Browning Island. By 1905 he was selling produce and carrying passengers back and forth to the mainland in a small launch called the *Eagle*, followed by a succession of other steamboats, each slightly larger than the one before. Summer picnics on Browning Island became the vogue, and a canoe club camped on the island regularly.

Around 1920 Archer purchased the 70-foot steamer *Mildred*, the only serious competition to the steamers run by Muskoka Lakes Navigation Company. The navigation company had a virtual monopoly on freight and passenger service, but the *Mildred* could get to places the company steamers could not. She went faster and charged her passengers less.

Browning Island is the second largest island in the Muskoka chain, a statistic it shares with Tobin's Island on Lake Rosseau. Both are 4.2 square kilometres (1.7 square miles).

5 BRACEBRIDGE WATER SUPPLY PIPE

The 1.2-metre-wide (4-foot) pipe that plunges down a rock face is the water intake pipe for the Town of Bracebridge, put in place in the mid-1960s.

6 ST. ELMO

St. Elmo's fire is a glow that appears at the end of masts and spars of ships at night during thunderstorms. Although there's no recorded information that says St. Elmo takes its name from that phenomenon, it's easy to see how a west-facing point such as this could witness sunsets that seem to touch the horizon on fire. The cottage community at St. Elmo dates back to the early days of settlement. By 1898 the businessmen of Bracebridge had made the spot a popular summer location. A newspaper article says, "Bracebridge people have an ideal summer resort at St. Elmo near the mouth of the Muskoka River, where many of its citizens have erected cottages in which to spend the heated term."

As you're cruising by, watch for the remains of the old steamer wharf, still visible, though decaying more and more each year.

7 EILEAN GOWAN ISLAND

Early map references to the island show it as Eileangowan, not Eilean Gowan Island. "Those who know something of the Gaelic language say the Eilean simply means 'island,'" says R.J. Boyer (*Muskoka Sun*, June 28, 1979). This was Island Gowan, owned by Sir James Robert Gowan of Barrie. Over the years people have assumed that the island was named after Gowan's daughter, Eilean, but James and his wife, Anna (Ardagh), had no children.

James paid $208 for the island, which he purchased from the Crown in April 1876. The patent described the tract as Hogg Island.

In 1832 James, an Irishman, came to Canada at 15 years of age. He studied law in Toronto and in 1843 became Simcoe County's first county judge, a position he held for 40 years. Following his term as county judge, he became a senator and was later knighted. He was a great friend of Canada's first prime minister, Sir John A. Macdonald, and contributed to the consolidation of the Statutes of Canada and the Statute Law of Ontario.

In 1902 the ownership of Gowan's island passed from Simcoe County's first county judge to Muskoka's first district judge, William C. Mahaffy.

Today there are many pretty summer homes on the island, as well as a public park maintained by the Town of Bracebridge. The park is on the south side of the island, where there's a good dock, picnic tables, a barbecue, and the ubiquitous "vault" privy.

8 ASTON VILLA RESORT

What you notice from the distance is the glint of sunlight on a wall of glass, high up in the trees. These are the windows in one of the terrace units at Aston Villa Resort. The owners, Fred and Shonnie Grise, say the resort is "a little bit of heaven." Indeed, its treetop location puts it as close to heaven as you're likely to get, short of climbing a mountain or flying.

The Grises come from a long line of resort owners, starting with Fred's great-grandfather, Didace Sr., who started the Royal Hotel in Honey Harbour in the 1890s. Since that time each successive generation of Grises has left a mark on the tourism industry in Muskoka. Fred's brothers also own and operate resorts: Peter and John at the Delawana Inn, Honey Harbour; and Mike at Elgin House, on Lake Joseph.

Aston Villa was built after the Second World War by Jack Johnson, who served as reeve of Macaulay Township for some years. Johnston also developed Aston Fairways, which opened in 1966.

The name suits the location, but its origin has nothing to do with picturesque places: it's the name of a soccer club from Birmingham, England, Mrs. Johnston's home town.

The Johnsons were Scottish immigrants who selected this location as free grant land in the mid-1860s. Jack Johnson sold the Aston Villa property to the Grise family in 1973.

9 WYLDWOOD POINT/THE KIDNAPPING OF JOHN LABATT

When Mr. Horace Prowse let a cabin on Wyldwood Road to three ordinary-looking men in a Ford with Michigan licence plates, he had no idea they were underworld mobsters planning the kidnapping of millionaire brewer John Labatt.

It was August 5, 1934. The men took the cabin for the balance of the season and returned, surreptitiously, in just over a week's time with their hostage.

They came in at night, possibly along a rough track that leads through the bush to the Beaumaris road. (Labatt later recalled having to stoop under some barbed wire at the back of the cottage.) Labatt's captors taped his eyes shut for the journey and on arrival placed him in the smallest, darkest corner of the cabin, where they chained him to the bed frame and took turns attending him. They kept to themselves, moving about mostly at night. In the end it was their unholidaylike behaviour that caused suspicion. The neighbouring cottagers came to Prowse, the cabin's owner, with their worries that "something funny" was going on. The men never swam, never wore casual clothes — in short, they seemed completely out of place at a cottage with one of the nicest beaches in the area.

Mr. Hardwick, the local constable, was called, and he prepared to visit the camp the next day. By that time, however, the kidnappers had vacated the premises and released Labatt on a street in Toronto.

Finding out there'd been mobsters in their midst left an uneasy feeling in the cottage community. One lady packed up her belongings and left, cutting her vacation short by two weeks. Meanwhile a wave of reporters inundated the cabin snapping pictures of pretzel wrappers and mouldy bread.

By September 13 the police had identified the men who'd taken Labatt. The kidnappers had criminal records in both Canada and the United States.

Author's note: If you're looking for Wyldwood Point from the water, watch for the pretty blue-grey cottage known as Rockwood. You can't miss it. This pinpoints the cottage community served by Wyldwood Road. Wyldewood Road runs parallel to the water along the point and turns inland to join Highway 118 at Leonard Lake.

The Clemson boathouse

10 THE CLEMSON COTTAGE

Like that of so many cottagers in Beaumaris, the Clemsons' good fortune was smelted in the furnaces of the Pittsburgh Steel Belt. The Pittsburgh connection is especially strong in the Clemson cottage, which is not only owned by a Pittsburgher, but also designed by one. In 1909 Daniel Clemson, a director of a U.S. steel company, engaged architect Brendan Smith to sketch out the plans for the summer complex. It took two years to complete. The main cottage, which is difficult to see from the water, is fitted out with oversized verandahs and a massive central living-dining room, flanked by two floor-to-ceiling stone fireplaces. The hillside below the cottage is testament to the wizardry of an English landscape architect, with banks of flowers and frothy greenery.

The buildings that you do see from the water, and will undoubtedly *have* to take pictures of, are the boathouses on the north side and the honeymoon cottage to the south. The original owner had the little cottage built as an artist's studio for his mother. Over the years the studio became a playhouse for generations of Clemson children, then the honeymoon retreat.

The boathouse complex is typical of the Old Muskoka cottage, reflecting an era when the lake steamers called in at the massive wharves and each family had a fleet of launches, sailboats, canoes, etc., to protect from the elements during the summer (and to hoist to the rafters for winter storage).

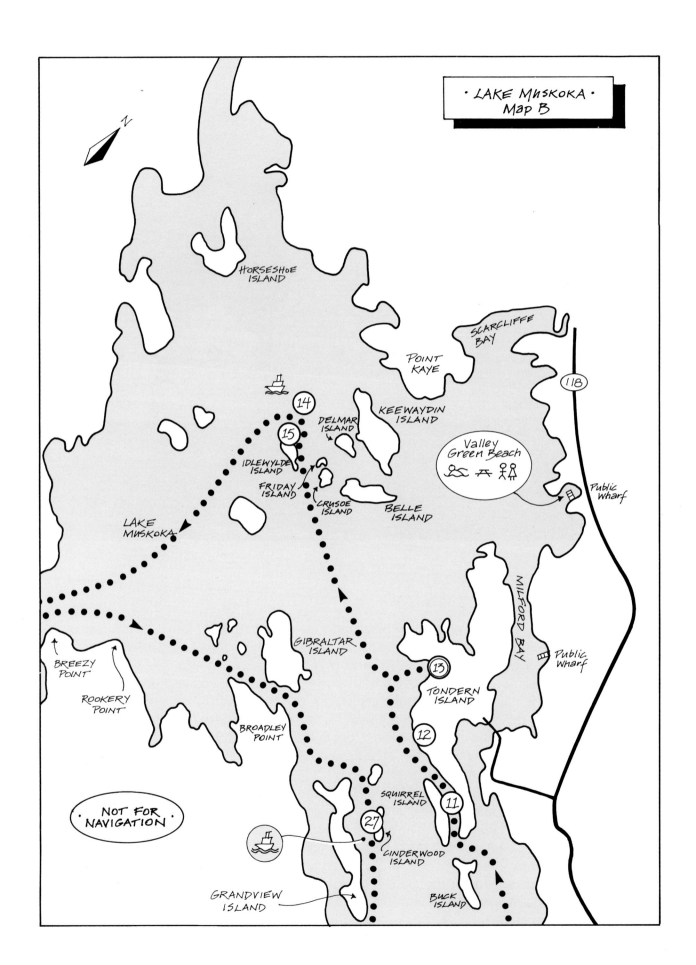

Stone pumphouses

In those days "going down to the dock" was almost an outing in itself, requiring the packing up of swimming attire and paraphernalia for an afternoon on the water. You did not bolt down the path from the main cottage to the wharf in swimsuits. Heaven forbid. These were the days of change houses by the beach, so you could slip into your swimming costume for the dip in the water and change back into more discreet attire for boat-riding or lakefront chats. The Clemson change house is located beside the boathouses.

You'll notice the heart-shaped motif on the woodwork, particularly the balcony railing. That's the hallmark of the builder, Peter Curtis, who used different shapes as a decoration on the woodwork in each cottage he built.

11 MILLIONAIRES' ROW

They call the passage between Squirrel and Tondern islands Millionaires' Row. The cottagers here are bankers and industrialists from the Pittsburgh area. Some have called them "quiet billionaires and king-makers." Their summer homes are typically Old Muskoka — rambling two- to three-storey frame cottages painted chocolate brown, forest green or grey, with generous verandahs and a maze of stone walkways, whose stone stairs are edged in white paint (so you can see where you're stepping at night). Most had separate living quarters for the servants in an annex or upstairs wing. These accommodations have now been turned into extra rooms for visitors. The boathouses are cottages in themselves, designed not only to house the boats and boating gear, but as living quarters for the young millionaires, who sleep above the water in pretty rooms with walk-out balconies. The window boxes, plump with red geraniums, send down cascades of ivy to the grey wharves. There are paths along the shoreline and cute stone pumphouses that you'd have given your eyeteeth to play in when you were younger.

The exclusivity of the Beaumaris shoreline did not happen overnight. Bernice Willmott, the wife of a descendant of the first permanent settlers, says the first Pittsburghers came for the fishing. The rail connections made Muskoka a destination that was at once remote and convenient to access. What's more, the visitors from the smoky steel-cities were desperate for some fresh air. Muskoka had lots of that to offer, and in those days there was no hay fever. These first visitors liked the area and built small, unpretentious accommodations, sometimes wielding the hammer themselves.

The arrival of the Beaumaris Hotel, with its well-heeled clientele, put the stamp of approval on the Beaumaris area as a "preferred" summering location. If you looked at the Beaumaris Hotel registers you'd find the names of families who now own cottages along Millionaires' Row. Once one summer visitor started buying land and building cottages, his friends followed suit, building bigger and better summer homes. (Not surprisingly, there was a bit of one-upmanship at work in the creation of the Beaumaris summer community.) As the cottage-building gathered momentum, the activity eventually spilled over onto the islands off Tondern.

What eventuated was the transplanting of a circle of friends and business acquaintances from the social milieu of Pennsylvania to the islands around Beaumaris — which is why they call the area Little Pittsburgh.

12 SHARON SOCIAL FISHING CLUB

It's the stairway that catches your attention, a long, broad set of steps that stretches from the wharf to the clubhouse. The idea for the club came about in 1891 after a group of men from Sharon, Pennsylvania, stayed as guests of the Solid Comfort Club on Tondern Island: ". . . so much enjoyment was had and so much physical benefit derived that it was resolved to organize a party of Sharon gentlemen for an annual encampment." The group met in the Sharon National Bank and set up a club called the Sharon Social Fishing Club. By 1892 they'd purchased land from Edward Prowse.

The first encampments were in tents with wooden floors, but by 1897 they'd put up the clubhouse. This building burned in 1956. An explosion occurred when the president threw the switchbox to put on the lights that June. A blue flame shot along to the staircase and in minutes flames engulfed the whole building. The new clubhouse was completed the following year.

Inside it's much like a small resort lounge, with a fireplace and comfortable chairs, several dining tables and a good-sized kitchen. But don't let the downstairs fool you. This is a man's camp. Its rough-and-ready atmosphere is better reflected in the upstairs dorm, where single cots are arranged head to head, army barracks style.

Even though the tents are long gone, members still call the stays at the clubhouse "encampments." And when the men are up, women are not allowed, except on Sunday afternoons. That's when the club holds its open house, brings in a good jazz band and keeps the drinks flowing.

It's a club that one executive described as being "a little bit elitist." You can't just roll up and become a member; you have to be invited. It has its share of millionaires, bankers and industrialists, all from Sharon, Pennsylvania, an area that's been called the Rust Belt of the state because of the steel and pipe industry there.

When the club first started, the men found plenty of fish, especially smallmouth bass. As the best fishing spots were scattered about the lake, the men called on boat captain Harper Walker to tow their rowboats, in a line, to various locations. In the evening Captain Walker came back and towed the fishermen home.

In the mid-1950s, however, a Sharon Club member reported that he hadn't caught a single fish all summer. The rock bass had moved in and "ruined the lake for smallmouth bass." The Ministry of Natural Resources is now stocking the lake, and the members fish for lake

trout, catching maybe five or six a week — nothing like the huge catches they could count on in early days. Today the accent is on the social side of the fishing club.

13 BEAUMARIS

No boat tour of Lake Muskoka is complete without a stop at Beaumaris to stretch your legs, take a picture of the yacht club and get an ice-cream cone at Willmott's Store. On the hilltop there's picturesque St. John Anglican church, surrounded by large pines. The church has seen over a hundred years of history in Beaumaris. It is a simple summer chapel, typical of many around the lakes, with basswood and pine panelling, leaded windows, and carpet runners. When you open the door the warm, woody smell of old attics comes rushing out to greet you, and you step into a sanctuary that's been preserved from another era.

Paul Dane, an Irishman, purchased the island from the Crown in 1868. An acquaintance of Dane's suggested he call the island Denmark, but Dane decided to call it Tondern, as a symbolic gesture. Around that time a tiny Danish village called Tondern captured world attention when it was swallowed up by Germany. The village had been an important lace-making centre.

Dane's chum in the new world was his nephew Maurice John McCarthy, who took over the island when Dane died in 1871. In 1873 McCarthy sold Tondern to two Englishmen, John Willmott and his brother-in-law Edward Prowse.

Prowse and Willmott split the island in two, Prowse taking the south half and Willmott the north. Soon the steamers were stopping off at their settlement, which they called Beaumaris Landing. The name can be traced to the great affection the families had for a vacation spot called Beaumaris on the Isle of Anglesey, Wales. The word Beaumaris is derived from the Norman English word meaning "beautiful marsh." Later, when the post office opened at the Beaumaris Hotel in 1881, the word "landing" was dropped.

By this time many sportsmen and vacationers had descended on Muskoka, and Edward Prowse saw the wisdom in starting a summer resort as an investment. In 1883 the expanded Dane residence, in which the Prowses were living, became the cornerblock of the Beaumaris Hotel.

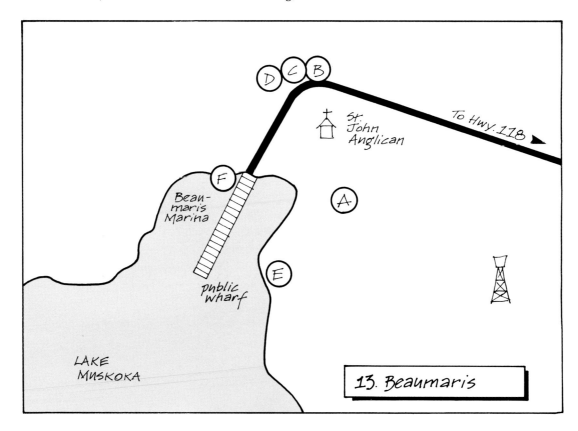

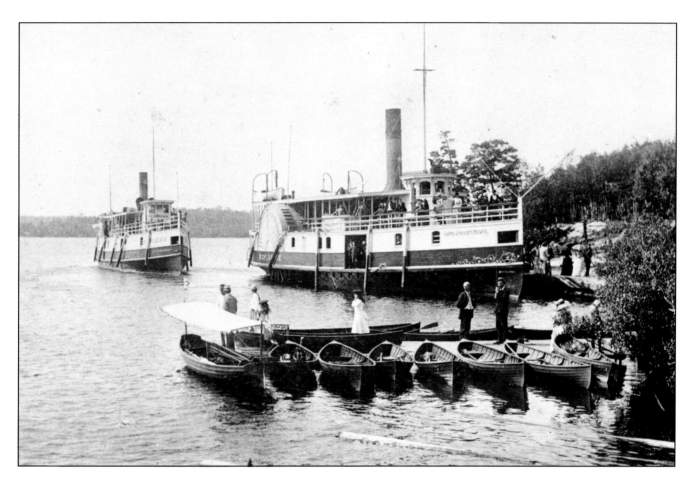

Steamers Nipissing II and Kenozha at Beaumaris (Muskoka Lakes Museum)

A THE BEAUMARIS HOTEL

In July 1945 a 19-year-old Toronto youth, an employee at the Beaumaris Hotel, awoke at 2 a.m., went down to the ash house and deliberately set fire to some papers. The mentally unbalanced youth then returned to his bed while the hotel went up in flames. A fellow employee banged on his door and pulled him out of bed. Afterwards he helped guests remove their effects and stood back to watch the fire. The arsonist effectively ended the life of one of the most successful resorts on the lakes. But fittingly, the Beaumaris Hotel did not give up easily. The fire had ignited a coal supply and was not completely extinguished until a half-year later.

The atmosphere at Beaumaris Hotel in many ways resembled that at today's Windermere House — tasteful, charming, fun. It was completely self-contained. You could pick up toothpaste at the hotel drugstore, get your hair trimmed at the barber shop, check out the action down at the bowling alley or billiard room. Whatever you could possibly wish for, you'd find just steps away: golf, tennis, lawn bowling, boat rentals, groceries. Five chefs presided over the kitchens, and an orchestra played music during both lunch and dinner.

In 1910 owner-manager Edward Prowse died. His son Horace managed the hotel until 1919, when he sold it to Andrew Nicholson. At the time of the fire, Andrew's brother George owned the hotel.

The present golf clubhouse is located about where the hotel annex used to be. A boardwalk connected the annex to the main hotel.

The John Willmott home, Beaumaris

B WILLMOTT HOMESTEAD

Prior to coming to Canada, John Willmott worked for the Bank of England, managing their interests and investments in Buenos Aires, including overseeing the operation of a sizable sheep ranch. He was a bright young man of good family background, with a promising future. He thought of purchasing Toronto Island, then discovered Tondern and liked what he saw. Willmott took the north half of the island and his brother-in-law Edward Prowse, the south. John and his wife, Katherine, settled into their log cabin, extending and remodelling the building as the family grew. Their home still stands today, as the Johnston and Daniel real estate office. There's a white footbridge from the roadway to the front lawn. The reception area inside the office is the original floor area of the log cabin.

John Willmott became the first commissioner of Game and Fisheries in Ontario.

C THE WILLMOTT STORE

John Willmott set up a general store in a location just behind the present-day Willmott's Store. The store supplied just about everything. Much of the Willmotts' produce came from their farm (land that is now the Beaumaris golf course) or from local farmers. The Butter and Egg Road (on the opposite side of Highway 118) got its name because a number of ladies along it sold their milk and dairy products to the store, the hotel, and the supply boats that stopped at the landing. The present store dates to the 1920s. John Hawley Willmott, John and Katherine's grandson, was the last family member to operate the store. It has changed ownership several times since then, but still retains the Willmott name.

The Beaumaris Yacht Club

The marina at Beaumaris

D THE BEAUMARIS POST OFFICE (1926)

The Beaumaris Post Office opened in 1881 in the Beaumaris Hotel. Around 1918 Norman Ellerington Willmott started as a postal clerk under the tutelage of postmaster Henry Clark. But Henry Clark died shortly after Norman started, and Norman stepped into the breach as postmaster.

In 1926 Norman moved the post office to the building adjacent Willmott's Store. The Beaumaris post office hasn't changed much since that time. You won't find a trace of stainless steel. The post boxes are all made of wood, some with lovely bevelled-glass windows so you can see at a glance if you've any mail in your box. It's a pokey little building, with room for about three customers to manoeuvre at the counter. Although you won't find a clerk dressed in visor and sleeve garters, you expect to. It's that kind of place.

It's a summer-only office now, and has been since 1979. But when Canada Post decided to close the office down completely, the summer cottagers rallied. The office closed in 1985, but reopened in 1986 as a franchise operation. It keeps afloat financially from the revenue collected for post boxes and also from contributions from the summer residents who use it.

E GRUMBLENOT/THE BEAUMARIS YACHT CLUB

Samuel Gill must have liked the way the sun shone on this particular piece of property. The Steubenville, Ohio, resident bought the property from the Crown in 1896 with a view to finally ending his wife's grumbling: she wanted a place with lots of sunshine, she said, so he built her a cottage that fit the bill and called it Grumblenot. Today that cottage makes up part of the Beaumaris Yacht Club. With its brown shingle siding, green roof and white French doors, the building looks like an old hotel. The verandah is a striking feature. To the north it's wide open, a cool retreat on a hot day; to the west it's enclosed in multi-paned windows, a vast foyer you could dance in. An addition to the main building houses an auditorium and stage. Stairways with landings lead from one area to another, and the deck is liberally sprinkled with tubs of petunias and white wicker chairs.

The Beaumaris Land Company purchased the cottage in 1921 for use as a yacht club.

F BEAUMARIS WHARF AND MARINA

The Beaumaris wharf was first situated on the north side of the bay. Workmen began the central, larger wharf after the federal government granted money for its construction in 1912. It is one of the longest wharves on the lakes today. Passengers who were waiting for steamboat rides would have had a long dash to shore if it started to rain. Fortunately they had the shelter of a pretty freight shed, an open-air station, to protect them from the elements. The historic building was removed some years ago and replaced with a utilitarian structure. The Local Architectural Conservation Advisory Committee is working to get a replica of the original back in place on the end of the Beaumaris wharf.

The Beaumaris marina is another historic spot on the waterfront. Edward Prowse built the marina to house the boats belonging to guests staying at Beaumaris Hotel. He called it Beaumaris Boathouse. For a time a sea captain named Mardon managed the boathouse, which dealt mainly with the storage and maintenance of sailboats, canoes and rowboats.

The marina stayed in the family after the hotel was sold to the Nicholsons (1919). Leonard Prowse bought the marina from Horace Prowse around 1915 and operated it until he died. During Leonard's tenure, the marina served as a hardware store and kept a stock of refrigerators and woodstoves.

The current owner, Jack Buwalda, purchased the marina in 1974 and has since expanded the business, especially its boat-storage capacity. Along with the sales and service of boats and motors, the Buwaldas have a marine store, boat rentals and clothing boutique, the Upper Deck

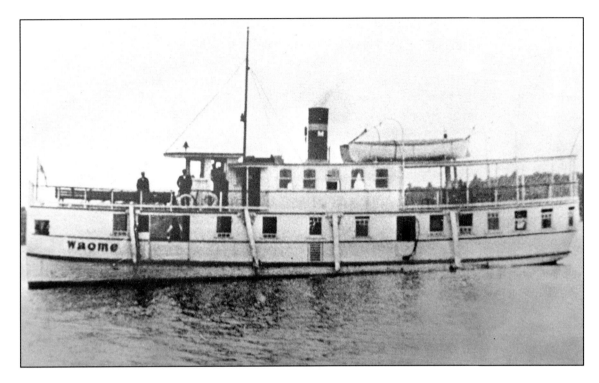

Steamer Waome sank near Idelwylde Island, October 6, 1934. (Gravenhurst Archives)

14 WRECK OF THE WAOME

> You just went right down with the suction of the boat. She was going stern
> first and you were standing on the nose. It went down and down until you decided
> it was too damn far down and you let go. The water pressure shot you right up."
> Robert Bonnis, survivor

Robert Bonnis was the fireman aboard the *Waome* on October 6, 1934. The crew had to break ice around the boat to make the mail run from Rosseau to Gravenhurst. All the other navigation company ships had been mothballed for winter. There was a handful of men still in the company's employ, three of them captains who were filling out the season with whatever work they could get: Captain C.W. Henshaw, pilot of the ship; Captain Arthur Thompson, first mate; and Captain Reg Leeder, cook. Also aboard was George Harvey, the purser; Alvin Saulter, the engineer; and a passenger from Hamill's Point, Rev. L.D.S. Coxon. The minister had the opportunity to take a bus to Gravenhurst from Port Carling but elected to stay aboard because he liked boat rides.

The *Waome* was approaching Idlewylde Island en route to Beaumaris. The purser (Harvey) had gone to his office for a shave. The engineer (Saulter) changed to coveralls to oil the engines. Robert Bonnis stood in the starboard companionway, watching a black cloud boiling over the western horizon. Then the storm hit, suddenly and mercilessly, as if a ball of fury had been hurled from the horizon and across the lake. The ship heeled over on her port side and took on water. Harvey made it to the deck. Captain Henshaw was thrown out of the wheelhouse and into the water. Reg Leeder, the cook, had been peeling potatoes in the galley. To escape he smashed a window on the starboard side of the lower deck, cutting himself badly as he catapulted through the opening. Trapped in the lounge, Thompson and the minister could not tell which way was up. They rushed to the aft door (the one in the sinking end of the ship). The ship sank stern-first in about a minute. Robert Bonnis described the confusion this way:

I was standing there and when she went over I wasn't standing anymore. I was lying on my back with a window square in front of me. I kicked it out with both feet and reversed ends. I came out on top. She was lying flat on her side. I saw the fender lying there, so I pulled the chain out of it that holds it onto the boat and then I looked at it and I said that's green oak. What good is that going to be. I just left it lying there. Saulter was just coming out of the gangway. He had been oiling and he had his overalls and his cap on. I was standing on the nose of her holding the flagpole when she went under.

She went under and those who came back up thought they'd never hit sight again. [Bonnis clung to the flagpole for a while and Saulter had his foot caught. Both freed themselves and shot to the surface.]

George Harvey [purser] grabbed a saddle [piece of timber that the lifeboat sits in] and said, "Here take this." And I said,"What are you going to swim on?" He said, "Well, that door there." He put one end of it in his belly and the wind took him on into shore.

The breakers were high. We were going with the storm [towards Delmar Island]. I glanced over and there was Alvin Saulter [the engineer]. He's fighting for his life, and I mean fighting for it. Even his cap is shrunk right on his head. And the waves are just going over him from one half to the other. Every time he came up he'd spit out a mouthful of water. I could see him. I started to swear. I called him all the names I could think of, even though he was my mate, the finest guy I knew. I tried to make him mad enough to fight. Then I just kept swimming over to him. I couldn't carry him in. So I took the saddle with me. I got right beside him and he disappeared. I thought "Oh god, I've missed him." Then he put his hand on my shoulder and he said, "Where's the stick?" That's the kind of guts he had. He was all man that little fella.

Then of course we're all out in the lake. Henshaw [*Waome's* captain], he's dying right behind me. He had both hands up and his eyes are as big as saucers. His heart was just going out. He died right there, right then, because no water entered his lungs and he floated right into shore and we picked him up and brought him home with us after.

Leeder, he cut his arm as he was coming out through the window. The funny part of it was, that fender I threw away, Leeder came in on it. He was just hanging on by one arm over the fender when he washed in. He passed out completely.

The men broke into a cabin on Delmar Island, got a fire going, and covered Leeder with rugs. When the storm subsided they hailed a motor launch that was coming down the lake to search for them. Later, divers recovered the bodies of Arthur Thompson and the minister, huddled by the door of the lounge.

Divers still visit the wreck. Its position is marked by white floating buoys. She sits on the bottom of the lake, under about 23 metres (75 feet) of water, her bow pointing towards Beaumaris. The smokestack is crumpled and caved-in, the wood is decaying more each year, and bits of the ship have been torn off by scavengers looking for souvenirs. But the hulk remains a reminder of the havoc that can be wreaked when a sudden storm whips across the lakes.

15 IDLEWYLDE ISLAND

On the west side of this island there's a rock outcrop that looks remarkably like the head of an Indian.

Book publisher William Gage purchased the island in 1903. Gage helped establish the Muskoka Cottage Sanatorium, a retreat and clinic for sufferers of tuberculosis, in Gravenhurst.

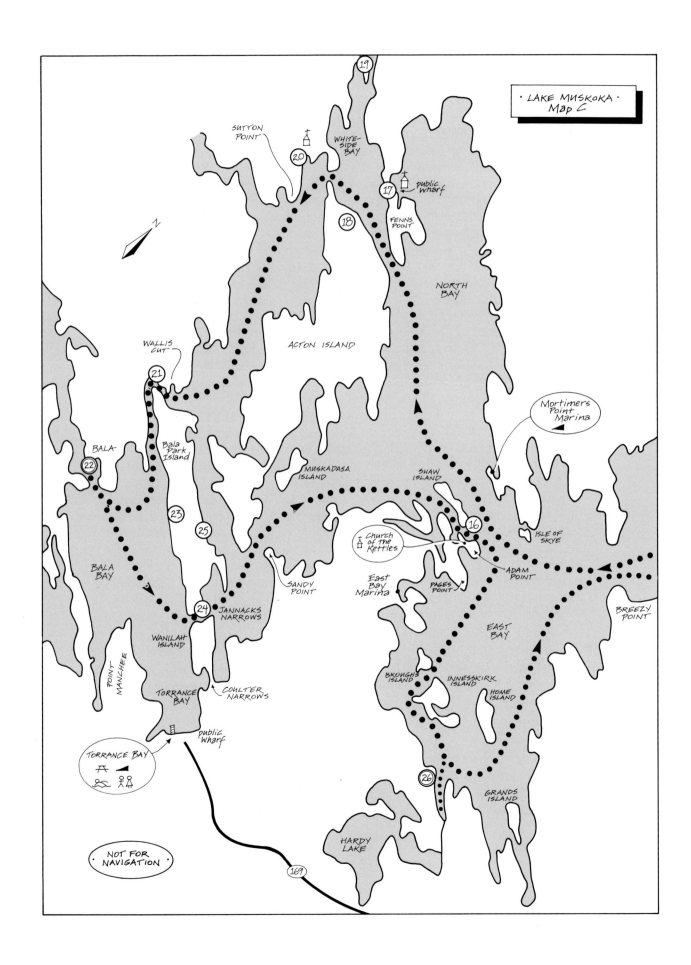

LAKE MUSKOKA
Map C

19

SUTTON POINT

20

WHITE-SIDE BAY

17 public wharf

FENNS POINT

18

NORTH BAY

WALLIS CUT

21

ACTON ISLAND

Mortimers Point Marina

BALA

22

Bala Park Island

MUSKADASA ISLAND

SHAW ISLAND

16

ISLE OF SKYE

23

25

Church of the Kettles

Adam Point

SANDY POINT

BALA BAY

East Bay Marina

PAGES POINT

24 JANNACKS NARROWS

BREEZY POINT

WANILAH ISLAND

EAST BAY

POINT MANCHEE

BROUGHS ISLAND

INNESSKIRK ISLAND

HOME ISLAND

TORRANCE BAY

COULTER NARROWS

public wharf

TORRANCE BAY

26

GRANDS ISLAND

NOT FOR NAVIGATION

HARDY LAKE

169

52

The Kettles, Lake Muskoka (Alldyn Clark)

16 THE KETTLES

This is an enchanted part of the lake, a place where hand-fashioned stick-bridges link islands to the mainland, and rocks rise out of the water like cauldrons (or kettles), their round, knobby tops feathered with a few blades of grass or a thin young pine. It's also a place where trying to get in close for a photograph can get you into trouble. Underneath the water the formations comprising The Kettles are joined by a twisted backbone of rock that can ding a propeller blade or scrape the bottom of your boat.

There's a legend that says the Huron Indians hid their sacramental vessels underwater in niches in The Kettles when the Iroquois drove the Huron people from their traditional lands.

The Church of The Kettles is perhaps the cutest church on the Muskoka lakes. Don't look for it at The Kettles themselves, though, but to the southeast, across from Shaw Island. There's a large dock with lots of flags flying. The walls of the church contain many windows, which can be opened right up in nice weather. The church-goers have even built benches along the side of the hill so you can listen to the service from outside the building.

Before the cottagers built the present church, they came to Robert Shaw's summer residence for services, on Shaw's Island. In 1885 they officially declared themselves The Kettles congregation and established a regular order of service. The next year Mr. Fairhead of Shaw Island invited his minister up from Toronto. Rev. C.O. Johnston loved the area and bought 10 acres of land from the Crown, setting aside one-tenth of an acre for the church.

Mortimer's Point

A group of volunteers put up the chapel in 1900. Over the years things have been added or renovated. Some Buffalo residents made the pulpit from saplings in 1921, and in 1929 the members enlarged the church to accommodate the increasing numbers attending services.

Across from The Kettles is Mortimers Point. The Mortimers came to Muskoka from England in 1872. The 1881 census lists 54-year-old William Mortimer, a farmer, and his wife Harriet, 41, and 13 children, eight born in England and five in Ontario, with ages ranging from 1 to 22. Like many other families on the lake, the Mortimers turned their home into a summer hotel called Wingberry House, around 1890. Descendants of the first settlers still reside at Mortimers Point and run an active marina business and seaplane service.

17 ST. ANNE'S CHURCH, FENN'S POINT

Unless you know it's here, St. Anne's is difficult to find, squeezed as it is between two cottages. The church is hidden behind the trees at the public wharf. It's a discreet wooden structure with one unpretentious steeple. The stained-glass windows on the side of the church are dedicated to the memory of Raymond Forwell and the Fenn family. Louisa and Frank Fenn were two of the original settlers on Fenn's Point, and their descendants still own property here.

The Kellys were early settlers, too. John and Ellen Kelly, both of Irish descent, left the United States in 1856 because of political feelings against Loyalists. They moved to Hamilton first, and John got work building railways. In 1868 he and his family came to Muskoka. His experience in heavy construction stood him in good stead when the railway came to Muskoka. He worked on the Grand Trunk Railway from Washago to Gravenhurst and helped blast out the first Port Carling locks.

St. Anne's is the oldest mission church in the local Roman Catholic parish, built in 1899 by Joseph and George Fenn, John Kelly and the Walker brothers of Walker's Point.

Acton Island causeway

18 ACTON ISLAND

To those of us who grew up with regular doses of *Front Page Challenge*, Acton Island is no ordinary island: it's Gordon Sinclair's island. The bridge to it was renamed the Gordon Sinclair Bridge in honour of the broadcaster and TV personality, after his death in 1984. Sinclair loved Muskoka, especially this island, which provided a summer escape for him and his family since 1947. Scott Young, Sinclair's biographer, writes: "By then the road north out of Toronto had become his major escape route. The love affair that so many Canadians have with cottage country had a firm advocate in Sinclair He would get up in the morning and open a cold beer and sit on the step of the cabin he'd had built so he could be private when he wanted privacy, watching the birds, the animals, and the fish jumping Every year, his log of life around the cottage provided him with on-air references, from a few lines on a newscast to whole editions of *Let's Be Personal* about animals, birds, how the trees were growing, how the fish were biting."

The largest natural island on the Muskoka lakes, Acton Island was named by George Acton Lowe, who settled on the north part of the island in 1873. Marion Maddock, in *Diary of Fanny Colwill Calvert*, says, "Their son was named Acton and so the island was named." Will and Tom Colwill and their mother, Fanny Colwill Calvert, purchased the lower part of the island in 1910. Tom and his mother took an interest in beekeeping and set up an apiary there (hence the name Apiary Road).

There was a time when you could pick your way across the rocks at Kemps Narrows and walk from Acton Island to Bala Park Island. The navigation channel has since been opened up. The narrows are named after an early English settler, George Kemp, who stayed briefly on the island in the 1870s.

Bannockburn church

19 WHITESIDE

In the 1860s Samuel, Isaac and William White took up blocks of property near each other in Medora Township. At the head of the bay, William started a general store and post office called Whiteside.

Around 1890 the settlers built a community hall, which also served as Orange Hall and Presbyterian church. William Fairhall had arrived on the scene and his busy lumber mill provided employment for most of the men in Whiteside and Glen Orchard.

But timber supplies dwindled and the Fairhalls abandoned their mill in favour of the tourist business. (They built Belmont Hotel, now Pinelands, on Lake Joseph.) Around the turn of the century, William White moved to Saskatchewan, looking for a better life. Isaac White moved from his farm to Bala, to start a livery business. Samuel had earlier moved to the north end of Acton Island.

The Orange Hall did not serve much purpose in the has-been sawmilling centre, and in 1921 it was dismantled and the wood used to build the Bannockburn church.

20 BANNOCKBURN CHURCH

You could say Bannockburn looks more like a cottage than a church. It's a pretty, green clapboard building with a glassed-in porch and many French doors leading to the central meeting area. The material for the church came from another meeting house, the Orange Hall at Whiteside. Around 1921 Mr. Albert Gordon gave some of his land for this church. At his request the church was called Bannockburn. The first services began in 1922. The congregation voted to become non-denominational in 1938.

One of the original settlers on this property (1883) was Ephraim Browning Sutton, whose home became the base for many anglers. They called it Camp Sutton. Sutton later moved to Bala and opened the Swastika Hotel, now the Cranberry Inn.

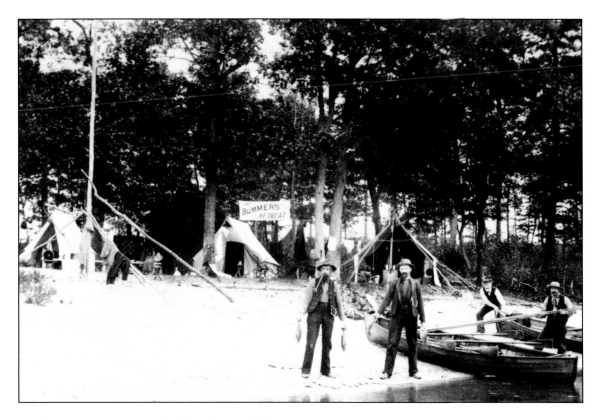

Sandy Point, near Acton Island, Lake Muskoka (Bracebridge Public Library)

21 WALLIS CUT

Just going through "the cuts" makes the boat trip to Bala worthwhile. Bala Park and Wanilah islands literally shut the door on Bala Bay, and the only access to it is through narrow passages between the islands and the mainland.

Of the three passages (Wallis, Jannack's and Coulter's), Wallis Cut is the most spectacular. Both the island and the mainland rise high above the water, and there's a railway bridge above, covered with psychedelic graffiti. The water in the channel is fast-flowing, and tricky to navigate in the spring.

The cut is named after Joseph Wallis, who came from Port Hope to Port Carling in 1874 on government business. Through his efforts, the local people obtained a shorter water route from Port Carling to Bala, with the blasting of the cut at this location in 1876. Before that, water only managed to trickle through at this spot, and only during spring flood conditions. People in Port Carling will recognize the Wallis name in connection with the lumber and shingle mill he set up downriver from the navigation lock.

22A BALA WHARF

Bala is an active place in the summer months, but the wharf is quieter by far than it was in the steamboat days. Back then the waterfront bustled with activity as passengers scurried from the train to waiting steamboats. The summer station sat above the wharf, built up on a platform, with a ramp leading to the dock level. The chain-link fence marks the edge of the rail line today. A little further on, by Weismiller's Lumber, was the main station, which remained open year-round. The Canadian Pacific line opened in 1907, a year after the Canadian National line on Bala Park Island.

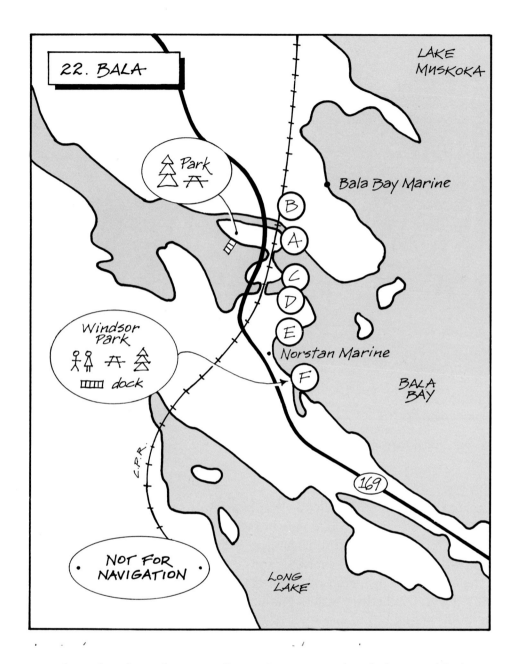

Cutting the right of way for two railways, in an area already hemmed in by water and waterfalls, left the environs uncommonly over-railroaded. Add roads and three water arteries from Lake Muskoka, and you're left with town-map lines as jumbled as a pile of pick-up sticks.

Bala was very much the creation of its founder, Thomas Burgess. The enterprising Scot ran just about every business a town could ask for, including the post office, sawmill, general store, bake shop, blacksmith shop and a supply boat. About the only business the Burgesses were not immediately involved in was resorting. By the time the first decade of the 20th century had passed, there were possibly more hotels within hailing distance of each other in Bala than in any other part of Muskoka. Around 1903 Burgess himself opened a small lodge called Rose Lawn on the Moon River.

Bala became a town in 1914 and held the distinction of being the smallest town in the Dominion (in 1950, for example, Bala had only 370 year-round residents, the smallest population figure of any town in Canada).

58

B MILLSTREAM

To the north of the wharf is the millstream. It was on this water outlet that Thomas Burgess set up a timber dam and water wheel to run a sawmill, which also had machinery for grinding wheat.

Thomas Burgess, originally from Kirkcabrightshire, Scotland, had been farming in Bruce County when he decided to investigate the lumbering possibilities in Muskoka. In 1868 he arrived in Gravenhurst and canoed up the lake to the falls. The site impressed him greatly, and when it came time to give the settlement a name, he called it Bala, after the most beautiful spot he knew, a lake district in Wales.

When Burgess arrived in the area, the falls provided the only outlet from Lake Muskoka. He created the millstream by blasting out the channel for his mill, which was operational by 1870. Once the navigation season ended, the Burgess family and others in the new settlement were cut off from sources of provision. During especially long winters it was common for the people in Bala to be living on whole-wheat bread by the time the lakes opened. Without the grist mill, life would have been very hard indeed.

In 1917 the Burgess family helped establish a hydro-electric facility on the site of the old mill. The dam and powerhouse are still there and in working order. In 1988-89 Marsh Hydropower Inc. leased the old powerhouse, which had been idle for many years, and got things going again. The small hydro development sells the power it produces to Ontario Hydro. The rejuvenated plant is called, fittingly, the Burgess Generating Station. If you're exploring around the town, it's worth strolling along the old millstream. The dry-stone walls and over-hanging trees give the watercourse an Old English flavour.

C BALA FALLS

To the south of the wharf you'll see sets of stoplogs marking the top of the falls. Early explorers called these falls the Musquash Falls. They are part of the Muskoka River watershed, whose headwaters are in Algonquin Park. Downstream the river branches into the Moon and the Musquash.

Before the Department of Public Works installed the first dam at the middle channel in 1873, water levels on Lake Muskoka went up and down like a yo-yo, with differences between high- and low-water readings varying by 2.7 metres (9 feet). But the first dam kept water levels too high and farmers complained that their fields were being inundated. As a result the department began blasting out floodwater spillways on the south channel, which, in its natural state, had not carried that much water. By 1878 the blasting of spillways had deepened the south channel so much that a dam was called for, and one was installed that year.

D BALA FALLS HOTEL, BALA MANOR

The white diving tower marks the Bala Falls Hotel property, now the site of a private summer home. Thomas Currie built the Bala Falls Hotel in 1889. At that time it was the second hotel in Bala. The pretty three-storey building burned around 1912 or 1913, and later Bala Manor hotel was built here. Across the bay was Cromarty Lodge. The Bala regattas took place on the waters between the two resorts.

E THE KEE TO BALA/DUNN'S PAVILION

For the baby-boomer generation, The Kee was an inescapable part of Muskoka summers. Every back road had The Kee's flyers posted on fence posts or maple trees — bright bold announcements of coming engagements, bands whose reputation guaranteed a big turnout and good music. You came to The Kee to be part of the excitement, to mix with the ski-dock crowd and (you hoped) bump into *those* guys who'd been ahead of you in the boat lock last

A *misty morning at Bala*.

Saturday, *those* girls who'd had the conked-out motor. You came by car or boat, with permission wrung from parents and promises given to drive safely.

The Kee's stadium-sized dance floor was always packed, shoulder to shoulder, with swaying bodies. Overhead there were dusty evergreen boughs hanging from the ceiling (the original owner's intent to create an outdoor atmosphere indoors was unfortunately wasted on a generation more impressed with stage-smoke and psychedelic lighting).

Gerry Dunn created the big pavilion for another era, the Big Band Era. Hugh Clairmont, a local jazz musician, says it personified a charming period in time: "The bandstand, located at one end of the large frame building, resembled the front of a cottage, with the white exterior and its windows, awnings and all, being decorated by flower boxes and a palm tree, no less. On warm nights, the dancers could cool off on a huge outdoor balcony overlooking Bala Bay and view the star-filled sky and the moon peeking through nearby mammoth pine trees."

Pharmacist Gerry Dunn opened his first open-air pavilion in Bala in 1929. It was part of his ice-cream parlour/general store business. As the popularity of the dance hall grew, he expanded, tearing down the old pavilion and opening the building now known as The Kee on July 1, 1942.

To open the new pavilion, "The Place Where All Muskoka Dances," Dunn engaged Frankie Master's orchestra from New York. A thousand people had reserved tickets at $3 per couple, and those who couldn't get in sat in canoes outside and listened to the music. They say the band charged $1,000 for the night — a huge sum in those days.

To this idyllic, out-of-the-way location, Dunn managed to entice most of the big-name bands of the day: Guy Lombardo, Woody Herman, Stan Kenton, Duke Ellington, Les Brown and his Band of Renown, the Dorsey Brothers.

Gerry Dunn decided to get out of the dance-hall business in 1962, but the pavilion has rightly earned its place as a Muskoka landmark. Times change, the music changes, but the magic of the pavilion is as it always was, and that is best summed up in the words of a summer cottager of the '40s who said: "When you're really in the mood to have fun, going over to Dunn's is great. It makes you want to pick up a nice pretty girl and whirl her away onto the dance floor, and care for nothing save her loveliness and the whirling, swinging, leaping vigour of dancing."

F WINDSOR PARK

Windsor Park takes its name from a large, three-storeyed hotel that occupied the site in the early days. If you look carefully, you can see the raised rectangular plot where the foundations of the New Windsor Hotel sat. The park is also the site of Bala's first hotel, the Clifton House, built in 1890 by John Board. The Boards sold Clifton House to William McDivitt in 1900. He had been operating the Windsor Hotel in Gravenhurst and took on the Clifton House in an effort to expand the family enterprise.

The McDivitts changed the name of the small boarding house to Windsor Hotel and proceeded to add several annexes to the existing structure, along with a laundry and gashouse. The building burned in June 1907.

From the ashes of the Windsor came the New Windsor Hotel. The remarkable thing was that the New Windsor was ready for summer business in just over a month's time, complete with stonework fireplaces, a dining room to seat 135, a 15-person kitchen and a waterfront ballroom. For a time a footbridge connected the New Windsor property to the adjacent point.

The McDivitts operated the resort well into the 1940s. After the building left their hands, it changed owners several times and was finally demolished in 1969.

23 BALA PARK ISLAND (JANNACK'S ISLAND)

To James Gayfer, a young man coming of age during the Second World War, nothing could touch Bala Park Island as a a place to relax and ponder life. He wrote down his thoughts in his journal and later shared them with his friend Betty Bowles:

> The veerys are letting fall their tiny chains of silvery bell songs. The robins are making 'quirt, quirt' sounds in the low bushes and far, far away I can hear (if I listen very closely) the dark, liquid repeated phrases of the whip-poor-will The dark earth is deep with last year's fallen leaves. Above stretches the soft green cloud of maples, birches, pines and hemlocks Who is there who will deny the warmth, the rightness of the sun shining through the translucent greenness of the leaves as he stands and looks at them against an azure morning sky Ah, there is peace here — hard work, rest and beautiful things on all sides. Surely one's quest for self-integrity begins and ends at Bala Park Beach.

Gayfer's writing eloquently captures the serenity of life experienced by all Bala Park islanders — the early morning walks, fixing up around the cottage, keeping the mosquitoes at bay, canoeing over to Bala.

The construction of the Canadian Northern Railway put Bala Park on the map. The line opened in October 1906. For the convenience of tourists making steamboat connections, there was a summer station at the waterfront, as well as the winter station beside the main line. No trace of the stations remains today, although there are some remnants of the old steamer

wharf on the southeast tip of the island. Passengers with cottages at the north end disembarked at a train shelter set up there. Today the trains whiz straight by. The well-used line runs along the west side of Bala Park, its embankments cutting a scar across the wooded shoreline.

In earlier days there was also a road running down the length of the island. The right of way is still used today, as a footpath.

24 JANNACK'S NARROWS

Bala Park Island was earlier called Jannack's Island, a name you can find on maps of mid-1880s vintage. Jannack, from all accounts, was the first settler on the island. The French-Canadian followed the itinerant life of the bushman-trapper, disappearing from the area around 1870.

Jannack's Narrows, at the south end of the island, likewise takes its name from Mr. Jannack, and is the most historically correct name of the narrows. The cut has also been called Jeanette Narrows, which may have been derived from a variant form of the word Jannack, or from the name of a local woman.

Jannack's name is remembered in the history books of nearby Torrance for the promise he did not keep. He was supposed to build a log house for Mr. George Jestin at Clear Lake over the winter of 1869-70. Jestin had visited the area in the summer of 1869 with two other men from Eramosa, William Torrance and Joseph Coulter. Torrance and Coulter built rough log homes before returning, and Jestin left instructions for Jannack to put up a home for Jestin's family. When the three men arrived the next spring with wives and children in tow, they found that Jannack had gone. There was a bit of a scramble to put up a dwelling for Jestin, but the trio formed the nucleus of the community of Torrance, so named because William Torrance took on the community's postmaster duties in 1875.

Before you go under the bridge at Jannack's Narrows, you'll notice a small brown cottage. This is the bridge-turner's house. It was once painted bright red, as part of the Canadian National Railway complex. The station itself was on the east side of the tracks.

25 CLOVELLY INN

Two tattered Union Jacks have marked the location of Clovelly Inn for some years. The building is barely standing. Yellowing lace curtains hang in the second-storey windows and an old 7-Up sign reminds you that the hotel had a general store and post office at one time. Will Colwill, an architect from Guelph, opened Clovelly Inn around 1923. He had discovered Bala Park much earlier, when he came to do some alterations on a client's cottage. In 1903 he purchased land on the island. Clovelly Inn passed to Colwill's daughter, Marion Maddock, who lives on Acton Island, within sight of the old tourist establishment. She says the building took in its last guests in 1960, but that the post office operated until the early 1980s.

26 HARDY LAKE PROVINCIAL PARK

The south end of East Bay is one of the most striking natural spots on the Muskoka lakes. The acquisition by the Province of Ontario of the lands surrounding Hardy Lake, including the adjacent shoreline in East Bay, will preserve the rugged landscape and give the public a chance to experience its unadulterated beauty.

You can't help but use superlatives in describing Hardy Lake. It is, without a word of exaggeration, the prettiest little lake in south Muskoka — and there's not a house or cottage on its shores. Along the west shore, there's a thin strip of white sand that looks like it's been flown in from the Pacific Ocean. In the same vicinity you'll find the ruins of an old homestead. The stone foundation is a marvel of pioneer architecture, still solid and sturdy enough to build on (the Ministry of Natural Resources has plans to erect a visitor information centre). Further back from this home site, there's a ruin of earlier origin, a rectangular outline of rocks that once supported a cabin or outbuilding. Perhaps one of the nicest surprises is finding a

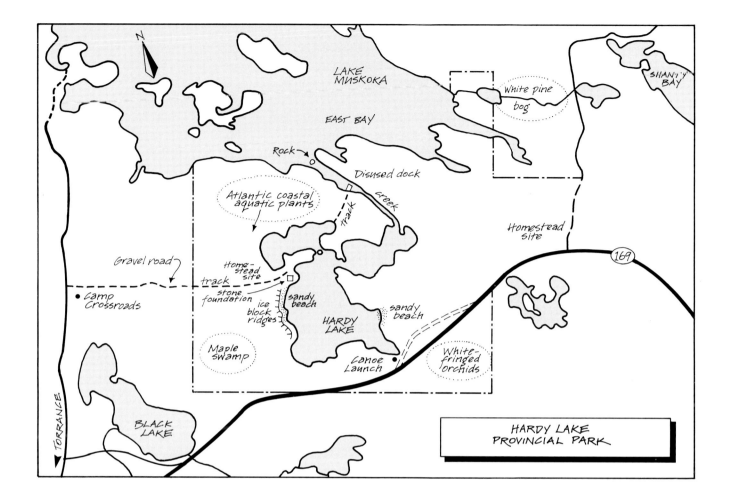

scattering of black walnuts on the ground, a rare find in Muskoka. The woods contain pockets of hemlock, oak and beech — the kind of bush you have to battle through.

Hardy Lake Park includes 648 hectares (1,600 acres) of land around Hardy Lake and 6,480 metres (4 miles) of shoreline on East Bay. To get to Hardy Lake from Lake Muskoka, follow your nose to the end of a narrow bay (see map), where a creek connects Hardy Lake with Lake Muskoka. Watch for the big, submerged rock at the mouth of the bay and go slow. You'll find the remains of an old wharf at the end of the bay. From here there's a short portage route to Hardy Lake.

Near the northwest corner of the lake, there's a rare "aquatics" zone. It features aquatic plants that are normally found along the Atlantic coast. This is a real natural oddity. Also of interest are the ice push ridges on the western shore and the barren rock on the east side of the park (possibly wave-washed by glacial lakes Algonquin and Nipissing). Another section of the park contains an open bog and black spruce-larch forest that supports a number of rare orchids and two species of rare insects.

In all, it's a naturally and historically significant place that you are welcome to explore *for the day*. Until the visitor facilities such as toilets, information centres, beaches, access roads and trails are in place, you are called upon to use the park judiciously. Landlubbers can reach the park from an access road north of Torrance (first right past Camp Crossroads). Be prepared to leave your car behind at the park boundary and enjoy the walk to the old homestead site.

27 CINDERWOOD ISLAND/WRECK OF THE WENONAH

Cinderwood was the summer home of Ruth and Carl Borntraeger of Pittsburgh. When Carl first camped on the island it had been burned over and was covered with cinders. Prior to the Borntraegers' tenure, people called the spot Wenonah Island because the hulk of the old steamboat had been beached here.

Wenonah means "first-born" in the Ojibway language, and it's an appropriate name for the first of many steamboats in the A.P. Cockburn fleet.

Cockburn, the founder of the Muskoka Navigation Company, hired two settlers from the Sparrow Lake area to build the steamboat on the shores of Lake Muskoka. Henry Heidman and William Grant had worked in the big shipyards on the Clyde in Scotland and knew what they were about in the shipbuilding profession. They built a paddlewheeler, the *Wenonah*, 80 feet long and almost 16 feet wide, and she set out on her maiden voyage on August 8, 1866, a trip from Gravenhurst to Bracebridge.

The *Wenonah* sailed the lakes for about 20 years, but old age eventually crept in and the navigation company removed the ship's working parts and towed the hull to Cinderwood Island, where the Proctor family camped out in it until they built a cottage. (Mrs. Proctor was Alexander Cockburn's sister.)

Over time, bits of the ship disappeared for firewood, and it grew more and more dilapidated. Some people vaguely recollect that a child drowned while playing aboard the old ship. Certainly the *Wenonah* had become a danger and an eyesore. Around 1890 the owners of the island asked the navigation company to get rid of it. They towed what remained of the boat out to open water, filled it with rocks and sank it. The *Wenonah* sank so fast there was hardly time to cut the rope, and the tug almost went down, too.

Divers have been looking for the wreck since the 1940s, and judging from evidence uncovered in the summer of 1988, it appears they may have been looking in the wrong place. The ship was believed to have gone down directly south of the island, but a letter from a Toronto resident to the Muskoka Tourism Marketing Agency suggests the navigation company scuttled the ship off the west side of the island.

28 STONEWALL ISLAND

There's no mystery about this name. The end of the island is a pinched-off section of land seemingly connected to the main part of the island by a wall of stones. The formation is natural but looks so wall-like that you'd swear someone had built it.

29 OLD WOMAN ISLAND

Charlie Musgrave, the lovable pianist who played on the steamer *Sagamo*, could stretch out the tale of Old Woman Island like no one else. He told how a young Indian brave carved his sweetheart's face on a stump of a tree. But, sadly, fate separated the pair. Years later the brave returned to the island. Time had twisted the carving of his lover's face, making it appear withered and creased. "Ugh! Old woman!" the brave said, horrified that he could have cherished such a visage. There's also the tale of an Indian who dropped off his old wife on the island and left her there so that he could run off with a young bride.

30 INUKSHUK/NINE MILE ISLAND

In the language of the Inuit, the rock cairn on the west side of Nine Mile Island is called an inukshuk. Its shape roughly resembles the figure of a man. The Inuit set up rows of inukshuks to drive caribou toward waiting hunters. The cairns also served as landmarks and still dot the Arctic landscape today, mostly on hilltops and prominent locations.

Here in the south, landscape architects have incorporated the shape as a symbol of the Canadian north and have set up inukshuks on the grounds of hospitals and airports. The

Stone man at Nine Mile Island, Lake Muskoka (Susan Pryke)

cottagers of Georgian Bay have taken the inukshuk to heart and you'll see a number of stone statues there.

The owners of Nine Mile Island say they built the statue for fun. They've made it appear as if the stone man has risen from Lake Muskoka, with the water lapping at his heels. It's not until you get closer that you discover the cairn is built on a submerged ridge that comes close to the surface.

This is one of my favourite landmarks on the Muskoka lakes. The island itself is picturebook perfect with its pretty cottage, docks, and a small lighthouse on the south side. It gets its name from being nine miles from Gravenhurst, Bracebridge and Port Carling.

31 MONTCALM
David Lafraniere, the man who built the Windsor Hotel in Gravenhurst (where the Gravenhurst Post Office is today), later established a resort at Montcalm Point. Montcalm House was built around 1900. Lafraniere, a French-Canadian, named the establishment after General Montcalm, who led the French against the British on the Plains of Abraham in 1759, and lost.

The hotel burned in November 1942. Now there's an impressive summer home on the point, built of pine logs and Muskoka rock and surrounded by about 2,000 square feet of decking — a real showplace.

32 SHADY LANE
They call the passage between Rankin Island and the mainland Shady Lane. It's a nice cruise through this passage, and worth it to see the spectacular stone estate on Pete's Point.

About midway down Shady Lane, you'll come to a dangerous shoal called Green's Rocks. Although the obstruction is marked with navigation buoys at either end, local cottagers found that wasn't enough. Boaters who were unfamiliar with the area often steered between the buoys, so the people who lived nearby added a cluster of fluorescent-orange buoys in the middle of the shoal to warn boaters to steer clear.

Muskoka River

"I have seen the Muskoka River so solidly blocked with logs that one could walk without the least danger of falling into the water, all the way from the foot of the falls to the river's mouth where the boom was."

E.F. Stephenson, 1922

Perhaps no other excursion could tell you as much about the nature of Muskoka at the turn of the century, in so compact a distance, as the trip up the Muskoka River from its mouth to the town of Bracebridge. That lumbering played an important part in the district's economy went without saying. The river was the lumberman's highway, often blockaded with logs which were on their way from the northern reaches of the watershed to the mills at Gravenhurst.

In the spring of the year you could be excused for overlooking the scenery on the shoreline as you bumped along in your boat, fending off logs, pushing your craft over or around them. Later, when the lumbermen had worked the logs through the system, you could sit back and enjoy the pastoral surroundings: the sheep grazing on the hillsides, farmhouses tucked against the rock ridges, tidy woodlots forming a backdrop for cleared pastures, these interspersed with tracts of bushland that extended right to the water's edge.

The *Islander* might steam by with summer passengers leaning on her rails — the men in straw boaters and bow ties, the ladies in lacy white collars — bound for a summer cottage or resort.

As you neared Bracebridge, however, the industrial look of the waterfront replaced the tourist pictorial: the cluttered tannery wharves, with their scow-loads of tanbark; the sawmill belching smoke from burning refuse; then the rough-looking wharf complex on the north side of Bracebridge Bay. A grist mill, woollen mill and log slide all cut into the natural edges of the falls, and trains rattled by on their way to the town station.

It was a working waterfront that got more cluttered and downright ugly as you approached the town. Today it's a residential shoreline. Parks have replaced the unsightly buildings and ramshackle boathouses at Bracebridge Bay. The falls are unmarred by mills and log slides. The last vestiges of the river's industrial past are being grassed over in condominium developments.

Today it's not steamboats but cruise boats like the *Lady Muskoka* that ply the river, along with the private motorboats and watercraft. The cruise upriver is a pleasant one, with opportunities to get out and explore once you reach the falls. From the dock you can stroll around Bracebridge Bay. There are walkways right across the falls and numerous grassy spots to enjoy the view or places to have a swim. There's a playground for kids at Kelvin Grove Park, and an art gallery and historic home at the top of the hill. Woodchester Villa is well worth a visit. It's an octagonal structure full of intriguing nooks and crannies.

The Town of Bracebridge started the bay project in 1969, in an effort to tidy up the waterfront and remind people of its historic landmarks. The final stages were completed in 1981. You'll find historic plaques with pictures of the sites as they used to be at intervals along the walkway, so you can take a walking tour and be your own guide.

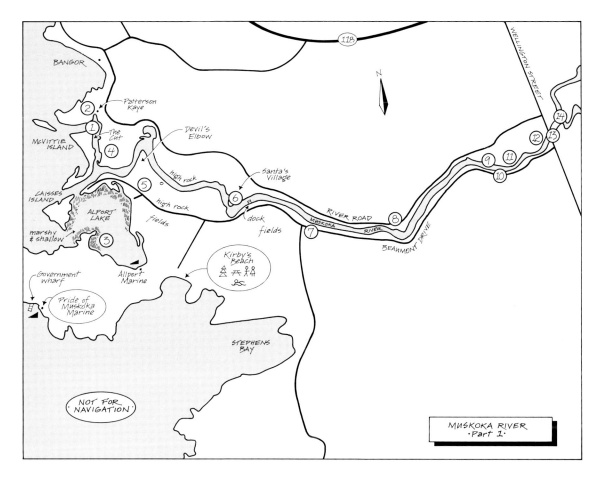

1 THE CUT/NORTH EXIT OF THE MUSKOKA RIVER

As glaciers retreated during the last Ice Age, meltwater poured off the Algonquin Highlands, drowning most of what we know as Muskoka under a huge body of water called Lake Algonquin. As the meltwaters subsided, the path of the river took shape. The Muskoka River was perhaps five times wider than it is today. In places, you can see the old banks of the river well back from present shorelines. Gary Long, an expert on the Muskoka River system, says the mouth of the river was once located at Santa's Village. As the huge volumes of water poured off the melting glacier, sand depositions built up, forming a delta that stretched to Kirby's Beach, Alport Lake and Golden Beach.

Islands such as McVittie are the result of delta-building at river mouths. As more and more sand builds up at one end or the other, such islands often become peninsulas. From the air it's possible to locate several old river channels, now high and dry, radiating out from the Santa's Village area, and you can see where parts of the mainland may have been islands in earlier days.

2 PATTERSON-KAYE RESORT

Judge W.C. Mahaffy, Muskoka's first district judge owned the land at the mouth of The Cut. He had a summer home at Sandy Bay, which his son George took over. George articled as a lawyer and later became a realtor, dealing principally in city subdivisions.

Although the residence faced Sandy Bay on Lake Muskoka, the Mahaffys had a dock at The Cut. (This dock is still standing, immediately west of the Patterson-Kaye property, and belongs to Mrs. Phyllis Kaye Moore.) In George Mahaffy's time there was a beautiful boardwalk from the dock to the home, with geraniums all along it. There were barns near the site of the present lodge and a sawmill.

Patterson-Kaye Lodge, Muskoka River

Around 1927 John G. Golden subdivided the land. For the sum of $275, William and Mabel Patterson and Phyllis Kaye bought seven acres and began construction in 1936. The lodge you see today is that original structure, renovated on the inside to keep up with the times. The Pattersons and Phyllis Kaye also built four bungalows and the Gatehouse, which dates to 1949.

The Pattersons and Phyllis Kaye ran the resort until 1959. To sell the business they put an ad in the *Globe and Mail* and the first day it appeared, Phyllis had a call from Frank Miller, who represented Muskoka for many years in the provincial legislature and served as premier of the province in 1985. Frank's son Norman took over the business in 1975.

3 ALPORT LAKE

This shallow lake was called Mud Lake on early maps. A small cut was made between the lake and the Muskoka River, creating what's now called Caisses Island.

4 ALEXANDER BAILEY'S TRADING POST

Early fur traders recognized the mouth of the Muskoka River as a strategic position for a fur-trading post. Certainly there was a post here when Lieutenant John Carthew explored the waterway in 1835. He noted "an old trading post and clearing of small extent" about a mile upstream from Lake Muskoka. By 1860 Alexander Bailey was looking after the post, which consisted of a log home with a "small potato garden around it." This observation came from Vernon Wadsworth, who accompanied provincial land surveyor J.S. Dennis on a surveying trip that year.

Captain Levi Fraser, a steamboater from the old days, said the post was set up at Brownings' Bend. Today the site is best identified as being in the George Road area, about where the main river branches into The Cut.

Around 1864 Bailey purchased land at the Bracebridge falls, where he set up a store, post office, grist mill and small hotel.

5 BEAUMONT FARM/ALPORT FARM

Today it's Max Beaumont's new brick home you see from the waterfront. In the early 1860s you'd have seen another fine house, the home of Augustus James Alport, the first reeve of Muskoka Township. Augustus purchased, sight unseen, the 700 acres comprising the entire point. He was born in Nova Scotia, but returned to England for his schooling. Around 1849 he packed up the family and moved to Lyttleton, New Zealand, where he hobnobbed with the town fathers, headed up commissions, and sat on boards of directors. Shortly after his first wife died, however, a diary excerpt says Alport "bolted" because he'd "disgraced" himself. He turned up in Canada with a baby and a wife 23 years younger than he.

Alport took an active part in the affairs of Muskoka Township. His home, Maple Grove, became the local gathering place. Squire Alport even entertained the Hon. Sandfield Macdonald, the first premier of Ontario, on the occasion of the premier's trip to see construction at the locks at Port Carling and the cut at Port Sandfield.

Next came Eugene C. Muntz, whose family ran a metallurgical business in Warwickshire, England. Eugene, Emma and their six children came to Canada in 1870, settling first on Lake Simcoe. They sold the farm to James J. Beaumont of Suffolk County, England, in 1889.

Besides farming, the Beaumont family ran a supply boat operation, which started in 1893 with the steamer *Nymoca* and later saw the addition of the steamer *Alporto*.

6 SANTA'S VILLAGE

Being halfway between the Equator and the North Pole, on the 45th Parallel of Latitude, places a town like Bracebridge in the ideal position to become Santa's summer home, and that's exactly what a group of businessmen in Bracebridge set out to make it in 1954. The idea came up at a New Year's Eve party where talk had turned to the amusement park called North Pole on New York's Whiteface Mountain. The group at the party felt they could create in Bracebridge a similar tourist attraction that would add to Muskoka's popularity as a vacation destination.

The group started a fundraising campaign that generated $127,200 and led to the acquisition of 18 acres of land along the river. Construction got under way the following spring, and a year later Santa's Village held its opening ceremonies.

Since that time Santa's Village has become part and parcel of the Muskoka experience. The magic of Santa and his elves combines with such child-pleasers as carnival rides and exciting playgrounds, making Santa's Village one of the best theme parks for small children. There are goats to feed, ropes to dangle from, and boats to paddle — not to mention a visit with the Jolly Old Man himself.

The park has an international reputation and attracts about 130,000 visitors annually. Santa's Village is open from June to September.

7 ALPORT VILLAGE

The corner of Stephens Bay Road and Beaumont Drive marks the location of the Alport post office and school. The school building, S.S. No. 3 Alport, is still standing and used as a residence. It's the white house with the verandah facing the river. This building is the second school on the site and was built soon after the Second World War. It was the last one-room schoolhouse in Muskoka Township to close its doors, in 1961.

8 RIVERBEND PUBLIC SCHOOL

If you look carefully you can see the schoolhouse origins of the home on the north side of the river at Hairpin Bend. It was originally a little brick schoolhouse, S.S. No. 1 Monck. Percy Smith built the building in 1906 for $344. The school opened in September of that year with Walter Lee in charge. By 1918 the school was closed. It reopened briefly for a school term in 1923.

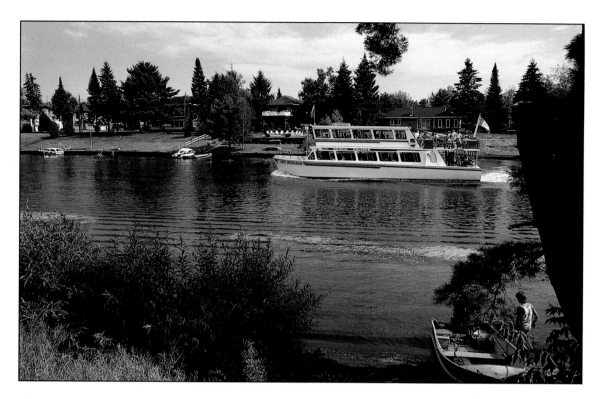

The Lady Muskoka cruising the Muskoka River.

9 BROFOCO (LOUNT HOMESTEAD SITE)

The pretty two-storey white home with red roof and old-fashioned chimneys is known as Brofoco to many Bracebridge residents (Bro-fo-co for the Brobst Forestry Company, caretakers of Annie Williams Park, see below). It was in this location (but not this home) that the first stipendiary magistrate in Muskoka settled. The appointment of Charles W. Lount as magistrate and Crown lands agent in 1868 is of particular importance because it marks the provincial government's recognition of Bracebridge as the judicial centre of Muskoka.

Lount, from all accounts, was not the kind of man you'd push around. He had an iron will and the physique to go along with it. His court sessions were marathons of endurance, lasting 12 to 16 hours at a stretch, with not so much as a break for a cup of tea. As a curiosity, it's interesting to note that the 1897 papers recorded what was then a "rare" sighting of a raccoon at this property. "It is seldom this animal is seen in Muskoka. A black squirrel, another animal rarely seen north of the Severn, was seen near the same place a few days before," the paper said.

10 SITE WHERE THE ORIOLE CAPSIZED

The shore opposite Brofoco is where the steamboat *Oriole* capsized on May 2, 1904. There was a rush on to get supplies out to those areas cut off due to the impassable state of the roads that spring. Deckhands found themselves packing box after box of supplies on the little steamer at the Bracebridge wharf, and still the goods kept coming. Finally the captain advised the hardware stores to stop sending shipments, as he planned to take only necessary goods on this first run.

The excessive load and the heavy current combined to set the steamer rolling and she started to heel over as she passed the Beardmore tannery. The passengers began climbing to the other side and the captain turned the wheel hard to bring steamer to the shoreline.

In A *Good Town Grew Here*, R.J. Boyer reports that the captain "ran along the deck, kicking in the windows so passengers could get out. The boat came to the shore and passengers were able to walk along the side and step on to dry land, most not even getting wet feet."

Workmen later raised the boat and widened it, and she resumed service that very summer.

11 ANNIE WILLIAMS PARK

The park comprises land which was originally the Lount farm. In 1925 Dr. J. Francis Williams purchased the 16 acres. He died just a year later, and the terms of his will showed that he intended the land to be a park, named for his wife, Gertrude Annie Williams, who died a few years later.

As a medical student, Williams was attached to the army during Louis Riel's rebellion in Saskatchewan. He came to Bracebridge around the turn of the century to set up a medical practice and was a magistrate for some years, as well. He gained recognition for planting thousands of red pine seedlings in Oakley Township at the age of 65. The newspapers of the day hailed him as "a completely unselfish man," a man "willing to plant a crop whose maturity he will never live to see."

The executers of Williams' estate set up a trust fund to provide for the care of the park, which was to be maintained in perpetuity for public use. The trust company employed the Brobst Forestry Company, which had tree farms in Willowdale and Bracebridge, to perform caretaker duties, which they did from 1928 to 1964. However, the revenue from the trust fund did not keep pace with the costs of looking after the park. So in 1965 the Bracebridge Rotary Club stepped in to make up the shortfall of funds and to take over the management of the park. The Bracebridge Lions and Kinsmen clubs also contributed to improvements to the park. There followed a massive facelift for the park. Dead trees were cut down and healthy ones pruned, the lawns were restored and the riverbank tidied up and protected by stone ballast.

The park is still private property, subject to municipal taxation, although the Town of Bracebridge contributes to its upkeep on behalf of the general public.

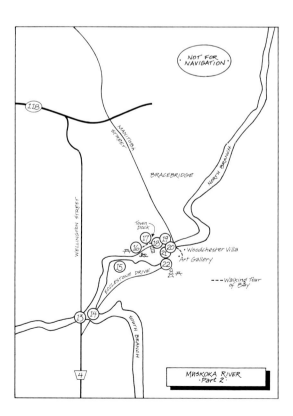

It's a vast green space with full-size shade trees and lots of room to roam. There are picnic tables, washrooms and a swimming area by a small dock. Within the park, which itself encloses the United Church cemetery, there's a wrought-iron fence that marks the burial plot of Williams, his wife and their only child.

12 BEARDMORE TANNERY SITE

The Beardmore Tannery site on the north shore of the Muskoka River, immediately west of the Wellington Street bridge, recalls Bracebridge's earliest industrial days. Here the Muskoka Leather Company, owned by the Beardmore firm of Acton, set up shop in 1877, eight years before the railway arrived.

The tannery imported hides from Central and South America, but obtained the tanbark from local hemlock, which the lumbermen had to this point despised, saying the lumber was no good. But it was the availability of hemlock that attracted Beardmore to Muskoka. The bark of the hemlock produced tannic acid, which was used in processing the hides.

The entire site was occupied by buildings of various sizes and shapes, giving the shoreline the cluttered, industrial look of a city waterfront. In the summertime tugboats ferried scow-loads of tanbark to the plants from around the Muskoka lakes. In 1922 the company consolidated its operations in Acton and closed the Bracebridge plant.

During the early years of the Second World War, the Canada Wood Specialty Company of Orillia took over part of the property for its Muskoka operations. Some years after the war Fowler Construction company took over the land that fronted on Gordon Street. Anthony Forgione held title to the other part of the tannery property and ran a busy sawmill operation for several years.

13 WELLINGTON STREET BRIDGE

The only predecessor to the modern bridge was a floating winter bridge composed of tannery scows moored end to end from the south to north banks. This was great for the settlers in the area, as they could cross the river on the scows instead of travelling all the way to the Bird bridge and back to the opposite shore. In spite of the obvious convenience of a bridge in this location, the Wellington Street bridge was not built until recently. The official opening ceremony took place in the summer of 1984.

14 THE FORK

Just upriver from the Muskoka Riverside Inn (which was originally built as a grocery store and mini-mall) is the point where the south branch of the Muskoka River joins the north branch. Upstream on the south branch is the community of Muskoka Falls, at one time favoured as the distribution centre for the district. However, when steam navigation became the preferred way to move goods and people around the district, access via the south branch of the river proved a liability for Muskoka Falls; this stretch of river harbours shallow sections that defied steamboat navigation.

15 ANGLO-CANADIAN LEATHER COMPANY

In the spring of 1891 a team of workmen descended on the south shore of the Muskoka River to clear land and put up the town's second tannery. W. Sutherland Shaw, the owner's son, came to town in May to supervise the work of the Shaw, Cassels tannery, later known as the Anglo-Canadian Leather Company. The firm also opened a second plant, in Huntsville, which was managed by C.O. Shaw of Bigwin Inn fame. Abbott Conway, grandson of C.O. Shaw, said, "When the Anglo-Canadian and Beardmore companies were both operating in Bracebridge, it is probable that Bracebridge was the largest centre of heavy-leather tanning in the British Empire." Together, the companies may have used as many as 10,000 hides a week.

Heavy leather was the leather of choice for the soles of logging boots, which were designed to have corks driven into them. The Anglo-Canadian leather could cling to the corks and hold fast when a man's weight hit a log. There was no other leather quite like it anywhere else in the world.

The Bracebridge operation catered mainly to an American market and was hard hit when the United States slapped a tariff on sole leather (the Smoot-Hawley tariff) in 1930, effectively closing the tannery. The tannery site is now a condominium development called River Edge Estates.

16 OLD WHARF

The Bracebridge town wharf has moved three times. The historic marker near the beach in Bracebridge Bay marks the site of the second wharf. It replaced a wharf on the opposite side of the bay, which had to be abandoned because of a growing sand bar. The sand bar stretched out from the foot of the falls, making it difficult for steamboats to manoeuvre.

In 1871 the navigation company asked the municipal government, then the Township of Macaulay, to set aside a new site for a second wharf. The council waffled on the request, and in the end the navigation company bought the land and put up a wharf. The township council eventually assisted by extending Kimberley Street and Dominion Street to the wharf. The two streets met in a vee on the hillside just above the wharf.

For a time the Kimberley Street extension saw the most use. The Dominion Street route was a bit rough at that point. The citizens called it the "air line." A wooden walkway along its length hung off the side of the incline and people who walked it were indeed walking on air. But in 1900 workmen filled in the dips, smoothed out the grade on the Dominion Street extension, and it triumphed over the Kimberley route as the road of choice to the wharf. Today you can just make out where the Dominion Street extension ran, but only when the leaves are down. The line of the old road is choked with regrowth and dead-ends at the Inn by the Falls' terrace unit. The Kimberley Street extension, however, has been brushed out for a hydro line and is used by agile pedestrians as a shortcut to the waterfront.

17 JUDGE MAHAFFY'S RESIDENCE (INN AT THE FALLS)

The pretty Victorian stone home that comprises the central part of Inn at the Falls is one of the older upper-class residences in Bracebridge. John Adair built the home when the Beardmore Tannery got under way (1877). The tannery property had been Adair's and he needed another residential spot. Within the same year William Cosby Mahaffy arrived. He and his wife had come on holidays but liked the village so much they decided to stay Mahaffy opened up a law office and purchased Adair's home.

In 1888 the provincial government organized the District of Muskoka and Parry Sound, and this necessitated the appointment of a district judge, William Cosby Mahaffy. Even the Liberal newspaper, the *Forester*, said of the appointment, that "if it had to be a Tory" it was a good choice.

The Kirk family owned the home after the Mahaffys. In 1943 the Allchins bought the property and created Holiday House, a small hotel. Jan and Peter Rickard changed the name to Inn at the Falls when they took over in 1988.

18 THE NEW WHARF

When you look at the town wharf today, with its gentle, grassy slopes and paved roadway to the main street, you have no inkling what a silly idea the location must have seemed to some residents back in 1903. At that time, in the middle of the bay, there was a sand bar which could come within a foot of the surface in a dry summer. The closest the steamers could get to the Bracebridge waterfront was the old wharf, sensibly located downstream where

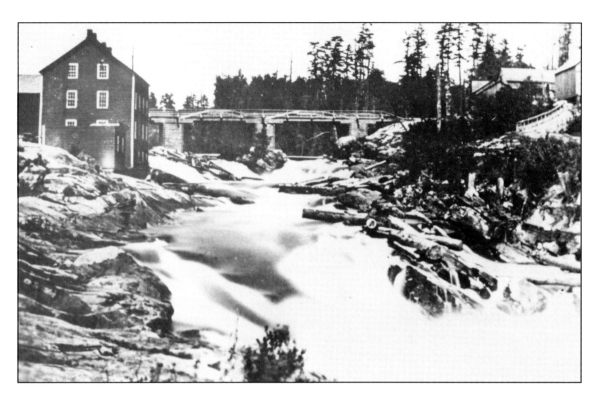

Bracebridge Falls, showing the Bird Woollen Mill on the left. (Bracebridge Public Library)

the river broadens. In addition to the sand bar, the shore by the new wharf site was solid precipitous rock.

The wharf was completed in June 1905, but access to it was another matter. Over the next few years council wrestled with the issues of dredging the sand bar and putting in a useful road. The construction of the new wharf road caused problems of its own when some careless workmen blew up a dynamite storage shed. It was June 2, 1906. After a drinking spree uptown, two workmen went back to the construction site and one of the men tossed a cigar into a case of decayed dynamite, which just happened to be sitting in a hut full of live dynamite. The blast rocked the entire town, lifted the roof on the powerhouse and smashed windows all along Manitoba Street.

In spite of the delay and confusion, the wharf road was completed that June. Still, the wharf could not be fully utilized by the large steamers until the federal government arranged to dredge the sand bar in 1908. The obstruction has been dredged at various times since then and will undoubtedly need to be cleared out again as the sand continues to collect at the outwash of the falls. Boaters are advised to keep to the river banks where the water is deep.

Many tons of rock have been removed to create the parklike setting surrounding the new wharf. Only the old photographs of the site remain to give evidence of the enormity of the task of building the wharf here.

19 POWERHOUSE

The powerhouse looks more like someone's home than a generating station. The building is the town's second generating plant and replaced the one at the top of the falls. Bracebridge had purchased the first plant from the Shaw tannery in 1894 and by doing so became the first municipality in Ontario to own and operate its own hydro-electric station. As the demand for electricity increased, the town fathers decided to upgrade Bracebridge's power-generating capacity. In 1900 construction began on the new station and it went into operation in 1902. Today it is the oldest hydro-electric station still in use in Canada.

20 THE DIVER

The stylized sculpture of a diver seems to stand guard at the foot of the falls. It was commissioned by the Town of Bracebridge from sculptor Richard Green and erected in 1982 on the opposite side of the falls. At the time people could not foresee the damage created by the accumulation of freezing spray, which bent the statue. The following summer workmen moved The Diver to the south side of the falls, where the spray is less intense.

21 GRIST MILL

The Bracebridge Bay walkway passes right across the millrace of Alexander Bailey's grist mill, situated on the south side of the falls. Bailey built the mill in 1864-65. He ran the mill for a short time then sold it to Robert Perry and Thomas Myers. The building stretched up from the foot of the bay, its roofline almost reaching the top of the rock ridge where the Muskoka Road crossed the falls. The road down to it, Mill Road, now forms part of the Bracebridge Bay walkway.

The mill changed hands several times before J.A. McCargar took over in 1901. He made considerable improvements and produced two brands of flour, one from western wheat and a blend of western and Ontario wheat called the Empire brand. During McCargar's tenure, the mill put out 75 barrels of flour per day. The mill burned in 1909 and was not rebuilt.

22 KELVIN GROVE PARK

Squeezed between Ecclestone Drive and the waterfront is a stretch of grass and a children's playground. It's part of Kelvin Grove Park, which extends beyond the road to encompass the tennis courts and Chamber of Commerce information centre.

The spot is a historic one, as it was here that Indians and early explorers disembarked to portage across the falls. In the early days a shingle mill and its trappings took up most of the space. The mill stopped production around 1899, when the price of shingles fell. The current from the river eventually undercut the mill and it had to be torn down. Mungo Park McKay acquired the land when he set up a foundry (where Falls View condominiums are today).

The Roaring Twenties unleashed a spirit of adventure across the continent. The desire to get out in one of Mr. Ford's automobiles spread to all parts of the country, including Muskoka. Mr. McKay himself was a member of the Muskoka Motor Club, and he sold the club this land for a motor park. Redmond Thomas, in *Reminiscences*, says a provision of the sale included naming the park Kelvin Grove Park, this being the name of a Glasgow park associated with McKay's childhood.

The club set up camping facilities and tidied up the grounds for park use. Unfortunately, the club fell on hard times during the Depression and asked the town to take over the park and the unpaid mortgage.

An afternoon dip.

Port Carling Waterfront

"Two days before my departure the weather turned very wet and stormy —
there was a regular Muskoka soaker; for when it does rain here it comes down
with a will; it is a case of water water everywhere; the verandahs are streaming,
the summer kitchen leaking, the guests grumbling, the children tumbling . . . All
the guests look like fish out of water . . . They hang around yawning and looking
first at the sky and then the weather glass and are generally miserable. Thank
goodness such days are the exception in Muskoka."

Ann Hathaway
Muskoka Memories: Sketches from Real Life

Port Carling is called "The Hub of the Lakes," and it's an appropriate nickname. The
island park, surrounded by a "moat" of water, actually looks like the hub of wheel. And it was
from this core area that much of the tourism-related business of Muskoka lakes revolved in
the early days. The locks made Port Carling a strategic point for commerce and transportation.

If you were a boatbuilder, a butcher, grocer, a hotelier, a confectioner, or any person
catering to the entertainment or recreational needs of summer visitors, you could be guaranteed
a healthy business at Port Carling. And that hasn't changed. No matter where cottagers or
vacationers are heading in the lakeland, whether by car or boat, they're bound to pass through
Port Carling at one point. This quality has transformed, and continues to transform, the face
of the village.

If you'd come to Port Carling in the mid-1860s, you'd have found a rough clearing, with
the stumps still standing, and the smoke from a dozen or more campfires disappearing,
pencil-thin, into the canopy of pine boughs. You'd have seen a cluster of Ojibway women
braiding sweetgrass around the fires, some sitting on felled trees, others on the hard-packed
earth, and nearby, children tracing pictures in the dirt with pointed sticks. Between the stumps
and the log huts grew rows of corn and the bushy tops of potato plants. The Indians called
the rapids Baisong, meaning "thunder, lightning." This "gathering place" was Obogawanung
or, as the early settlers called it, "Indian Village," where Chief Begamegabow presided over
about 100 Ojibway.

If we can trust the memoirs of Seymour Penson, an early settler and lithographer, the
white settlers were an intriguing mix of heart-of-gold eccentrics, burly master craftsmen,
gentlemen of arts and letters, exuberant French half-breeds, and dyed-in-the-wool Orangemen,
with the odd remittance man, recluse and profiteer thrown in for good measure.

The Baileys were the first to put down roots in the village. Penson described Alexander
Bailey as a French half-breed who spoke the Indian language, "a tall stately old man who
would have fitted splendidly into the Fenimore Cooper romances He was a man of quiet,
even speech, and his words were well worth listening to, for he was wise, and had a full
knowledge of everything that pertained to the woods." Alexander's brother was another character
altogether. Michael Bailey was, in Penson's words, "fiery, quick and jerky — often lazy, impetuous
and drunk." The Bailey brothers split the present-day townsite, with Alexander taking the part
south of the river and Michael locating on the north side.

But the real father of Port Carling was undoubtedly Benjamin Hardcastle Johnston, a widower with four sons. Johnston took matters in hand when he arrived around 1868 and set about establishing a post office and getting signatures on a petition for a navigation lock to by-pass the rapids.

In his efforts to get a lock on the Indian River, Johnston found a champion in John Carling, minister of public works for the Province of Ontario. Carling's colleagues in the ministries of Roads and Crown Lands saw the project as a waste of money. They went so far as to liken its significance, from a boat-traffic standpoint, to linking up "two frog ponds." But Carling persevered, as did south Muskoka's representative in the legislature, A.P. Cockburn, and the project got under way in 1869. When it came time to name the settlement, Benjamin Hardcastle Johnston called it Port Carling in honour of John Carling.

The arrival of the white settlers, with their shops and post offices and lock-building, proved all too much hustle and bustle for Chief Begamegabow. He packed up the women, children and dogs and left for Parry Island. Yet there is still a stretch of river bank called Indian Village, because a nucleus of Indians continued to summer at the rapids, plying their handcrafted wares to the scores of tourists who descended upon Port Carling every summer.

Port Carling is perhaps the best tourist trap on the lakes (and I say this kindly). You *have* to stop here. You *have* to try your hand at locking yourself through the small lock, even if it's just to turn around and come back again. And who can resist wandering through the Muskoka Lakes Museum, with its settler's home looking like something from *Little House on the Prairie*. For boaters, Port Carling provides the perfect destination — and there's lots to do when you get there, which is sure to impress Aunt Sarah or Cousin Joe, when they've grown tired of sitting on a lawn chair at your cottage.

1 MURDON MARINE/BESLEY SAWMILL

When Murray and Don Brown set up their marina about 30 years ago, there were some small outbuildings and repair shops on the property, and two cottages. When it came time to move one of the cottages, they found part of the engine that ran an old sawmill — still embedded in the concrete foundation.

William Besley put up the first steam-powered mill in this location in the late 1870s. He sold it to John McDermott, who then sold to Ben Butterfield.

2 WALLIS SAWMILL

An earlier mill than the Besley mill, Wallis's had a site behind the main street shops. Joseph Wallis was responsible for the cut at the north end of Bala Park Island, still known as Wallis Cut. He came to Port Carling around 1874 and set up a sawmill and supply shop in the village. The sawmill operated on steam power and was not in Wallis's hands for long. A 1879 map of Port Carling identifies it as Vanderburgh's sawmill.

3 DISAPPEARING PROPELLER BOAT COMPANY

Disappearing propeller boat. Dis-pro. DP. Dippy. The name has been shortened over the years, but the boat itself takes up a full space in people's hearts. The dippy is one of the most endearing creations ever to come out of Muskoka. The company, which was operated by W.J. (Billy) Johnston Jr. from 1916 to 1924, had a relatively short production run. Yet the dippies it produced are among the most prized possessions on the lakes today.

The dippy is a quirky little craft, just right for romantic outings. You could best describe it as a glorified wooden rowboat — pointy at both ends, with polished wooden seats and a gasoline engine mounted in the middle. A jointed propeller shaft extended from a metal housing into the water. If the boat hit a log, the propeller "disappeared" into its metal housing like a turtle into its shell. The operator of the boat could also pull the propeller up into the housing in shallow waters. For the Muskoka lakes, where shoals seem to jump up from nowhere, this was indeed a welcome invention.

THE LOG DRIVE

From the 1870s to '90s, at the height of the logging boom, the forests around Muskoka echoed with the crack of felled trees as they split from their stumps, and the *whoosh* as they sliced through the forest. Once down, the trees were beset by sawyers, hacking their lengths into neat, branchless sawlogs. The lumber camp had an army of workers: choppers to fell the trees, sawyers to slice them, teamsters to haul the sleighloads of logs to the water.

It was winter work: cold, lonely, physically demanding. Often the shantymen were up at 3 a.m., working by light of torches at the skidways, continuing on to 7 at night. The loaders grabbed what lunch they could — a slice of frozen bread and a chunk of boiled fat pork, eaten on the run.

The logs were piled high on the sleighs, their weight ever threatening to cannon over the horse and driver on steep inclines. In Muskoka the lumbermen sanded the hills with hot, burnt sand to keep the load from gaining speed downhill.

As the sun transformed the snowbound rivers into gushing waterworks, the winter camp dispersed and the drivers stepped in, releasing the logs from their shoreline depots and guiding them down the boiling, icy waterways to the mills. "The rush was on," says Bert Shea in *The History of the Sheas*, "The bunk, bunk of the logs bumping together in the slide or on the stones of the rapids was a continual sound, mingled with the roar of the water." The drivers followed the logs downstream, racing along the shoreline jabbing at the logs with long poles to keep them from stranding, sometimes hopping from log to log as the drive moved forward. (Amazingly, many of these river-drivers never learned to swim.)

Once the logs were on open water, the drivers herded them into a boom and towed it to the mill, using a horse-driven capstan mounted on a floating raft. The drivers anchored the raft, or float, ahead of the boom and attached the horse to the arm of the capstan. The horse walked around in a circle, winding up the rope and pulling the boom forward. Once the boom came close to the float, the drivers rowed the float ahead, anchored it and started the process all over again.

At this point the drive became less a hassle to the lumberman, but a problem and danger to the settlers themselves. To the person who'd been rationing his flour all winter, a river full of sawlogs was not an uplifting sight. The waterways were vital supply lines, in many cases making the difference between life and death to the settlers in isolated areas. Yet the lumber companies could, and did, "hog" the water, and were powerful enough to get away with it.

Young Billy, who is not to be confused with his uncle (also W.J. Johnston, the grandfather of boatbuilding in Port Carling), set up his boatbuilding shop behind the Presbyterian Church (on the downriver side of Duke's quonset storage shed). It was a large three-storey structure. Plugging into the popularity of the Ford automobile, Johnston called his first dippy the Water Ford, then came the John Bull and the Uncle Sam.

The end of the First World War signalled a period of prosperity for the DP company, and the managers opened a branch plant in Tonawanda, New York. Paul Dodington, one of the authors of *The Greatest Little Motor Boat Afloat*, says that by 1922 the Disappearing Propeller Boat Company was the largest motorboat-building operation in Canada and its success had enticed the Bank of Nova Scotia to Port Carling and instigated the provision of a hydro power line from Bala.

Then, just as suddenly as it came on the scene, the Disappearing Propeller Boat Company did a disappearing act of its own. Times had changed. The plant suffered financial difficulties and folded in 1924. It re-opened again, briefly and on a break-even basis, from 1925-26.

4 JOHNSTON'S BOATWORKS

W.J. Johnston Sr. was known as Uncle Billy Wagtail because he wore a long swallowtail coat that wagged and jigged like a bird's tail when he walked. Uncle Billy was the first boatbuilder in Port Carling, and he was also the the son of Benjamin Hardcastle Johnston, the man who got the village going.

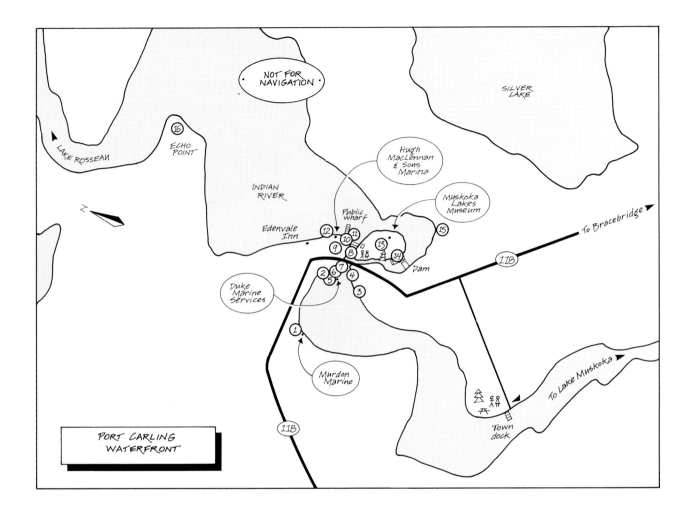

In the 1880s Uncle Billy established a boatbuilding shop below the lock, specializing in sailing dinghies, rowboats and canoes. He also set up a boat-rental shop on the island above the lock, where he had competition from Ditchburn and Bastien.

Uncle Billy's nephew, W.J. Johnston Jr., a partner in the business, took over the assets of the boatworks when he formed the Disappearing Propeller Boat Company.

5 DUKE BOATS/MATHESON'S BOATS

Every once in a while a small community sees a rift develop between two people, be it brothers, friends or close business associates. In most cases the argument blows over and wounds heal. But the argument that developed between W.J. Johnston Sr. and John Matheson in 1910 took on monumental proportions. Matheson had been building boats for Johnston for some time — some say he taught Johnston the finer points of boatbuilding. He also managed Johnston's boat-rental operation in Windermere in the summers. The cause of the rift is not recorded, but it resulted in Matheson setting up his own shop directly across from Johnston's, where Duke's Marine Service is today. Although their businesses faced each other from opposite sides of the river, not a word passed between the two men for a year and a half.

Those who've studied the boatbuilding history of Port Carling count Matheson as one of the finest craftsmen. In 1923 he sold his shop to Ernie Greavette, who paired up with Charlie Duke the following year to build and service boats. Matheson had been planning to retire, but was back at boatbuilding in another location in a few years. Aud Duke and William Gray, in their book *The Boatbuilders of Muskoka*, say John Matheson just couldn't sit still: "He had a

Motor launch, Port Carling

pile of bricks in his basement which he would move around when he didn't have anything else to do. After he stopped building boats he kept himself busy with a small launch which he parked at the government wharf, jitneying people to their cottages or sightseeing."

The Greavette-Duke partnership dissolved by 1926. Charlie Duke took control of the shop and soon had his sons Claude and Aud working with him. This was the era of the motor launch, and the Duke-built boats were among the classics, well known for their "piano-finish."

In the early '30s the company faced more than its share of trouble with fires. In 1930 an arsonist set the Duke storage shed alight. The next year the main shop burned when a fire swept up the main street of Port Carling. The Dukes built a larger shop, and that building still bears the Duke name, although it has not been run by the family since 1977.

6 THE 21 CLUB

In its day the 21 Club rocked the Port Carling waterfront. You'd have had no trouble finding it. You simply had to follow the wail of the trombone to the door next to Duke's. The owners kept the lights dim and the patrons sneaked in with booze bottles in paper bags. There were no liquor licences in those days, but customers grew adept at the slight of hand required to "sweeten" their glasses under the table. These were the days when names like Woody Herman and Dizzy Gillespie were as familiar as commercials for Lux soap.

At the 21 Club you'd find Ernie McGann and his Paradise Islanders or Muskoka's own Hugh Clairmont torching the night air with the swing sounds of the '40s. The crowd jitterbugged, fox-trotted, danced the Big Apple. And when the airmen came up the lake by boat from their convalescent home in Gravenhurst, the club could be mistaken for the kind of wartime canteen you've seen in a Greer Garson film.

A picture of the large lock at Port Carling, taken by a panoramic camera (probably in the 1920s). Notice the swing bridge. The roof of the Hanna Company General Store peeks above the trees in the centre of the picture. Port Carling House is barely visible, except for the steps leading up to the front door. Whitings Drug Store is seen on the right. (Betty Salmon)

At that time the club belonged to John Whiting, who also owned Whiting's Drugs at the other end of the lock. Marshall Louch managed the 21 Club for Whiting. Prior to Whiting's tenure, the place had been called the Casino, a dance hall put up by Mr. Minett and Mr. Newton after the big town fire in 1931. If you go back even further, you find that George Sutton, the man who introduced the townsfolk to the soda fountain, operated a restaurant and dance hall in the same spot, dating from about 1914.

The war years marked the zenith of the 21 Club. During the '50s it was used more and more for community functions, then became, as one local resident says, "kind of a divy place," as a new breed of teenager took up residence on summer evenings. Still, the building lasted longer than many of its contemporaries. In the winter of 1983 Jim and Doug Myers, proprietors of the IGA, started dismantling the club to make way for an expansion to their store.

7 THE LITTLE POST OFFICE

Before the government installed the two-lane lift bridge over the Indian River in 1973, a small wooden post office stood between Lock Street and the river. Mr. Harris put a post office up here after Hanna's store (which had handled the mail) burned in 1931. Small as it was, and in as precarious a position (with scarcely a toehold at the corner of the bridge), the little post office fairly whirled with activity, especially when the steamboats came in. At times there'd be long line-ups outside the doors, waiting for the postmaster to sort the mail The construction of the two-lane bridge spelled the demise not only of the little post office, but also another Port Carling landmark, Norma's Lunch, on the opposite side of the river.

8 THE LARGE LOCK

Lake Rosseau is a little over .6 metres (2 feet) higher than Lake Muskoka. Before the government dammed the river, the waters tumbled down the Baisong Rapids on their way to Lake Muskoka. You get some idea of the force of water that once flowed around the island if you take your boat around the south side in the spring when the channel buoys are bent flat in the current.

In an area that depended on its lakes as the most reliable means of transportation, the rapids created a serious bottleneck. Passengers had to disembark on the downriver side of the rapids, unpack their goods, cart them across the portage, and reload into another vessel on the upriver side. Fortunately, pioneer Muskoka had her share of champions in the government, men who believed the district held enough promise to warrant the dollars spent to facilitate access to the upper lakes. Men like A.P. Cockburn, the area's representative in the Ontario

legislature, and John Carling, the minister of public works, foresaw the lock providing an incentive to settlement and resource-development.

A.P. Cockburn was not without some personal interest in the lock construction, as he had moved his field of operation to Muskoka with the expressed thought of putting steamers on the lakes. He'd toured the lakes in 1865 and within a year had the *Wenonah* built and running on Lake Muskoka. Then, in the spring of 1869, he managed to get another steamer, the *Waubamik*, up the rapids and into use on Lake Rosseau. (To get the steamboat up the rapids, workmen built a dam behind the *Waubamik*, floated her ahead till she hit bottom again, built another dam behind her, and so on until the steamer had been stepped, or warped, up the rapids.)

The government awarded the lock-construction contract to Ginty and Manning for $35,000, and they put a team of 30 men on the job in July 1869. Seymour Penson writes that very little headway was made that summer: "About 15 feet of drilling was a day's work for three men and the amount of rock loosened very small. The rock was much more refractory than the contractors anticipated." The lock opened to navigation late in 1871, and there has been expansion and reconstruction several times since then. One of the most welcome improvements was the installation of electric gates, which speeded up the lockages considerably. It used to take 30 minutes to go through the lock, now it takes only 10.

9 PORT CARLING HOUSE

In 1869 Mr. John Thomas erected a squared-log hotel called the Polar Star. From Seymour Penson's memoirs we learn that Thomas was a native of the southern United States and had "done something during the war that made it inadvisable for him to go back." After 17 years he sold the hotel to Robert Arksey. Arksey built the Interlaken Hotel around the original log structure. (The original log hotel became the dining room of the Interlaken.) The hotel commanded a picturesque view from atop a hill that sloped down to the boat lock. In the summer young maples and Lombardy poplars completely encircled the building and only the roof peeked out above the trees. Arksey sold the establishment to Joseph Ruddy in 1897, and Ruddy changed the name to Port Carling House.

There are residents in Port Carling who remember the rowdy days when the shanty boys came into town after months in the logging camps. That's when the bar at the Port Carling House would be "covered in blood from one end to the other" when brawls erupted. The Port Carling House survived until the 1970s. During the demolition of the building, the workmen uncovered the squared timbers of the original Polar Star Hotel. Today a line of modern shops sits on what used to be the front lawn of the hotel.

10 WHITING'S DRUG STORE

Of all the landmarks to disappear from the Port Carling waterfront, perhaps none is missed more than Whiting's Drug Store. A breezy balcony encircled the second storey on the river side, and at dock level there was an ice-cream parlour. With its white-tiled floor and marble counters, the parlour looked cool and crisp. A sign above the portico in the 1920s advertised "Fruits and High Class Refreshment" and "Dancing Every Night" — not to mention the slot machines that happily gobbled up any loose change.

Prior to John Whiting's emporium, there had been a restaurant, built by the proprietor of the Port Carling House. A Mr. Goulding of Toronto operated the establishment for a few years before Whiting bought it.

A row of tuck-shop-style boutiques stretched along the dockside from Whiting's to the Port Carling Boatworks. The shop stalls were little more than a hole-in-the-wall affair, with swing-front openings that could be padlocked shut at night. Here artisans sold handwork, baskets, leather belts and bags. The shop stalls and Whiting's all disappeared from the waterfront in the late 1960s or early 1970s.

Whiting's Drug Store

11 DOCKSIDE PAVILION

Whether you call it a freight shed, a shelter or a "roof on sticks," the Port Carling pavilion is a simple structure. It's present good looks are the result of work by the Local Architectural Conservation Advisory Council (LACAC), whose members sought government assistance to restore it in 1988. The group used old photographs of the area to determine when the building went up (around 1900 is an educated guess). The photographs also helped establish what the pavilion looked like, which is why pretty wooden shingles have replaced the green asphalt ones. The coxcomb on the ridge-line is an authentic touch, too. The Ontario government has designated the pavilion a heritage structure.

12 PORT CARLING BOATWORKS/HUGH MACLENNAN AND SONS

Young Billy Johnston started the Port Carling Boatworks in 1925 after his Disappearing Propeller Boat Company folded. He brought along some of the employees of the DP company: Cameron and Doug Milner, Charlie McCulley and Harold Cooper. They started making cedar lapstrake outboards, rowboats, and a boat similar, but not identical, to the disappearing propeller boat. Then came the SeaBirds, a line of boats which established the company's reputation. The SeaBirds helped bring big-boat ownership to the average person by being well built and competitively priced.

Billy Johnston left the company not long after it started, leaving the Milners, McCulley and the others to see the company through the Depression. In 1931 the boatworks burned down completely, but by the mid-1930s, the company had revived and expanded, setting up a companion operation in Honey Harbour, Georgian Bay.

About that time farmer Hugh MacLennan took the pennies out of his daughter's piggybank and set off to look for work at the boatworks. His farm in Uffington was as productive as it could be, but times, and crops, were poor.

But the boatworks didn't need help. "We get guys like you coming in here every day," Charlie McCulley barked from behind the desk. "Try me for a week," MacLennan said. "If I don't pan out, you don't owe me a nickel." That, as it turned out, was just the right thing to say to Charlie McCulley And it got Hugh MacLennan the job. "I started here at 36 cents. But it was 36 cents an hour more than I had," MacLennan says.

Boatbuilding proceeded at a hectic pace during the Second World War. The Port Carling Boatworks, in conjunction with Minett Shields in Bracebridge, had taken on a government contract to build Fairmiles for the navy. The Port Carling operation made up parts for the corvettes, with the bulk of activity taking place in Honey Harbour. After the war Charles McCulley took over the operation and settled down to the pleasure-boat business.

MacLennan stayed with the Port Carling Boatworks right through the McCulley years, working as a mechanic. Soon after the company changed hands in 1958 and stopped making SeaBirds, MacLennan set up his own marina across the bay, but returned as owner of the boatworks facility in 1965.

Today the company is run by Hugh MacLennan Jr. and his wife Joan. The shop is still fitted out with overhead rails to move boats from one place to the other and has a belt-driven machine shop where both Hugh Sr. and Hugh Jr. can make just about any part an old classic boat might need. Over the winter the MacLennans renovate wooden boats and rebuild engines, and from spring thaw to the following freeze-up, they're busy running the marina and repairing Mercury motors.

13 THE ISLAND

You could say the island has been the centre of attention in Port Carling since people first arrived. Even during the days of Obogawanung, the island's shorelines would provide a meeting place for the Indians who made their home by the rapids.

And it was on the island that Donald Cockburn set up a trading post, at a spot about where the large lock is today. When Benjamin Hardcastle Johnston moved to the Indian village from the Brackenrig area, he chose the island for his home site. His home became the first post office, making the island a destination for every settler in the area. The construction of the locks made the island the hub of navigation and, correspondingly, of commerce. And what better place for a church picnic or Victoria Day celebrations.

But the island did not look as parklike as it does now. It was, in fact, covered in tall pine trees, fenced in by a strange collection of boat liveries and sheds. Part of that collection was an ugly, corrugated-iron building called the fish hatchery. The Muskoka Lakes Association set it up in 1911 in a spot behind the present-day museum. The building stood idle for some years and was finally torn down.

Also gone from the island is Temple and Sons Theatre, operated in conjunction with a billiard hall and boat livery. The Temples set up the theatre in 1926, behind the lockmaster's building. The theatre opened from May to September, screening the popular silent movies of the era, complete with piano accompaniment.

The Muskoka Lakes Museum is a relative newcomer on the island, built during Canada's centennial year, 1967. Several wings have been added since that time, along with Hall House. This settler's home is a real beauty, and you have to marvel at the size of the trees the pioneers had at the ready. The logs in Hall House are 66 centimetres (26 inches) thick and 9 metres (30 feet) long. Members of the museum board, along with local residents, dismantled the house and moved it from its original site on White's Road, Glen Orchard, to the museum, trailering each log across the narrow pedestrian ramp that provides access to the island.

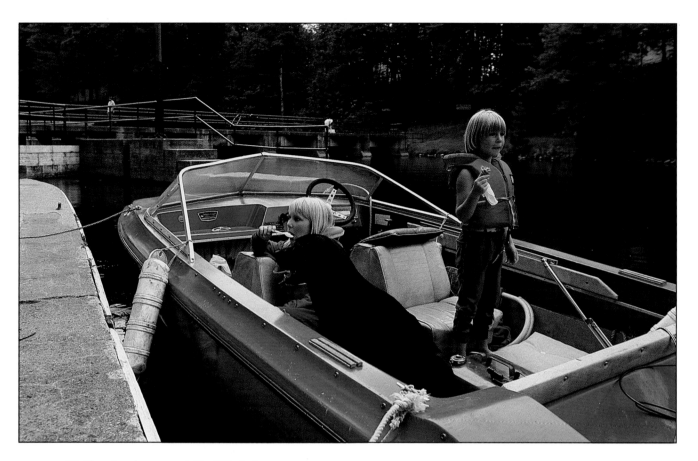

Waiting for clearance at the little locks.

Hall House provides an appropriate display area for the museum's collection of pioneer items, while the marine section is a testimony to the boatbuilding heritage of Port Carling—lots of old photographs and mementoes of boatbuilding days, and several small wooden craft, including an example of the famous disappearing propeller boat.

14 THE LITTLE LOCK

The same boat boom that established the reputation of the Port as a centre for fine watercraft put incredible pressure on its lock facility. The arrival of the motor launch on what had otherwise been a steamboat-only playing field heralded a new era, the era of pleasure-boating. By the 1920s so many boats passed through the large steamer lock on a daily basis that water levels began to rise in Lake Muskoka. So it's no surprise to read in the minutes of the 1921 Muskoka Lakes Association meeting that a small lock had been installed. This was replaced in 1940 and automated in the 1960s.

LOCKING THROUGH

Bridge clearance: fixed span (over south channel), 2.4 metres (8 feet) high; lift span when closed (over north channel), 2.7 metres (9 feet). Large lock dimensions: 46.5 metres (155 feet) long, 9.9 metres (33 feet) wide, 2.4 metres (8 feet) deep. Little lock dimensions: 19.8 metres (66 feet) long, 3.75 metres (12.5 feet) wide, 1 metre (3.3 feet) deep.

The small lock operates 24 hours a day, seven days a week, all season. Unless an attendant is on duty, it's up to the boater to lock himself through, following instructions in the control booth.

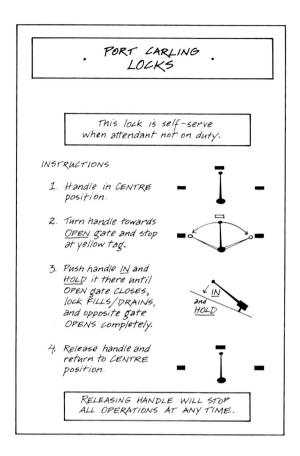

The large lock is operated by the lockmaster for vessels that don't fit through the self-operational locks, or to relieve congestion during peak traffic periods. Boats wider than three metres (10 feet) or with masts higher than 2.4 metres (8 feet) must signal approach with one four-second blast of the whistle.

15 INDIAN VILLAGE

The shores opposite the island are quieter these days, and only a few cabins remain to delineate the location of Port Carling's Indian Village. The summer months used to see scores of Indians encamped on Indian Bay. They came from the Rama and Gibson reserves to their summering place. Here, amid the ruckus of barking hounds and crying babies, they wove sweetgrass into baskets and decorated trinket boxes with porcupine quills.

With the coming and going of the steamers, the Indians had a captive tourist market for their goods. In many respects, the Indians' bazaar, set among the pine trees, could be described as the forerunner of the outdoor arts and crafts show so popular through Muskoka today.

16 ECHO POINT

At the turn in the Indian River, take a look at the point on the west side. Sitting among the trees, overlooking the boathouse, is a little log cabin. It's an unassuming little place, but its pedigree is impressive. This was Timothy Eaton's retreat cottage, originally built in 1902 on the Eatons' Ravenscrag property near Windermere. In Eaton's declining years he had this small cabin built so he could get away from the guests at the main cottage.

When new owners of the Ravenscrag property planned to replace the old cabin, Ian and Dianne Turnbull decided to try moving it, piece by piece, to Echo Point. They've since reassembled a second, larger log home on a site adjacent to Eaton's cabin.

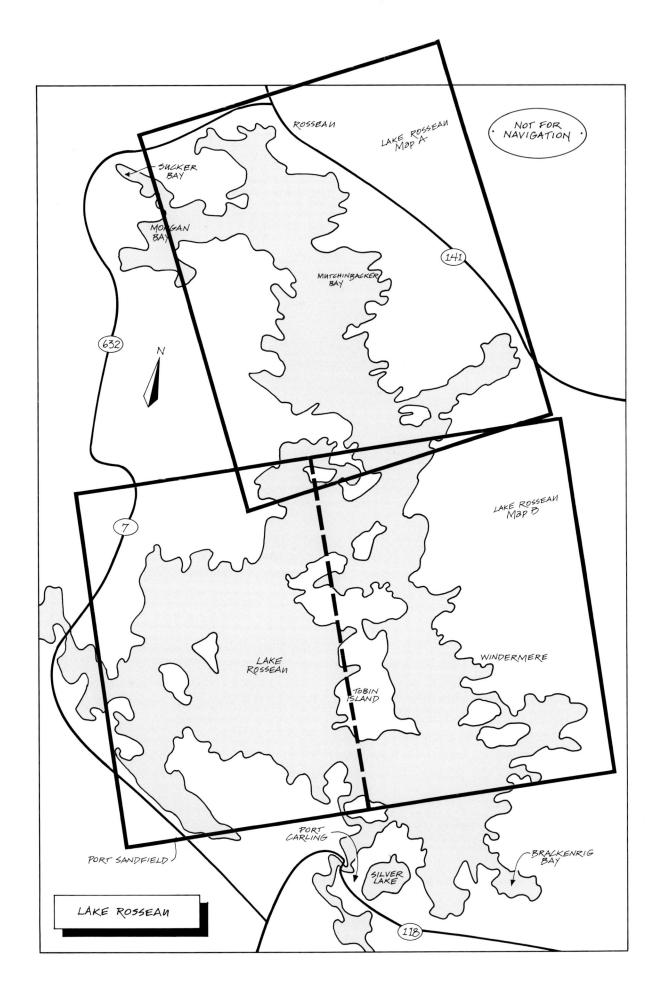

NOT FOR NAVIGATION

ROSSEAU

LAKE ROSSEAU Map A

SUCKER BAY

MORGAN BAY

MUTCHINBACKER BAY

141

632

N

LAKE ROSSEAU Map B

7

WINDERMERE

LAKE ROSSEAU

TOBIN ISLAND

PORT SANDFIELD

PORT CARLING

BRACKENRIG BAY

SILVER LAKE

118

LAKE ROSSEAU

CHAPTER 5

Lake Rosseau

"In every direction that the eye could roam; on the mainland or amongst the islands of the lake, the dominant feature was the dark masses of pine and hemlock And what strange forms these conifers sometimes took. On point and islands where strong winds had much sweep, the trees clung desperately to bare grey rocks, and drove their roots deep into crevices to find some little sustenance, and to keep their head aloft. Here their dwarfed bodies were twisted and tortured into the most fantastic shapes by fierce winds, and made to look like piney elves and gnomes."

Seymour Penson
Memoirs

If you had to pick just one of the Big 3 Muskoka lakes to visit, Lake Rosseau would be the best choice: metre for metre there are more varied points of interest here than on the adjoining waters. I call it the "resorts, relics and royalty" lake.

Certainly Windermere House is the quintessential Muskoka resort. It's what all summer hotels should look like — candy-cane crisp against a blue sky. But there are others, hotels with histories as long as their verandahs, some tastefully preserved, some falling apart at the seams, some just a memory, a patch of young birch trees where the buildings used to be.

Lake Rosseau is perhaps the most talked-about lake in Muskoka. There are no secrets here. This is where the who's who come to visit — royalty, politicians, media personalities. No doubt, as many distinguished guests holiday on Lake Muskoka and Lake Joseph, but Lake Rosseau is more apt to let you know about it.

That's not to say it is an exclusive club. The lake is very accommodating to its boaters, providing places to dock, and places to swim (including a beach that looks like it's come off the pages of *Canadian Geographic*). There are waterfalls to explore, a lighthouse to photograph, and a rock that looks like an elephant's head. Lake Rosseau gets top marks for variety, fun and history. Pack a picnic and enjoy.

NAMING OF THE LAKES

The name Muskoka honours the indian Chief Mesqua Ukee (also spelled Musquakie). Alexander Shirreff is given credit as the first to record the use of the name Lake Muskoka, in 1829. He mentioned the fur traders as the originators of the name, after an indian chief who hunted in the area.

Lake Rosseau was named in the 1830s after Jean Baptiste Rousseau, a fur trader from Penetanguishene. Over the years the first "u" in Rousseau's name has been dropped. Lake Joseph is named after Rousseau's father Joseph. Surveyor John Dennis thought he had discovered the lake several decades after the Rousseau era. By sheer coincidence, he also christened it Lake Joseph, after his father.

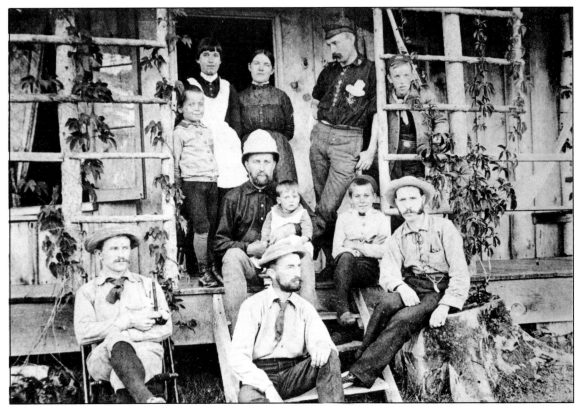

Plaskett family, Bohemia Island. "*The pegs on which we hung our clothes were made out of wood . . . the bunks were built to the wall. One room had four bunks in it. There were no locks on the doors, just sliding wooden latches,*" *wrote Miss J. Plaskett of the family's cottage as she remembered it in the 1880s.* "*On arriving, the mattresses or ticking had to be filled with hay, which was emptied on the floor before leaving the previous year. The ticking had been hung up away from the destruction of mice and squirrels. Of course there was no style in those days. The men wore grey flannel shirts and we took all our old clothes and wore them out.*"
(Muskoka Lakes Museum)

1 TOBINS ISLAND

Tired of coping with flooded fields along the banks of the St. Lawrence each spring, Joseph Tobin and his cousins moved east in 1867.

Edna Ramey, great-granddaughter of Joseph Tobin, says one one cousin purchased land at what became the crossroads of Lawrence and Yonge Street in Toronto; the other cousin purchased property where Hyde Park is today. Both paid $100 for 100 acres. "My illustrious great-grandfather was offered 100 acres where Bloor and Yonge Street is today, but he had four sons and he felt that wouldn't be enough. So he came up to Muskoka and picked this hunk of rock out in the middle of Lake Rosseau and gave his $100 for that," she says.

While Tobin's Island may never have the commercial value of Bloor and Yonge, when all's said and done, Tobin's descendants can't be too displeased. The island is a beauty. As for the land being a hunk of rock, that's not entirely true. Tobin's neighbours thought the island was perhaps the most desirable spot in the district. It hadn't been snapped up earlier because the Indians had a burial ground on the southwest point, known today as Hauserman's Point.

Joseph and Bridget Tobin had 12 children, six girls and six boys. Joseph divided the island up, giving the northwest section to John (hence John's Bay) and the northeast portion to Angus. Hugh and James owned land in the middle of the island, and the lower portion remained Joseph's until his death, when it was divided between the younger sons, Daniel and William.

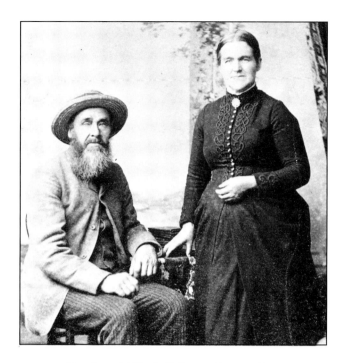

Frank and Elizabeth Forge, Portage Bay.
(Evelyn Longhurst)

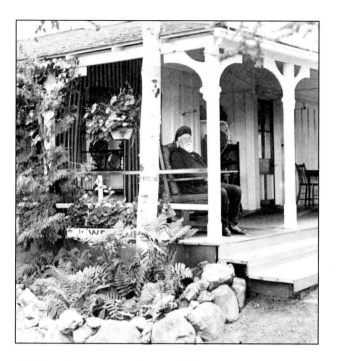

Sir Timothy Eaton on the verandah at Ravenscrag.
(Evelyn Longhurst)

The Joseph Tobin homestead was the site of one of the early tourist hotels, Oaklands Park. It burned down twice, and the family did not rebuild it the second time.

John Tobin's daughter Lil married a McNaughton. Their descendants have lived year-round on the island to the present day. Since it was difficult for the children to get to the mainland for school, the board of education built a school on the island in 1913. The school was situated about midway between the north and south ends of the island so that the Tobin children and McNaughton children would each have the same distance to walk. The school closed in 1936. It has been moved to Lily Bay and is now used as a summer cabin.

2 FRANK FORGE, PORTAGE BAY

Although steam navigation made its appearance on the upper lakes in the 1870s, Frank Forge was content to row to his customers. He travelled all the way to Lake Joseph on a twice-weekly supply run, bringing fresh lamb, butter, milk, eggs, vegetables and ice, his rowboat loaded to the gunwales. To make the run, he rose at 4 a.m, slaughtered the lambs and loaded the boat. He'd return late at night, singing, so his wife, Elizabeth, would know he was nearing home. Remarkably, for a man who spent so much of his time on the water, he never learned to swim.

It was from Forge that Timothy Eaton purchased land for Ravenscrag. Forge took care of the Eatons' property until he was well into his 80s. His homestead faced Wellesley Island, near the head of Portage Bay, so named because the portage to Three Mile Lake started at the end of the bay. Today a beige-coloured boathouse sits adjacent the original home site.

3 RAVENSCRAG

Many a summer cottage has its name painted on the rocks, but the block letters that spell out the name Ravenscrag stand for more than the name. They are synonymous with a certain style, a chic to which all well-to-do Muskoka cottagers seemed to aspire in the early days. Ravenscrag belonged to Timothy Eaton, founder of Eaton's Department Store. The Eatons had vacationed at Windermere House before buying the property in the late 1880s. From 1887 onward, they built up a family compound of six cottages.

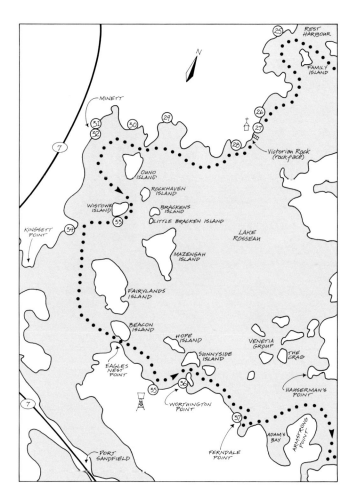
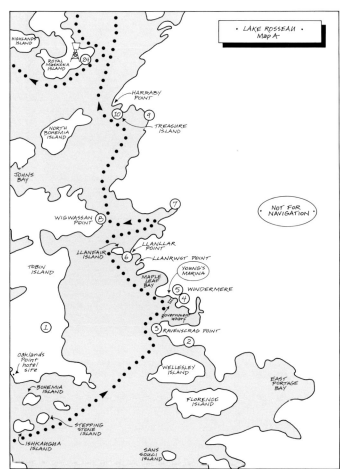

Here the family entertained the big names of Toronto society — although in Timothy's day there was no drinking or smoking allowed. You can imagine the strawberry teas held on their spacious verandahs, where striped canvas windbreaks flapped in the breeze and silver trays lined the walls.

You didn't run down to the lake in your swimsuit in those days, but changed into modest swimming attire in bathhouses built near the water's edge. The Eatons relished their waterfront pastimes and even built a long water slide beside the dock for fun on hot days. (Some of the local children used it as a ski jump in the winter.)

With two department-store giants setting up beside each other in the major towns and cities, Canadians began to think of Eaton's and Simpson's as a matched set. Where Eaton's was, so too was Simpson's. That held true at the cottage, too, as C.L. Burton, the president of the Simpson's chain, had a cottage on nearby Florence Island.

The Eatons' relatives, the Burdens, eventually came heir to the Ravenscrag property (Mrs. Burden was an Eaton), which is how Canada's World War I flying ace, Billy Bishop, came to call it his summer home. Bishop married one of the Burden girls, and he spent considerable time at Ravenscrag, often helping old Mr. Forge, the caretaker, with the haying.

The Oslers purchased Ravenscrag around the late 1940s. The houses of the Eaton era have all been torn down. Bats had infested the attic of the main cottage and years' worth of bat droppings had accumulated in the rafters — not a pleasant smell. Only Timothy Eaton's retreat cottage remains, although not here. Ian and Dianne Turnbull dismantled the cottage and re-erected it on Echo Point, Indian River.

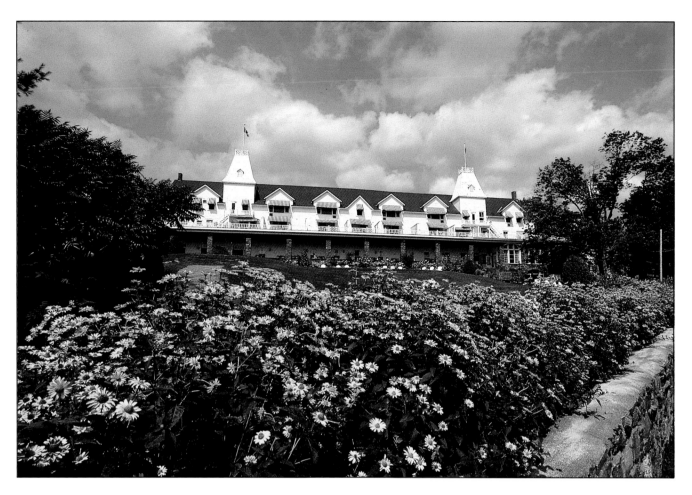

Summer at Windermere House

4 FIFE HOUSE/SETTLERS BAY COMPLEX

The lots comprising most of the present village of Windermere belonged to David Fife Sr., whose son David Jr. built Fife House, where the Settlers Bay complex is today.

David Fife Jr. and his wife, Mary Ann, operated Fife House from 1889 to 1913. They built a frame hotel, three storeys high, with a dining room looking out at Ravenscrag Point. Fife often assisted the local doctor when he performed operations in the area. Fife administered the anesthetic and afterwards visited the patients to dress the wounds.

For some years the Johnstons owned Fife House, but it returned to the family under the proprietorship of Arthur Fife, who died in 1960.

5 WINDERMERE HOUSE

Thomas Aitken came to the Windermere area about the same time the Fifes did. The hardy Shetland Islander, described by his neighbours as a "dark, taciturn man," would go on to establish perhaps the most genteel resort in Muskoka.

The fields of Watt Township are lush and gently rolling, quite unlike most of Muskoka. The soil is clay-based, generally deep, heavy and fertile, a legacy of the silt deposits of an expansive lake which covered most of the district for some 900 years, collecting the run-off from melting glaciers. The Windermere area became prime sheep-grazing pasture in the days when all the best restaurants included Muskoka lamb on their menu.

Windermere House
(Muskoka Lakes Museum)

As early as the mid-1860s Aitken took sportsmen and fishermen into his home. The modest boarding facilities proved popular enough that Aitken decided to erect some cottages especially for tourists. In 1883 Aitken's guests were treated to the beginnings of Windermere House as we know it today, with the construction of the first tower, an addition to the main building. (The main building now houses the Windermere dining room.) In 1902 Aitken expanded the front section and built the second tower. The classic lines of Windermere House and its reputable clientele established the aura of distinction still associated with the resort.

The name Windermere, which is taken from the English lake district, was actually first used for the post office at the mouth of the Dee River. When the post office moved to Thomas Aitken's home in 1870, the name went with it.

Windermere House remained in the Aitken family until 1980, their proprietorship spanning three generations.

6 LLANLLAR

If you could choose just one summer home that epitomizes the Lake Rosseau style, it would have to be Llanllar. Mind you, only the boathouses and teahouse are visible. The main cottage is hidden among the trees, a characteristic typical of the grand old cottages of Muskoka. The gable ends of the boathouse complex are unique, shingled in the colours of a Muskoka sunset.

It was the flower gardens that made Llanllar famous, and they still attract the afternoon-cruise crowd. But no matter how hard you try, you simply can't see how extensive and beautiful the grounds are, from the vantage point of a boat. Still, the rock garden and the boathouse flower boxes are lovely and have been the subject of many a photograph.

Rev. Elemore Harris purchased the property around 1900 and built a family cottage, and a smaller cottage for the caretaker. When their son died, the Harrises put the cottage up for sale. Joseph Irwin bought Llanllar at the end of the 1908 summer season. The Irwins and their relatives (the Sweeneys and Millers) were no strangers to Muskoka, having spent summers on Lake Joseph and Lake Rosseau since 1886.

In the Harrises' day, the only garden was a box-shaped plot at the end of the bay, planted in colours to resemble the Union Jack. Around 1926 Miss Elsie Sweeney, granddaughter of

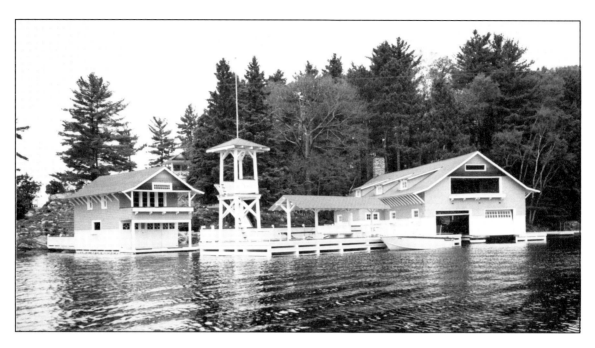

Llanllar, Lake Rosseau. (Susan Pryke)

Joseph Irwin, began to transform the grounds into a gardener's delight. With the help of her gardener, Osburne Longhurst, she built rock gardens behind the boathouse complex and set out the expansive perennial garden at the foot of the bay. Later she established a native garden, in Japanese style, with ferns, periwinkle and lilies bordering a small stream.

Elsie Sweeney died in 1972. During her time at Llanllar (at least until the 1960s), the family opened the grounds to the public every year. The garden tours were instigated as a fundraiser for the Windermere churches. Elsie Sweeney played the organ at the United church for 50 years.

The ultramodern Llanrwst (on the point south of Llanllar) and Llanfair Island (opposite Llanllar Point) are part of the family complex.

7 CLARK'S FALLS, DEE RIVER

Getting a close look at the Dee River falls from the boat is a tricky thing to do and can only be safely attempted in a rowboat or canoe. The water in front of the falls is littered with old sawlogs. Some of them have taken a notion to lift their heads to the surface, so be extra careful when manoeuvring in this area.

Archibald Taylor established a sawmill at the Dee River falls around 1867-68. The Ontario-born millwright, of Scottish descent, ran a small log-sawing operation, cutting about 160,000 board feet of lumber in a year with an water-powered upright saw.

In Taylor's time men built a timber dam above the falls to raise the water for the logs that came down from Three Mile Lake each spring. The pond behind the dam also created a head of water to run the mill. A flume channelled the water to the mill, which was located on the north side of the bay. The lumbermen built a log slide to by-pass the falls.

The falls are worth taking a closer look at. They form a bridal veil over the rocks, then charge through a natural trough. You can still see the concrete support saddles that trace the route of Clark's penstock. The mill burned in 1929, but if you have the energy, you can fight your way through the bushes and find the old foundations.

8 WIGWASSAN LODGE

Those who remember the Wigwassan Hotel look with some longing at the empty hillside. The facade of the Wigwassan was quite dramatic, and people often confuse photographs of it with those of the much grander Royal Muskoka.

In 1906 Frank Hurlburt built the hotel and called it Waskada. But he encountered difficulty getting the steamboats to call at his place and he sold it in 1913 to a Mr. Rice. In about three years' time Rice grounded the operation in a thick mortgage.

Enter the Canadian Chautauqua Institution Limited. This group of Methodist ministers and lay people was dedicated to providing cultural and educational programs of a decidedly Christian nature. Chautauqua Institution Limited bought the Hotel Waskada and re-opened it in 1920-21. John Wesley, the founder of the Methodist Church, preached in a village called Epworth, so the Chautauqua group called its resort Epworth Inn. The inn became the headquarters for the Muskoka Assembly of the Canadian Chautauqua Institution and the post office was called Muskoka Assembly.

Each year the Muskoka Assembly brought together an impressive array of musicians and speakers, many from the ranks of Canada's literary establishment. Here you could rub shoulders with the likes of Sir Charles G.D. Roberts, Edwin Pratt and Bliss Carman — and at the same time soak up inspiration from the Muskoka environment.

Visitors flocked to the island and purchased lots to be near the "happenings" at Epworth Inn. But the Depression years took their toll, forcing the closure of the inn. In 1931 George and Katie Martin purchased the hotel and called it Wigwassan, which means "silver birches."

The Martins upgraded the resort, and the Wigwassan soon became the place to be if you were young and active. By the 1960s the resort offered three hard-surfaced tennis courts, two lighted shuffleboard courts, lawn bowling greens (probably a hanger-on from the Epworth days), a nine-hole putting green, badminton, croquet and horseshoes. Still, the main attraction was the two-storey boathouse/auditorium that sat right on the water. Upstairs it had one of the largest dance floors on the Muskoka lakes, with round and square dancing six nights a week.

Today you can just make out where the cribs for the dance hall were located beside the boulder-strewn remnants of the launch wharf. The hotel itself sat way up on the hilltop, where young trees have taken a firm hold. The hotel was dismantled in 1967. Only a gazebo remains to testify to the once-lively era of the Epworth/Wigwassan resort.

9 ROSTREVOR

What you notice from the water is the long tan-coloured line brushing the water's edge. The fine sand beach is the most extensive on Lake Rosseau. The grass is held back with a low concrete border, and fat-trunked oak trees provide delicious shade. It's an ideal location for a resort. But the appropriateness of the site for summer vacations had nothing to do with Arthur Dinsmore's settling here in the early 1870s. The Irishman and his family came to Canada to start a new life. Clearing the land, farming and logging occupied the family for several decades. It wasn't until 1898, when many resorts and tourist homes had been established on the lakes, that Dinsmore built the lodge in the gambrel style (really just a large cottage with a verandah, some gable windows and a modest tower on one end). Dinsmore called it Rostrevor, after his birthplace in Ireland.

The original lines of the building have been somewhat ruined by the addition of the left wing, which left the pyramid-roofed sunroom looking rather small and inelegant in the middle of the roof line.

In the summer of 1988 the contents of the resort were auctioned off, with a view to building condominium units and restoring the main lodge.

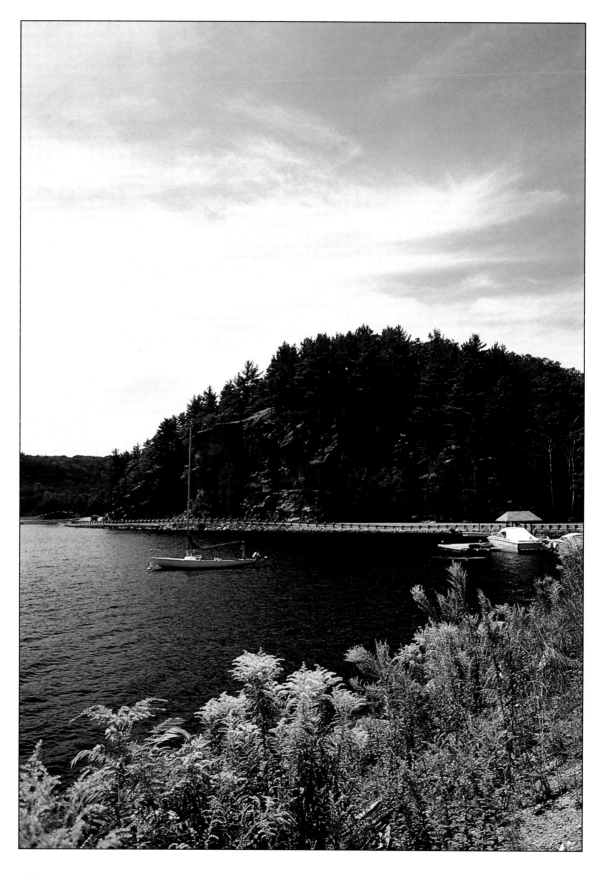

Skeleton Bay

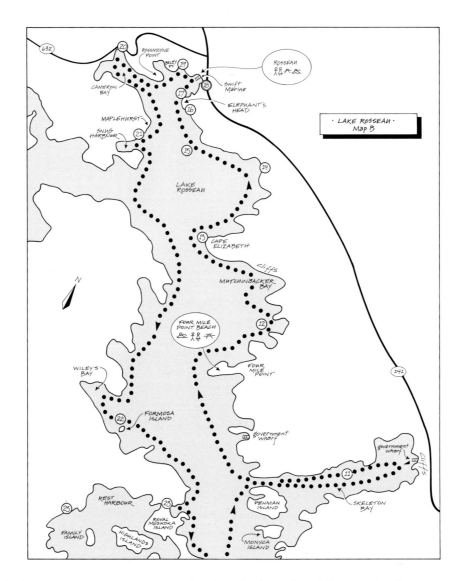

With the owner's permission I took a last look at the old resort in the summer of 1989 to see its famous stamped-tin ceilings. It was an eerie experience finding the little lodge completely quiet. Auction registration numbers littered the hardwood floor of the dining area, and the rooms, pierced by shafts of afternoon sunlight, smelled of dead mice and yellowed newspaper. Outside, the stone gate and beach staircase were being swallowed up by tall grass. This is the way the hotel dies, in the too-revealing summer sun, the tiger lilies still growing in the weeds.

10 TREASURE ISLAND

While there are no gold doubloons hidden in the crevices of the rocks, or peg-legged pirates clomping about, there are certainly treasures aplenty in this charming location: the lovely rocky shoreline, the steadfast pine trees, and a picturesque log home.

The present owner, Bruce Mitchell, says Dana Porter built a two-storey log cabin here in the early 1920s, but Charles Gundy (of the Wood Gundy brokerage firm) made substantial changes to the building when he purchased the property in the late 1940s. He added the dining room and a second fireplace, and took off the front verandah. Those were grand days in the property's history, with servants to see to preparations of food and cottage maintenance.

In 1953 Gerald Walker bought Treasure Island. He sold to the Mitchells in 1983.

11 SKELETON BAY

A name like Skeleton Bay has to be explained. In this case it's not the bay itself that has the fabled skeletons, but the lake that drains into it. Skeleton Lake, to the east, flows into the bay via the Skeleton River. When Vernon Wadsworth, who helped with a land survey in the 1860s, asked the Indians at Port Carling how Skeleton Lake got its name, their chief told him they called it Spirit Lake because ghosts were there. The Indians feared camping there on that account, Wadsworth said.

As to the skeletons themselves, surveyors did discover two, on the north shore of Skeleton Lake. These were the bodies of an Indian mother and her son, who died one winter. The boy was too weak to move on with the rest of the band, so his mother stayed with him, and the two died together.

12 MUTCHINBACKER BAY/FOUR-MILE POINT PARK/ROSSEAU FALLS

If ever a bay warranted closer inspection, Mutchinbacker Bay is it. There's a sandy lagoon worthy of a magazine cover, a waterfall that churns white through the rock clefts in the spring, and beautiful rocky cliffs running along Cape Elizabeth Point.

Four-Mile Point Park has a lovely swimming beach, the kind where you can see the veins of sunshine wiggling along the sandy bottom. There's a grassy park behind the beach, with toilets, barbecues and road access. There's no dock, but it is easy enough to hoist the outboard out of the water and run the boat up on the beach.

The name Mutchinbacker (also spelled Mutchenbacker) can be traced to Peter Mutchenbacker, who managed the sawmill business here for Snider Lumber Company, based in Gravenhurst. His name appears on a Crown land grant for Lot 32, Concession 2 Cardwell Township, dated March 26, 1877. Peter and his wife, Theresa, lived at Rosseau Falls for close to 30 years, then moved to Gravenhurst.

The Snider Company operated a steam-powered mill at the foot of the falls. The waterfall, though impressive in the spring, dries to a trickle in the summer and could not sustain a water-powered mill. It's quite eerie walking up the falls in July, over aprons of water-worn gneiss, knowing that in spring these very rocks will be inundated. It's as if someone turned off a tap, and you half expect it to be turned on again. Driven into the rock at intervals are iron posts, remnants of the log slide that traversed the length of the falls. At the base of the chute there are some concrete abutments from the mill, and the remains of the wharf lying on the bottom of the bay.

The mill changed hands over the years, with Mutchenbacker again owning it for periods of time. In 1905 Mutchenbacker sold the land to Jacob Kaufman of Kaufman Furniture Ltd. in Kitchener.

The mill closed in the early 1930s and was dismantled in 1941.

13 CAPE ELIZABETH

Cape Elizabeth was the location of the F.W. Coate family and descendants. If you sew, you'll recognize the Coate name as a brand of thread manufactured by the same Coate family who put down roots in this part of Muskoka. Frederick William Coate, an auctioneer and commission merchant, was on a business trip to the Severn River when he decided to visit an old friend of his, William Lawrason, at the top end of Lake Rosseau. As a result of that visit, Coate bought a considerable amount of land adjacent Lawrason's in the 1870s.

Frederick's eldest son, Charles Buckland Coate, moved to Tennessee after he married, and from there to New Orleans, but each summer he returned to Cape Elizabeth.

The Coate settlement had grown to about ten houses by 1921. At that time the Cape Elizabeth wharf and the Monyca wharf were the only private wharves on the lakes that were listed for scheduled steamer stops. Cape Elizabeth landing was so well known that C.B. Coate

could buy a return railway ticket from New Orleans to Cape Elizabeth and the ticket agents would knew exactly where it was and booked the luggage through direct.

14 MUSKOKA WOODS SPORTS RESORT/LAWRASONS

It's not difficult to see why Julia Lawrason called her home The Beach. The Muskoka Woods shoreline is the envy of of the lake, and it looks particularly inviting with a line of sailboats pulled up on the sand.

William Lawrason had settled here by the early 1870s, in a log home near the creek. (They later built a frame house.) Lawrason died after taking a shot in the leg at a turkey shoot in Rosseau. His wife, Julia, soon after began taking summer visitors into her home.

The log cabin also became Julia's retreat. Here she organized the area's first Women's Auxiliary meeting, patterned after a similar group she'd seen in Ottawa in 1891. The cabin was later incorporated into the summer home of Mr. Arthur McCrae, Lady Eaton's brother. This lovely clapboard cottage, with its gingerbread fret work and multi-paned windows, is now aptly called The Manor House and is still in use at Muskoka Woods. The bowling green of McCrae's era is still visible beside the cedar hedge.

The Christian and Missionary Alliance Church purchased McCrae's property and ran a camp. Then, in 1980, John Boddy took over and set up the John Albert Boddy Youth Foundation. Boddy wanted the camp to provide a Christian focus for youth.

Since 1980 the youth foundation has constantly upgraded the facilities, while making every effort to preserve the heritage of the original buildings. The chapel (to the left of the circular dining/administration building) is perhaps the most unique piece of architecture on the lakes, with a vaulted bulb-shaped roof and one wall made entirely of glass. The chapel is being renovated for use as a conference centre.

The sports facilities at Muskoka Woods are of such repute that Canada's gymnastic team used the camp to prepare for the Seoul Olympics in 1988. The camp has an international reputation and is open year-round, handling some 400 youths at each session.

15 LIGHTHOUSE SHOAL

This is undoubtedly a picture-taking spot. The pretty white and red lighthouse seems to be floating on the water. In reality it sits atop a submerged shoal, which makes it quite impossible to get close to, unless you're in a canoe. Before the government dredged a cut linking lakes Joseph and Rosseau at Port Sandfield, and blasted out the rocks on the Joseph River, the water levels on Lake Rosseau were much lower. The shoal here was actually a small island. Indeed, notes at the Humphrey Public Library say two people were buried here at one time.

According to the Canadian Coast Guard, the lighthouse was established in 1890. The government changed the gas light to one powered by a caustic soda battery in 1961. In 1968-69 they installed a dry-cell battery, and in 1985 a solar panel. The Canadian Coast Guard has maintained the light since 1969.

16 ROSSEAU LAKE COLLEGE/KAWANDAG

Kawandag is an Ojibway word meaning "the meeting place of the pines." The trees that inspired the name are much in evidence on this point, but you can't help but wish the mansion-like summer home of Sir John and Lady Eaton were still here.

If you know what to look for, though, you can still spot the vestiges of the Eaton years. On the south shore there's the sandy beach with its sod-roofed bathhouse, where the Eatons changed into their swimming costumes. Then there's the steamer wharf with its dollhouse-like pavilion, designed to protect the ladies from the rain and sun while they waited for the

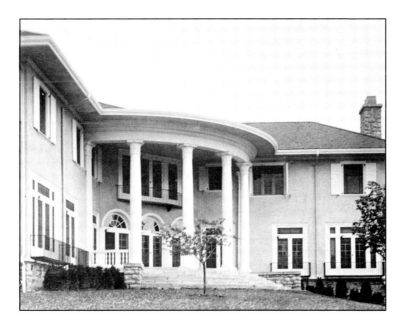

Kawandag, the Eatons' summer estate.
(Evelyn Longhurst)

steamboat to arrive. The cribs of the boathouse are visible in the water beside the wharf.

Directly behind the wharf are stone steps leading up through the pines to the lawns of the former estate. Lamp standards, now rusting and globeless, once lit the stairway in the evenings. The Eatons' perennial garden, with its rock pools and terraced banks of flowers, are now overrun. Today the modern, ground-clinging buildings of Rosseau Lake College take the place of the mansion that looked out over the lake.

The estate was a truly grand one: Scottish stonemasons built the foundations and fireplaces, craftsmen from Europe installed the interior woodwork. There was a room to watch the sun rise in, and one to watch the sun set. The spacious grounds included tennis courts and a golf course. There were stables, of course, as the Eaton boys loved their horses and often rode up from the family farm at King City in the company of the man who looked after the stables. Lady Eaton also had a pretty log cabin, her retreat, which is still standing on the college grounds.

Sir John Eaton died in 1922. Lady Eaton sold the property in 1945, having purchased Snug Harbour, across the lake.

For a while Kawandag was run as a posh resort. In the 1960s some entrepreneurs transformed the grounds into a frontier outpost called Fort Kawandag. The fort failed after only two seasons.

The idea to create a private school at the Kawandag site took shape in 1966, and the school was founded in 1967. Rosseau Lake College now offers students an alternative to conventional classroom study through a challenging program that incorporates an outdoor emphasis. The Eaton mansion, which housed the school's library and lounge, burned in 1973.

17 ELEPHANT'S HEAD
The name comes from a rock formation that looks like the brow of an elephant, on the Rosseau side of the point (near the college's sailing dock). It looks as if the elephant is rising out of the lake with part of his trunk is still underwater. The profile is best seen from the Rosseau side.

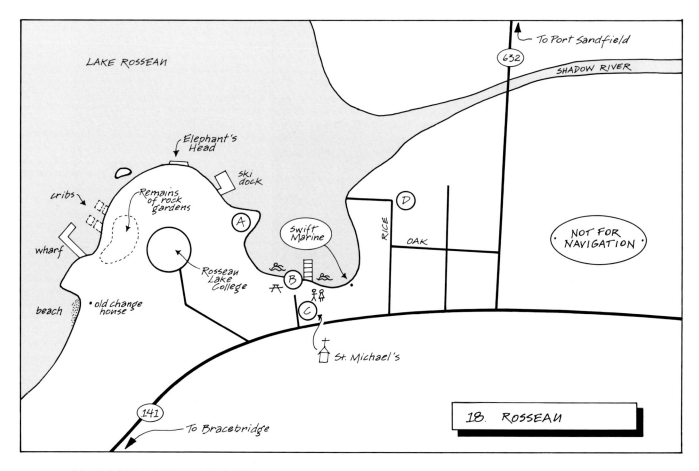

18 ROSSEAU WATERFRONT

In 1860 there wasn't much to Rosseau. If you paddled into the bay you'd find Abram Asey's bark wigwam. He was the only individual living on Lake Rosseau at the time. Edward Clifford was the first white settler. Around 1863 he and a trapper called British Bill owned most of what is now the village of Rosseau. Then came Ebenezer Sirett, "the Squire," who sliced himself a huge section of free grant land near Ashdown Corners. The Beley family, who have a point named after them, followed Sirett.

Ashdown Corners, the junction of the Nipissing and Parry Sound roads, served as the focal point of settlement in the pre-steamboat days. The community had a store, hotel, church, post office and Orange Hall at a time when Rosseau was merely a drawing of a town plot on an official map.

The arrival of the steamboats, coupled with the establishment of Muskoka's first "getaway resort," quickly shifted the focus to the waterfront, and Rosseau usurped Ashdown Corners' role as village centre.

Officially, the settlement's name was Helmsley. But the owner of the resort, William Pratt, wasn't much taken with that name, nor did he like seeing mail arrive at his wharf, only to be hauled inland to the post office at Ashdown Corners. He petitioned for a new post office to be opened in his hotel, Rosseau House.

When the hotel burned in 1883, the post office moved to William Ditchburn's house. The post office stamp, with the word "house" filed off, continued in use in the new location. They say this postal stamp was partly to blame for the village being called Rosseau, even though it was officially Helmsley on land deeds until 1926. Rosseau was incorporated as a village in that year.

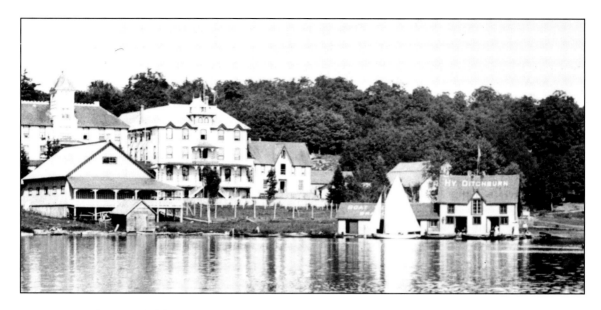

Rosseau waterfront. Dithchburn's boat livery and Monteith House. (Peter Wood photo)

A IMMIGRANT SHED

Rosseau claimed the title "Gateway to the West" because so many of the Prairie-bound immigrants passed through the settlement. A four-room structure on Elephant's Head Point provided shelter. Later, when Henry Ditchburn acquired the property, he rented it out to summer visitors, calling it Bay Point Cottage.

B DITCHBURN BOAT LIVERY

By choosing Rosseau as their homesteading ground, the Ditchburn brothers had unwittingly landed in the very part of Muskoka where events would conspire to put men with boatbuilding skills in a propitious position. The construction of the area's first major resort, Rosseau House, created a demand for recreational boats.

John, William, Henry and Arthur Ditchburn came to Canada in 1869 with funds provided from their mother's estate. When the estate funds were lost through bad investment, the brothers had no choice but to stay. Still, they seemed to revel in the adventure of the new land, learning how to hunt for deer and care for livestock. They purchased the point of land known as Kawandag (later sold to John and Flora Eaton).

Henry was the driving force behind the boatbuilding business. As early as 1875 he had a fleet of boats for hire at Pratt's Hotel. Later he set up liveries at all the major resort locations on the lakes: Rosseau, Windermere, Port Cockburn, Port Sandfield and Port Carling.

Always putting himself in the most advantageous position, Ditchburn moved his head office to Muskoka Wharf station in Gravenhurst around 1890.

C MONTEITH HOUSE

While there's not much to indicate the hustle and bustle of the old days, the intersection of Highway 141 and the town dock road was the centre of town in the early days. Even before Monteith's three-storey hotel crowded into its spot at the foot of the hill, there had been a stopping place of some sort here. The first was John Beal's log tavern, called the Ro Seau Hotel (the word "hotel" being a bit of an overstatement in this instance). The log cabin changed hands many times, growing into a pretty two-storey frame building.

John Monteith bought this building in 1878 and put up a large three-storey addition facing the lake. Later he built a dance hall where guests could fox-trot across "the best dancing floor in Muskoka" or step out on the verandah to drink in some of the cool night air. The dance hall was located where the marina's boat-storage sheds are today. Monteith's sons, Arthur and Bert, continued the hotel business after their father's death. From 1938 to 1950 the Shopsowitz family, of Shopsy's Meat fame, owned the hotel. It burned in November 1950.

The little church you see behind the Rosseau government wharf was part of the Monteith House complex. This was originally John Monteith's butcher shop, and later a staff house.

D PRATT'S HOTEL/ROSSEAU HOUSE

William H. Pratt, a jovial New Yorker who was game to try a new idea, took a tour of the lakes with A.P. Cockburn in 1869 and decided to open a resort at the top of Lake Rosseau. The remoteness of the location was part of the appeal. It seemed there were people willing to pay exorbitant prices to go as far away from civilization as possible, provided they had all the comforts of home once they got there. Pratt charged $5 a day, at a time when the average wage was $1 a day.

He opened the hotel in July 1870, winning praise from the press for setting up the finest hotel in Ontario. Pratt's witty nature earned him quite a reputation. W.E. Hamilton described an incident where an English guest tried to find something Pratt could *not* bring him (this in response to Pratt's remark, "We have everything here you can call for"). The Englishman thought he'd caught Pratt up when he asked for a bottle of double seltzer water — hard to come by, even in England. "Certainly," said Pratt, and produced the seltzer, which had been sent by mistake in a shipment from Toronto. Hamilton says, "The sight of it caused the guest to wonder and collapse."

Pratt attracted considerable clientele from England and the southern United States. In fact, the resort had some 40 guests from the South in residence when the building caught fire in October 1883.

19 SHADOW RIVER

> The little fern-leaf, bending
> Upon the brink, its green reflection greets,
> And kisses soft the shadow that it meets
> With touch so fine,
> The border line
> The keenest vision can't define;
> So perfect is the blending.
>
> The far, fir trees that cover
> The brownish hills with needles green and gold,
> The arching elms o'erhead, vinegrown and old,
> Repictured are
> Beneath me far,
> Where not a ripple moves to mar
> Shades underneath or over.

Excerpt from "Shadow River"
by Pauline Johnson

Shadow River, Rosseau

If you have a canoe or rowboat, you can poke your nose up the Shadow River, once called White Oak Creek. The river received its name because of its reflections. Surveyor Vernon Wadsworth said, "I named the creek at the head of Lake Rosseau White Oak Creek from the prevalence of white oak trees that lined its banks. Tourists have since named the creek Shadow River, and indeed the shadows displayed are wonderful."

It was here that poet Pauline Johnson took the famous canoe ride which inspired her poem "Shadow River." Johnston was the daughter of a Mohawk chief and an Englishwoman. She and her school friends spent some idyllic summers camping in Muskoka, and Johnson wrote several poems about the area. (Contrary to local belief, "The Song my Paddle Sings," Johnson's most famous poem, was not written in Muskoka.)

20 CAMERON BAY: STARTING POINT FOR THE NIPISSING COLONIZATION ROAD

A private cottage lot at the end of Cameron's Bay marks the starting point of what was an important thoroughfare in pioneer days. The Nipissing Colonization Road ran 107 kilometres (66 miles) from Cameron's Bay to Nipissing. Colonel Cameron, whose name is attached to the bay, took part in the construction of the road. The government of the day hoped it would stimulate settlement in the northern districts. Work began in 1866, but it took a long time to reach Nipissing. Not until 1875 could wheeled traffic actually use the road over its full length.

In pre-steamboat days, northbound settlers rowed up Lake Rosseau to Cameron's Bay. When the steamboats appeared on the upper lakes, Rosseau became the disembarkation point. The construction of a railway from Gravenhurst to Callander in 1886 made the Nipissing Road unnecessary. Today the bush has reclaimed its hold on much of the right of way. A plaque marking the road's starting point has been mounted in the rock near the boathouse at the top end of the bay, on the north side.

21 SNUG HARBOUR

In 1987, when Prince Andrew brought his young wife, Sarah, to Canada for their first official visit, the rumour mills speculated that they would secret themselves away in Muskoka. Those stories, coupled with the unmistakable presence of security personnel in and around Rosseau village, had people ready to give their eyeteeth to know exactly where Andrew and "Fergie" were. Well, the guessing stops here, at Snug Harbour. The royal couple were, in fact, in the McEacherns' pink cottage, right on the waterfront.

It's not a cottage you can miss. It seems to celebrate the lakefront setting with its casual beach-house style and bubbly pink hue. Of course, the main cottage, which is hardly visible behind the trees, is a solidly beautiful stone house; tradition still has a firm foothold at Snug Harbour.

Col. Frank McEachern had much to do with overseeing Andrew's school years at Lakefield College in Peterborough. McEachern's wife is Florence Mary, daughter of Sir John and Lady Flora Eaton. Snug Harbour succeeded Kawandag as Lady Eaton's summer home,and it was she who had the pink cottage built.

22 FORMOSA ISLAND

Anyone reading the 1918 *Muskoka Lakes Blue Book Directory and Chart* might do a double-take on spotting the owner of Formosa Island: Woodrow Wilson, president of the United States. Wilson discovered the beauty of Muskoka before becoming president. He stayed at The Bluff, Rest Harbour, in the early 1900s and subsequently purchased Formosa Island.

While he kept the property for some years, Wilson stopped coming to Muskoka after 1910, when he was elected governor of New Jersey. He became president of the United States in 1913. In 1914 the Muskoka Lakes Association invited Wilson to become a member. He wrote back that he did not feel he should, as he could not take an active part. (The MLA auctioned off the letter for $15 in 1915.)

Shortly before he died, Wilson reminisced about Muskoka with his daughter: "Do you remember our picnics there," he said, "and your mother reading poetry under the pines?"

23 ERNSCLIFFE HOUSE, JUDDHAVEN

A modern summer estate, with dramatic lines and concrete construction, marks the site of Ernscliffe House, in the area known as Juddhaven. Francis and Ann Judd came to Canada in 1875 with eight children, ranging in age from 1 to 21. When they located their land, they found they had 200 acres of rock. They moved into a trapper's shanty and set to work building a house. The trees came from the islands because there were no pines on their property. Francis called his home Juddhaven.

Of the Judds' many children, only two stayed in Muskoka, Alfred and Ralph. Alfred married a schoolteacher and they built Ernscliffe around 1890. Their son Bernard carried on the hotel business after Alfred died. In the 1960s the Redemptorist Fathers bought the site for a retreat. It changed hands again and eventually burned.

24 ROYAL MUSKOKA

Looking at an aerial photograph of the Royal Muskoka Hotel you'd be excused for thinking a spaceship had skidded to a halt in the pine trees. Two rectangular wings angled out from the round hub of the resort, which had enough turrets to shame a fortress. You can't help but be impressed at the audacity of the man who designed it. Certainly there was nothing on the three Muskoka lakes to match it for scope and grandeur, except perhaps the Muskoka Sanatorium in Gravenhurst.

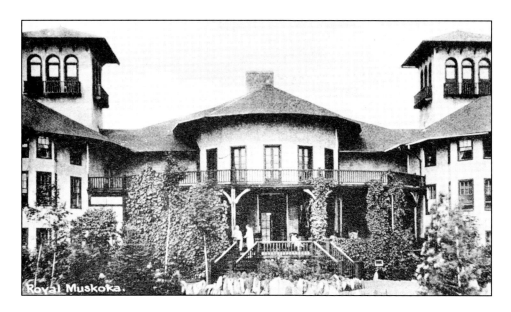

Royal Muskoka

The Muskoka Lakes Navigation and Hotel Company built the hotel in the first years of the 20th century. A brochure claimed the Royal Muskoka to be "the largest, best equipped, and most comfortable summer hotel in Canada, with a cuisine of the highest order of excellence." The company seemed to spare no expense creating spaces so expansive that groupings of 25 wicker chairs could still look lost in a foyer. Mind you, by today's standards, the rooms would seem rather sparsely furnished: narrow iron beds, airy wicker furniture, and windows with simple pull-down blinds.

Within the calm, grey stuccoed walls, fiddlers and harpists played in the minstrel galleries while great logs burned in the fireplace. You could idle your time away on verandahs that seemed to stretch on forever or stroll down to the steamer dock on a pathway paved with tanbark. A line of bathhouses opened onto the shaded beach.

Keeping the big hotel open during the Depression meant there were more waiters and chambermaids than guests at times. The hotel became a millstone around the navigation company's neck, drowning any profits the boats made. After the Second World War, Gordon Douglas Fairley took the hotel over and made a valiant attempt to bolster its image, to no avail. Then, in May 1952, the hotel burned. Today the property has been subdivided into cottage lots. The water tower alone stands vigil above the treetops, reminding people that in its shadow a once-proud hotel looked out over the lake.

25 THE BLUFF

The bluff that gave its name to the resort is visible as a rocky scar on a leafy hillside. To the left of the scar, there's a cottage sitting in about the same spot as the Snows' hotel. Thomas Snow built The Bluff around 1902. His wife, Victoria, wrote a column in the *Canadian Countryman*. Thomas's interests included painting and poetry. Woodrow Wilson holidayed at The Bluff several times before he became president of the United States.

If you're cruising past this spot on the RMS *Segwun*, the captain will likely remark that people took great delight in claiming, on a scorching summer day, that they could show you a spot where there was six feet of snow. Thomas was a tall man, so the claim was indeed true.

The hotel burned in 1934.

The Lang Estate

Summer chairs at Clevelands House

26 MORINUS HOTEL

Spot the tiny red turret on the waterfront building and you'll have pinpointed the Morinus Hotel site. Actually there were two hotel buildings on the property, one about where the turret building is now, and another further back from the water. The original resort, since burned, belonged to William McNaughton. The property is now Camp New Frenda, run by the Ontario Conference of Seventh-Day Adventists, Oshawa. It's a co-ed, vegetarian camp that offers a wide range of programs. There are weeks for teens and weeks for younger children, as well as camps for family groups, for the blind, and for those needing rehabilitation. The program includes horseback riding, BMX bike racing, mountain-climbing skills, archery and the usual waterfront activities. Camp New Frenda is open in the winter, too.

27 ST. JOHN THE BAPTIST CHURCH, VICTORIAN ROCK

The twin spires of St. John the Baptist church are a landmark on the lake, peeking above the treetop like candles on a birthday cake. William McNaughton, who owned the adjacent property, gave the land to the local Roman Catholic mission in 1899. In the next two years the local residents raised money and built the church, which was blessed by Bishop O'Connor on July 22, 1902. In the 1950s Father O'Leary set about enlarging the church and adding oil heating and an electric organ.

From the ample docks at the base of the church you can see the silhouette of Queen Victoria's face in the rock outcrop just west of the dock. The phenomenon is best viewed by piloting your craft close to the shoreline or stopping your boat at the dock.

28 THOREL HOUSE

The pretty stone wall that runs along the shoreline distinguishes this property. The grounds are both extensive and immaculate, stretching out of view of the waterfront. This beautiful retreat, owned by the Langs, was once the site of Thorel House, a modest summer hotel built by George Thorel around 1914. George and his wife, Elizabeth, came to Canada from England in 1886. They settled at Barnesdale, on Lake Joseph, where George's sister Gabrielle Barnes was living. After spending some time in the West, the Thorels returned to Muskoka and bought this property in 1894. Thorel House was torn down in 1970.

29 TARTAN HOUSE

The grassy slope you see on the mainland behind Duck Rocks was the grounds of Tartan House resort, originally called Edina Beach.

The Besley brothers, George and William, settled here in 1868 and ran a sawmill for a short time in this location before moving to Port Carling. In 1926 Peter Nicholson purchased the property and established Edina Beach Lodge, which he sold to Edward McLean in 1966. The McLeans renamed the lodge Tartan House. The resort has since been torn down.

30 PAIGNTON HOUSE

J. Frederick Pain came to the Lake Rosseau area in 1869. He was a rather well-to-do Englishman, born in Calcutta. When the doctor advised him to move to a colder climate to ward off his bouts of malaria, he thought of his acquaintances the Wrenshalls and the Besleys, who had taken up land on the shores of Lake Rosseau. He moved to this spot in the 1870s after trying out some other locations in the area. In 1884 he married Martha Tuck, and together they built up a resort business which they called Paignton House after Fred's birthplace, Paignton, England.

Fred's son Dick carried on the business after his father retired in 1918, and the business passed to Dick's sons, Archie and John. The Pains ran the resort until the 1970s. The resort is now operated by the Granite Group.

31 CLEVELANDS HOUSE

Life was not easy for Charles and Fanny Minett when they first came to Muskoka. The land had to be cleared, a garden plot established, the home built. To keep their cow from starvation, they hauled grass on their backs from the beaver meadows. Such were the struggles of establishing a farm in Muskoka.

Charles and Fanny left England soon after they married. Charles worked as a cabinetmaker in Toronto for a couple of years, but the damp weather irritated his bronchitis, so he headed for the free grant lands of Muskoka in 1869.

The Minetts cleared the land and began taking in sportsmen as boarders. Seeing how popular the lakeland was becoming, they decided to forgo building a barn and put up a larger house instead. That house, with various additions, became the Clevelands House we know today.

The long wharf has been a focal point at Clevelands since the steamers first began to call. As all his guests arrived by boat, Charles wanted his hotel to look like a ship. That's why, when it came time for him to add a third storey, he incorporated a mansard roof and octagonal tower, which resembled the pilothouse of a very large lake steamer.

During the construction of this addition, in 1891, Charles fell and received injuries that eventually led to his death. The second-generation Minetts built the North Lodge, or annex, in the spot where the family's first log home had been.

From 1953 to 1969 the resort became a top-notch recreational facility, with a small golf course, tennis courts and horseback riding. Bob and Fran Cornell, the present owners, have expanded these recreational facilities, making Clevelands House one of the liveliest and largest resorts on Lake Rosseau.

32 CHELTONIA HOUSE

The *long, white* "Terrace" unit at Clevelands House waterfront sits where Fraling's general store used to be. William and Louise Fraling's house is still standing, on the slope behind the Terrace unit. They called it Cheltonia, after a village in England. The turn-of-the-century building is now an accommodation unit at Clevelands House.

33 WISTOWE ISLAND

The English mystery writer Algernon Blackwood recorded these words about Wistowe Island in *Episodes Before Thirty*: "The Muskoka interlude remained for me a sparkling, radiant memory, alight with the sunshine of unclouded skies, with the gleam of stars in a blue-black heaven." The island provided a refuge for Blackwood after the embarrassment of a failed business venture in Toronto around 1890.

Blackwood stayed in a cabin that later became the beach house. It had "two camp beds, a big table, a side balcony and a tiny kitchen in a shack adjoining." One look at the main cottage on Wistowe today and you know times have changed. It is a typically roomy summer home, with basswood walls and ceilings, and an elegant central stairway. F.J Phillips built the cottage around 1911.

Mr. Edgar B. Whitcomb, a real estate agent and founder of Detriot Brass, succeeded Phillips as owner in 1913. Whitcomb had his own steamboat, the 70-foot *Rambler*, to carry him back and forth to the mainland. The servants were dispatched to the island a day ahead of time to prepare for the family's arrival from Michigan. The cook's diary is still at the cottage. While she revealed no secrets, she faithfully set down the meals and special arrangements that were needed to effect the smooth running of the household.

Efficiency seems to be the watchword of the Whitcomb household, and it is said that Edgar would not tolerate tardiness, to the point of leaving his own wife stranded at the Port Carling dock if she were not back from her shopping trip at the appointed time.

Whitcomb had a phobia about fires and kept glass jars filled with carbon tetrachloride close at hand to throw at the blazes, should they occur. He also installed a sprinkler system in the kitchen and had stairs out his bedroom window to the roof. All windows had hefty ropes set at the sills and his guests learned how to vacate the premises quickly through the practice of fire drills.

Mr. Whitcomb left the cottage and island to the Episcopalian Church in Detroit. Eleanor Killam Wilson purchased the island in August 1954. Her son Henry Wilson now owns Wistowe.

While the *Rambler* is no longer in her berth at the Wistowe boathouse, the passenger launch *Lady Elgin* has found a new home here. This is appropriate, as the *Lady* started out at Wallace Marina, not far away. The Ditchburn company built the *Lady Elgin* in 1927 for Henry Wallace. The Wallaces operated a jitney service and took tourists on scenic lake cruises. The *Rambler* is still on the lakes, and owned by Tim Chisholm, Stepping Stone Island.

34 WOODINGTON

Michael Woods was running from the complications of city life when he came to Muskoka in 1882, some say for his health, others for a less harried lifestyle. He was a warden at the jail in Toronto, and, according to local historian Violet Jocque, an ex-convict had threatened his life. He and his wife, Charlotte, moved to Lake Rosseau and put up a two-storey log home called Fair View Farm. This was a more or less productive farm, producing milk, eggs and vegetables.

The Woods also took tourists into their home, and Michael added to the family coffers with work as a game warden and justice of the peace. It wasn't until 1894 that he built Woodington House on the hill overlooking the lake.

The resort has been held in time like Miss Haversham's wedding table in Dickens' *Great Expectations*. It is indeed cobwebbed and faded, and its second storey gapes above the treetops, windows forming a toothy grin. This is what turn-of-the-century resort hotels were like: big, rambling places, with plain rectangular bedrooms (33 on the second floor and 32 on the third), pull-down blinds, and great big verandahs to sit on. That's what makes Woodington House special and why boats pull up to see the "ghost hotel."

But it is far from uninhabited. Steve Rooney, his sister Anne McCabe, and other members of the family use it as a cottage. The Rooneys purchased the resort from Blair Ashmore in 1973. Ashmore, who had worked at Woodington, ran the resort from 1965 on, having purchased it from Michael Woods' daughter, Nancy May Anderson.

35 THE MUSKOKA LAKES GOLF AND COUNTRY CLUB

The water tower at the Muskoka Lakes Golf and Country Club is a landmark on the lakes, looking very much like a small rocket held aloft in a tree-shrouded gantry. Perhaps the most interesting thing about the golf and country club is that it wasn't meant to be a golf course at all, but a children's hospital. The story starts in 1912, when Lillian Massey Treble purchased Cedar Island with a view to building a children's hospital in an invigorating environment. Soon afterwards she acquired the west half of the Norrie farm for a landing.

Following the purchase of the farm, she had a road put in. Workmen built a large boathouse for her 75-foot steamboat, the *Minga*, and a bungalow with rooms for staff. (The ballroom/pavilion of the clubhouse — the part that projects out over the water — was originally the *Minga's* boathouse.)

She employed Stan Fairhall to keep Lillywood Farm operational and went ahead with the installation of a waterworks and sewage system for the hospital, which was to be built on today's tenth fairway. But the dream of a children's hospital died when she did, in 1915.

Muskoka Lakes Golf and Country Club. INSET: Well-dressed golfers in the early 1900s.

In 1919 Colonel J.R. Moodie, Charles Wheaton and James Hardy purchased Lillywood for $15,000 with plans to turn it into a golf and country club. That plan became a reality in January 1920. The club purchased the rest of Mr. Norrie's farm for fairways and greens.

The club was an immediate success and became, as it still is, the focal point of social activities for cottagers, many of them the monied, influential members of their respective towns and cities. It's not surprising, then, that the club was able to "buy" a Spitfire bomber for the war effort ($25,000) and raise money to set up three mobile canteens (each $2,600). During the war years the ladies of the club brought their sewing machines to the clubhouse and churned out bandages, mine-sweeper mitts and other items.

Today memberships at the club are a hot item. "There have been people on the [waiting] list for eight years," one member says. "And they may be on it for as long as 15 years."

36 WORTHINGTON POINT

The name Worthington honours one of the early owners of the point, Mary Worthington. The point was originally part of William Norrie's farm.

In 1909 J.J. McLaughlin purchased the property. J.J invented the original Canada Dry formula. His father was Robert McLaughlin of McLaughlin Carriage Company, the forerunner of General Motors. J.J's brothers, George and R.S. (Robert Sam), continued on in the horseless carriage business, overseeing the production of the famous McLaughlin Buick. (When George and J.J. came up to Worthington Point, the trip from Oshawa took nine and a half hours in the McLaughlin Buick.)

George McLaughlin's granddaughter, Mary Hare, and her family carry on the family ties with Muskoka. Her summer home is on Sunnyside Island.

Charts of Lake Rosseau show a seaplane landing at the base of Worthington Point. This operated from the early 1950s to about 1984 under the name Red-Wing Flying Service. The company conducted chartered and scenic flights and sold airplane fuel. The hanger is still there, though not in use.

37 FERNDALE

Few properties on Lake Rosseau can capture the imagination of a writer like Ferndale can. Perhaps it's because this spot belonged to Seymour Penson, a man who, even in his death, seems very much alive because of his drawings and manuscripts. Penson illustrated the 1879 *Guide Book and Atlas of Muskoka and Parry Sound Districts* (the number-one reference for Muskoka researchers). When you pore over his revealing memoirs in the archives, the trappings of the reading room seem to fade away and you are instead in some Edwardian sitting room, chatting with an elderly gentleman who knew "the scoop" on the early Muskoka pioneers.

The Pensons came to Muskoka from London in 1869, having agreed to take land in Macaulay Township: "We were going to settle on land that we had not examined and we were going to risk our entire future on the bare assertion of Messrs. Bird and Squirrel that there was good land back out of sight, still this was only what hundreds of men from the British Isles did when these lands were being settled. If any of us had strayed a hundred yards from the blazed trees we should have been totally lost, and so would Bird and Squirrel; and if we had travelled the lots from end to end I doubt if we should have been much wiser, for the thick mat of leaves that covers the floor of a northern forest, and the difficulty of seeing the rocky ridges in the thick timber, would probably have deceived our inexperienced eyes."

Fortunately the Pensons met a man who told them the land they were about to take was no good. This same man suggested they'd find better land if they struck out for Medora Township on Lake Rosseau. This the family did, pitching a rough tent of hemlock boughs at the end of a bay. "Around about where we camped we found many ferns, which gave my mother the idea of calling the place Ferndale. It was a pretty name and seemed suitable, so we adopted it at once," Penson wrote.

While Seymour pursued his artistic career, finding work painting large backdrops for theatrical sets, around 1880 his father and mother opened a tourist resort on the point. Seymour took this over for a time, then sold it to John Cope.

In 1926 Canadian Keswick purchased the resort, running it as a Christian retreat. On the north shore of the point there's a terraced "amphitheatre" built into the slope overlooking the beach. Here outdoor services were held every morning.

Ferndale's main building burned in the mid-1940s and was rebuilt. Many new buildings went up at this time, one of them a chapel.

Canadian Keswick filed for bankruptcy in 1976. The property had lain idle for some years when Wayne Skinner announced to the local media in January 1984 his plans to create a splashy new resort, Lake Rosseau Village Inn, destined to become the Las Vegas of the North.

By the spring Skinner's project had already turned sour, leaving the Toronto Board of Education Teachers' Credit Union crying fraud. They'd sunk $11 million into the project. Lake Rosseau Inn grounded in a mire of lawsuits. Out of view of the waterfront, the half-finished recreation complex, with its steel girders exposed to the elements, began to look like a ruin.

In 1989 Hunter Milborne publicized his plans to create a condominium project in an "Old Muskoka" theme, a plan that could breathe life back into the beautiful and historic headland.

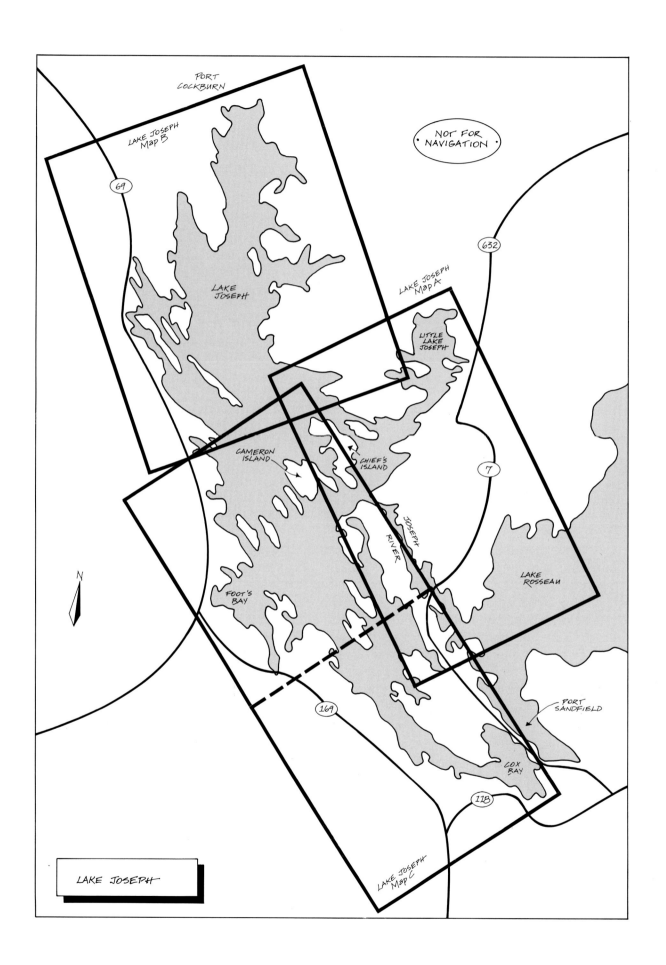

PORT
COCKBURN

LAKE JOSEPH
Map B

69

LAKE
JOSEPH

NOT FOR
NAVIGATION

632

LAKE JOSEPH MapA

LITTLE
LAKE
JOSEPH

7

CAMERON
ISLAND

CHIEF'S
ISLAND

JOSEPH
RIVER

LAKE
ROSSEAU

N

FOOT'S
BAY

PORT
SANDFIELD

169

COX
BAY

118

LAKE JOSEPH
Map C

LAKE JOSEPH

CHAPTER 6

Lake Joseph and the Joseph River

"It will be noted that the waters of all the other lakes and rivers of Muskoka are, although translucent and clear, yet of a dark or tawny hue, while, strangely enough, those of Lake Joseph are a clear white. Its islands, too, rise perhaps more abruptly, and to higher elevations, and more rugged cliffs line its shores, than do those of the other lakes. Backed by these peculiarities, the inhabitants of the Canton of Lake Joseph claim for it a beauty surpassing that of all the others."

The Northern Lakes of Canada, 1886

There's something different about Lake Joseph. The waters are not blue-black as in lakes Muskoka and Rosseau. They are, instead, slightly green, in places almost clear, veined with sun ripples that go farther down than you'd think possible in what is the smallest but deepest of the Muskoka lakes. The Indian name for Lake Joseph was Obwadgwajung, "The Clear Water."

And then there are the islands, scattered about as if God had sown them like seeds on the surface of the lake, some only three trees wide, others arching out of the water like giant whales, each with a "peek" of grey rock at the waterline and mounded with pine.

Of the three lakes, Lake Joseph is the least assuming. Life seems to proceed at a quieter pace. The cruise boats don't cruise here. It's further away and the daytrippers, frankly, aren't interested (they want to see Lake Muskoka's Millionaires' Row and Lake Rosseau's Windermere House).

All this is a blessing to the people on Lake Joseph, who know the secret places on her shorelines — and there are many of them, including the prettiest channel in Muskoka, a hidden rock pool, and the wreck of a steamship still clearly visible in the water.

JOSEPH RIVER

1 GREGORY POINT

Judging from written records, William Gregory-Allen was an unwilling immigrant. The Gregory family owned an estate in North Wales. When William married his mother's maid, his family paid him a remittance to keep him out of the country. Seymour Penson says of Gregory-Allen: "He was a remittance man and his remittances were sufficiently strong and regular to enable him to get the work done for him."

The Gregorys received an inheritance in the 1890s and at that time added the word Allen to their name. William ran the post office at Gregory from 1880 until his death in 1906.

His son Richard built Golpha House on the south point of Gregory Bay. When the family moved out west around 1915, Richard sold the hotel to Mrs. L.T. McKinley, who called it the Nepahwin-Gregory, intriguingly advertised as a "summer and winter resort" in 1918. Also highlighted in the Nepahwin-Gregory brochures were a casino, telephones and electricity — the latter being a first for a Muskoka resort.

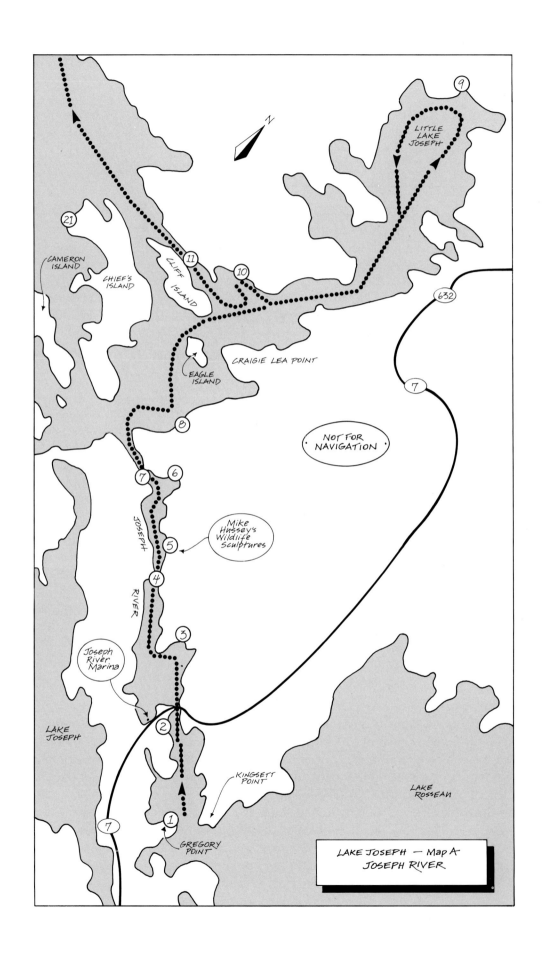

2 GREGORY GOVERNMENT WHARF/CHRIST CHURCH

The government wharf is easy to miss as you're heading up the Joseph River. It's on the west shore, just before you get to the Joseph River bridge. The wharf has a green-roofed shelter on it. From here you can walk up to Christ Church and wander around its interesting and well-kept grounds. The church building dates to 1890, on land donated to the Anglican Church from Michael Doyle in 1889.

3 THREE TREE HOUSE/HENRY HOMESTEAD

The family home at the Boathouse Marina location belonged to Thomas Henry. Henry, a Scotsman, ran a store in London, Ontario before moving here in 1883. Charles Ames helped him move into an existing house on the property, doing the job for "$2.25 and some onions."

The house burned and Thomas rebuilt around 1890. This building is still standing, though there have been additions over the years. The Henrys had planned to raise sheep, but the notion did not pan out. Instead, they turned their home, Clover Hill Farm, into a resort. When G. Morton Henry took over his father's business in 1921, he changed the name to Three Tree House. (Three pine trees used to stand on the point.)

In addition to renting rooms, Morton Henry built boats in the rooms above the boathouse. His daughter Isabel represents the third generation of Henrys in the family homestead. She and Bill Ingram opened a marina here in 1970. Bill is an RCAF officer who "retired and went to work," as his wife says. The Ingrams' son Mike and their grandchildren also take an active part in the business.

4 THE NARROWS

The Narrows is an appropriate name for this part of the river. You feel you could reach out and touch the shoreline. At various times over the years the Department of Public Works has attended to this section to make a navigable passage.

5 MIKE HUSSEY'S WILDLIFE SCULPTURES

The Husseys' home is just what you'd expect an old Muskoka cottage to look like. A gentle slope of green grass leads up to an inviting verandah with old-fashioned screen doors. George Caldwell had the house built in 1917. He'd come to Muskoka as a schoolteacher and married a local girl. Mike and Pauline Hussey represent a new breed of immigrant "settlers." A vacation trip to Algonquin Park in 1973 left such an impression on the pair that as soon as they got back to Wales, they arranged to move to Canada permanently. They worked for a while in Toronto (Pauline as a freelance accountant and Mike in engineering management) then they left their mainstream jobs altogether. They got into carving "by accident" when they bought some machine-carved ducks at a Toronto furniture store, painted them and put them in the antique shop they'd set up in their Joseph River home. The birds were nothing special, but they attracted a lot of interest. Mike figured he could do a better job and started carving his own birds, with Pauline doing the painting and finishing. Gradually the carving took over the antique business. Today they've established an international reputation. Their work is especially well received in Asia, where it has been presented to dignitaries in China and Japan. The Husseys' studio is open seven days a week, from 9 to 5, throughout the summer.

6 AMES HOMESTEAD

Charles Ames, a.k.a. Karl Omyck, took on an Irish-sounding name when he arrived in Quebec with his mother and father in the 1850s. Mr. Omyck thought an Irish name would stand the family in good stead in the colonies. The Ameses moved to Rockton, Ontario and from there to the Joseph River in 1869. A shoemaker by trade, Charles established a farm on the property adjacent the creek. He also ran a sawmill from 1888 to about 1915. A grey boathouse in the bay marks the Ames property. Behind it is the Ames home, built in 1887.

7 THE ROCK CUT

The earliest recorded reference to a waterfall on the Joseph River is found in David Thompson's field notes of 1837. He describes them as a small fall of about 18 inches high and 50 feet wide, over a face of smooth, grey rock.

It appears the first blasting of rocks took place some time in the mid-1870s, leaving a cut just wide enough for a rowboat. By 1897 a channel 25 feet wide and 4 feet deep had been provided at The Cut, and boulders removed from the river bed at The Narrows. The Public Works Department continued to make improvements over the years, particularly in 1915, when they widened and deepened the boat channel. There is also evidence that some of the more well-to-do summer residents put up money to make the channel wide enough for bigger steamboats.

WATER COLOUR AND CLARITY

The colour of lakes is influenced by the amount of suspended or dissolved material in the 3water. Water with little suspended matter in it will absorb all colours but blue. The blue colour is reflected back from the water, making it appear that colour.

Lakes that are nutrient-rich appear brown, and lakes that contain suspended pulverized rock appear chalky white. Lakes Muskoka, Rosseau and Joseph are classed as oligotrophic (nutrient-poor) lakes, and therefore fairly clear.

MEASURING CLARITY

Although the name "Secchi disk" sounds like some high-tech machine, it is really a white plate on a string. Secchi was the man who first recorded the clarity of lakes by tying a rope to a plate and lowering it into the water until the plate disappeared from view. The same principle applies to Secchi depth reports today, which show that Lake Joseph is the clearest of the Big 3 Muskoka lakes.

SECCHI DEPTH (1988)

Lake Joseph: 7.4 metres
Lake Rosseau: 6.4 metres
Lake Muskoka: (not including Muskoka Bay and Gravenhurst Bay) 5.1 metres
Muskoka Bay: 3.6 metres
Gravenhurst Bay: 3.8 metres

CLARITY AND ACID RAIN

It's no secret that Muskoka is one of the areas hardest hit by acid rain, that chemical brew produced when smelters and coal-fired generating stations spew sulphur dioxide into the atmosphere. Muskoka's lakes are susceptible to acidification because the Precambrian bedrock lacks sufficient buffering ability to counteract the effects of acid rain.

Acidification lowers the amount of dissolved organic carbon in the lakes, making them appear clear. But researchers are also quick to point out that not all clear lakes are acidic. Some lakes are clearer than others because of the bedrock they're in, or because they have a larger drainage area, with less swamp water flowing into them.

The historic references to Lake Joseph as "the clear water lake" suggest that its clarity is a function of its natural situation.

Considering the acid rain that falls on Muskoka, the Big 3 lakes are coping pretty well. The Ministry of the Environment classes them as "moderately sensitive to acidic deposition." Their pH is around 6.8, which is about as non-acidic as Muskoka lakes can get.

pH (HIGHER THE pH, THE LOWER THE ACIDITY)

Lake Joseph: 6.75
Lake Rosseau: 6.83
Lake Muskoka (main part of lake): 6.79

Tennis players at
Carlingford House.
(Betty Salmon)

8 CARLINGFORD GOVERNMENT DOCK

This has to be the most intriguing bit of public access on the Muskoka lakes — not over a gravel road, nor even a laneway, but across a smooth rock face. With no shoulders to delimit the public right of way, people have painted white lines on the rock to show the edge of the "road" down to the government dock. Step outside those lines and you're on private property.

In earlier days this was the wharf for the Carlingford House, opened by Frank and Mabel Ames in 1910. To get to the hotel you walked up the rock and veered to your left, along a boardwalk with birch railings. The Carlingford was a pretty though unassuming resort. The Ameses held church services on the verandah on Sundays, along with good old-fashioned hymn sings. Guests from Toronto and Hamilton challenged each other to baseball games, the winners claiming a cup improvised from a painted lard tin. Frank Ames took the guests out in the boat for picnics, or for berry-picking — the object of the toil being to convince Mabel to make one of her famous berry pies when they returned.

The brown cottage on the right of the public access to the wharf is one of Frank Ames' homes. The Ameses sold the Carlingford to the Pearson family, who took the hotel down in the late 1940s, but saved the fireplace. The Pearsons built a white cottage where the Carlingford used to stand.

Lookout Mountain,
Natural Park

9 NATURAL PARK

For many years this spot at the top of Little Lake Joseph was *the* destination in Muskoka. The navigation company won a continent-wide reputation for its trips to Natural Park. This was the plan: take the biggest ship in the line (the *Sagamo*), give it a run with an intriguing name (the 100-Mile Cruise), send it to a place with a heart-stopping lookout, and, bingo, you're in the tourist business. People who took boat trips loved it; people who lived on Little Lake Joseph loved it. The Sag's arrival at Natural Park could draw children and onlookers like a carnival show.

Amid much ooo-ing and aahh-ing the passengers filed off the steamboat, along tidy paths and nature trails, and up the slope to the top of the hill. There the brave of heart could tiptoe to the edge and look straight down at Mirror Lake (which was called Slide Lake until the navigation company changed it to something more romantic). From its inception, Natural Park generated a windfall of postcards showing people standing at the edge of the cliff.

The Muskoka Lakes Navigation and Hotel Company purchased the property in 1923, thinking it would be nice to have a recreational sideline to the transportation business. As the use of steamboats declined, the sightseeing trip kept the steamboats running. In 1958, however, the navigation company had to pull its last few boats off the lakes. Natural Park is now privately owned.

The landing is marked today by a brown boathouse with white double doors. To the left is a creek, then a ledge of rock with two iron posts driven into it. This is where the navigation company's second wharf was located (the first was about where the boathouse is today).

10 CROUCHER HOMESTEAD

There is always a danger when you write about buildings which are on their last legs that they will indeed fall down by the time the book is published. When I wrote this, the Croucher building would have fit a child's definition of a haunted house. Pine trees crowded the doorway, allowing only the second-storey gable to peek out at the lake, with its weary grey siding and broken glass.

George Coucher built the house in 1885. In its day it was a stylish Victorian house, with cheery gingerbread trim and verandahs on three sides. George and Ruth Croucher raised six

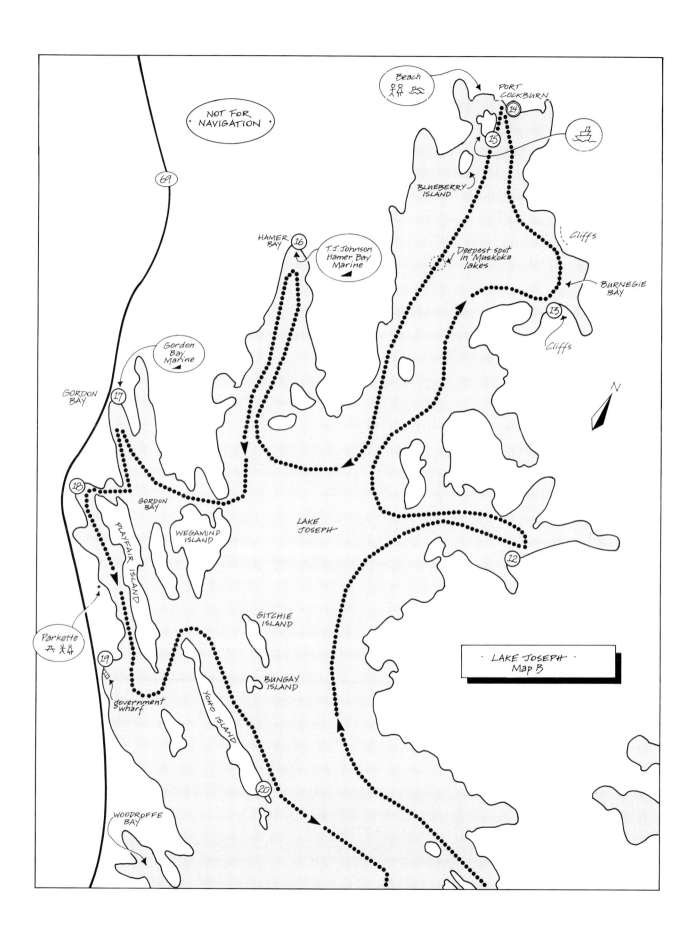

Beach

PORT COCKBURN

14

NOT FOR NAVIGATION

69

15

BLUEBERRY ISLAND

Cliffs

Deepest spot in Muskoka lakes

BURNEGIE BAY

HAMER BAY

16

T.J.Johnson Hamer Bay Marine

13

Cliffs

Gordon Bay Marine

GORDON BAY

17

N

18

GORDON BAY

PLAYFAIR ISLAND

WEGAMIND ISLAND

LAKE JOSEPH

12

Parkette

19

GITCHIE ISLAND

LAKE JOSEPH
Map B

government wharf

YOHO ISLAND

BUNGAY ISLAND

20

WOODROFFE BAY

children here, kicking off a line of descendants who continue to live and work on the lakes today. George's brother-in-law Tom Waters had a sawmill on the adjacent property (the cleared area to the right of the homestead, where the big pine tree is). George's expertise as a sawyer was very much in demand, as hotel-builders called on him to fashion the tongue-and-groove planking for their floors — all of it done by hand.

The Craigie Lea post office operated out of Croucher's home for some years and, for a brief time, schoolchildren took their lessons in the Crouchers' front room.

11 CLIFF ISLAND CHANNEL

If you cruise between Cliff Island and the mainland on a sunny summer day when the breeze is down and the lake is quiet, you will feel there can be nothing more beautiful on this earth. The shoreline of Cliff Island tumbles and plunges to the water. On its face, identically tall pines stand like soldiers, their branches, to a man, bent in the same windblown direction. The pretty log cabins on either side of the water call out to have their picture taken. This is one of my favourite passages on Lake Joseph.

12 STANLEY HOUSE/CAMP EKON

The metal roof on the old Stanley House hotel winks at you above the treetops. This is the second hotel; the first was a grander-looking structure with a tower and gables. The William Bissonette family operated the resort for the longest stretch of time, from 1910 to 1937, but a W.B. McLean got it started in the late 1880s.

In 1937 the Bissonettes sold the camp to the Jesuits, who ran a summer school for their brethren here and built St. Mary's Church on the property. About 1960 the Jesuits started a youth camp called Camp Ekon. Ekon is the name the Huron Indians gave Jesuit Father Jean de Brebeuf. Brebeuf's stature (he was six feet four inches tall) prompted the name, which means "a tree that heals."

The Jesuits operate the camp seven weeks of the year, with about 80 campers at a time — girls for part of the season, boys for the other.

The building has suffered the ravages of time: boards are missing from the verandah, the stairways are worn and wonky, and there's a greyness to the interior, but the brightness of the people running the operation seems to make up for what the building lacks.

The camp's front wharf is where the *Kenozha* burned in August 1918. "The crew of 14 barely had time to abandon ship before she became a crackling inferno," writes Richard Tatley in *The Steamboat Era in the Muskokas*. "The blazing ship was cut loose from the dock and drifted slowly across the bay. Finally she grounded, burned to the waterline, and sank The skeleton of the old *Kenozha* is said to be still visible in the shallow water at the north side of Stanley Bay."

13 ROCK POOL, BURNEGIE BAY

It's a bit like a scene from a Jacques Cousteau special. You swim under an inverted vee in the rock, through water the colour of lime juice. The echoes of your splashing bounce off the grey rock above. Close to your cheek, a spider the size of your hand scurries into a crack. You swim cautiously, expecting some "thing" to fall on your head or some fish to dart out from a crevice. When you emerge, you're in Neptune's private pool, fashioned of rubble and rocks, and big enough for three or four mermaids.

Long ago Mother Nature must have shook the dickens out of the cliff face; some house-sized boulders snapped off and landed here, creating a walled-in pool. The beauty of it is its privacy, and it is best enjoyed on one of those still, hot summer days, midweek, when no one else is around. From the main part of the lake, the point can be identified as the one where a "nose" of rock makes a gash in the otherwise pine-clad hillside.

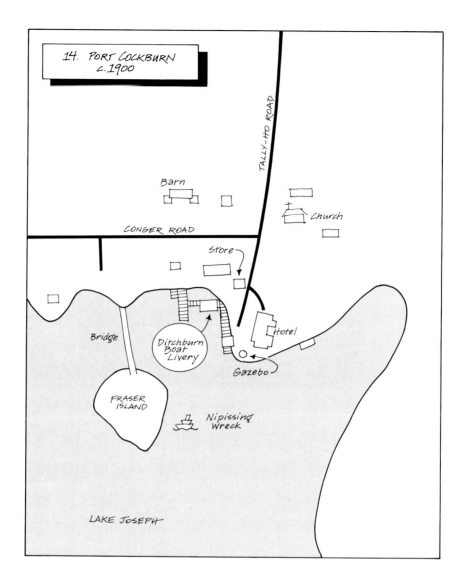

14 PORT COCKBURN

In today's scheme of things, Port Cockburn is "that nice bit of sandy beach at the top end of the lake." Indeed there's little to show for what was once a busy community with a store, a church, a boat livery, and a well-known hotel. In the days before the railroad, traffic funnelled through Port Cockburn as steamer passengers transferred to the stagecoach to make their way to Parry Sound and points north.

Hamilton Fraser, a friend of navigation company head A.P. Cockburn, liked the look of the area. At that time he'd been living in Brampton, although he'd recently come to Canada from New York. He built a hotel in the pine trees on the rocky point. Today a modern, glass-fronted cottage takes the place of Fraser's Summit House, which burned in October 1915.

Hamilton Fraser built the hotel in 1872, not long after the government had completed a road link from the lakehead to the Parry Sound Road. In addition to the hotel, Fraser operated a substantial dairy farm and a store (see map for location of Port Cockburn buildings). One of the buildings which has survived from Fraser's era is the little church, now looking a bit derelict and overgrown. It was built around 1890 for the guests at the hotel, although they did not appreciate the uphill walk. In the end, Fraser had to switch the venue for services to the ballroom of the hotel.

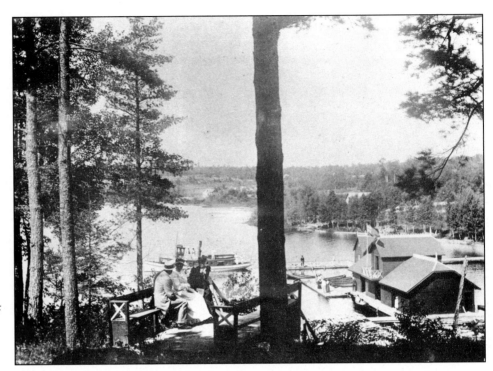

View of Port Cockburn wharf from Summit House.
(Muskoka Lakes Museum)

Patrons of the Summit House held the hotel in high regard, and it was not uncommon to find the names of politicians and bigwigs on the hotel register. Life was as citified as Fraser could make it at a wilderness resort. The walls were hung with European tapestries, the ceilings with crystal chandeliers. Fraser even lured the chef from Toronto's King Edward Hotel to Summit House for the months of June, July and August. The steamer landing had the facade of a busy street, with its boathouses, freight sheds and livery. It stretched out from the west side of the point, in front of the fine sandy beach you see there today.

The Frasers also built a bridge over to their island. The piles that supported the bridge are still visible in the shallow water. (I haven't been able to determine exactly when the bridge was built, or taken down, but I did find a picture of it in an 1888 tourism brochure.)

The prominence of Port Cockburn as a steamboat landing faded when both the CN and CP railways by-passed it. After 1906-07 Barnesdale station became *the* important port on Lake Joseph.

Port Cockburn, the community Fraser named after his friend A.P. Cockburn, is a quiet collection of cottages today. There is a public beach in the little cove to the west of the Port Cockburn beach, maintained by Humphrey Township.

15 WRECK OF THE NIPISSING

To lovers of the *Segwun*, Muskoka's sole surviving steamship, the site of the *Nipissing* wreck is something of a mecca. In 1871 A.P. Cockburn built the sidewheeler *Nipissing*. He chose the name because the ship would play a role in getting passengers to the starting point of the Nipissing Road, near Rosseau, and from there to Canada's North and West.

The steamer made a twice-weekly run to Port Cockburn. One August night in 1886 the *Nipissing* caught fire at the Summit House wharf. The crew feared the fire might spread to the hotel, so they cut the ship adrift and it beached at Fraser's Island, where it burned to the waterline and sank.

Today you can still see the skeleton of the wreck — its ribs splayed out on the bottom — in the shallow water beside a private dock.

Rocky Crest
(Sylvia Hurlbut)

16 HAMER BAY

Herb Todd was the first settler in Hamer Bay. He lived about where Terry Johnson's marina is today. On old maps the bay is called Dixon Bay, after the Dixons at the end of the point.

The Hamers arrived around 1876, locating on land at Hamer Lake. Soon afterwards they returned to Collingwood, where they'd settled when they first came to Canada, then returned to Hamer Lake around 1880. These were hard times for the Hamers, days they were happy to put behind them.

To a man like Joseph Hamer, who had worked in the cotton mills in the Old Country, the free grant lands of Canada held a promise of a better life. That promise turned to wishful thinking when the family faced the grim reality of life on the Canadian Shield. Joseph called his Hamer Lake home Barrwood-Lee, after a place in Lancashire. Here they raised ten children and scratched away at the soil, trying to make a living off the land. Joseph worked for some time at one of the lumber mills in Parry Sound, coming home only on weekends.

By the turn of the century things looked a bit brighter for the Hamers. The sons, John and Fred, moved over to Lake Joseph, where they found work looking after tourists and cottagers.

John Hamer built a home at the top of the bay in 1906, and the following year married Rosetta Myers. Their home is still standing, adjacent to Johnson's marina. Fred Hamer built across the bay from John, where the sawmill is today. The brothers built Rocky Crest for their sister Bessie sometime between 1906 and 1909. The cottage could accommodate about 20 guests.

The Hamers had an interesting water system that took advantage of the height of a small lake behind them. From here they channelled the water down to Rocky Crest and over to John and Fred's homes. Of course the beavers hated to see the water rushing out of the lake and stuffed the outflow pipe full of branches at every opportunity. The Hamers knew the sieve was plugged when they started to find leeches coming out of the tap.

Bessie Hamer ran Rocky Crest until the 1950s. Stan Hamer took it over for a few years, then it remained idle for a long time. In 1984 Kanata Hotels created a resort complex on the site. The original Rocky Crest (now the dining room) sits in the middle of a collection of modern buildings. The rock which gave Rocky Crest its name is still an inviting spot for sun-bathing and water-watching.

Terry Johnson has been running the marina at Hamer Bay since about 1978. In addition to the regular marine service, Johnson's is one of the few places that carries sail rigging.

Marina worker, Gordon Bay

17 GORDON BAY/HATHERLEY HOMESTEAD

In 1881 Henry Francis Hatherley left Liverpool for Canada in hopes that the North American climate would improve his health. He was 16 years old. With him were his two brothers, James and Alfred. Excerpts from his diary indicate that he and James had settled in this part of Muskoka by 1885. In February of that year Henry noted he was making moccasins from an old pair of corduroy pants, and James was drawing a few logs with cattle. They had helped put up a schoolhouse in Parry Sound and had not been paid their wages yet. In June 1885 Henry "got paralysis" and had to return to England for a while.

Before marrying Gertrude Hamer in 1896, Henry built a house by Portage Creek. Today that house site is a picnic spot at the confluence of Portage Lake and Gordon Bay. The couple kept sheep, and Henry ran a painting and decorating business.

Ernest Hatherley built the white frame house on the south side of Portage Creek in 1932. In those days there was only a single-lane humpbacked bridge over the creek and a muddy road to Parry Sound.

Ernest's son Bruce started Gordon Bay Marina in 1959. It is one of the largest marinas in northern Ontario, offering not only a full-service mechanical shop, but also boat and motor sales, rentals, boat storage for up to 300 boats, and a line of marine and cottage accessories at Barry's Cove Boatique. (P.S. Yes, they do carry marine charts.)

18 GORDON BAY POST OFFICE

The two-storey red building with the black roof is the old Gordon Bay Post Office. James Hatherley built this home for his bride, Jessie Hamer, in 1886. It was their first and only home. It became a post office when the railways went through (the CN line officially opened in 1906, CP in 1907). James Hatherley was the postmaster and also the schoolteacher at the nearby school. At the waterfront a spring bubbled up from the sand. Settlers used to cool their milk in it, and children drew water here each day and carried it up to the school.

19 LAKE JOSEPH CENTRE, BARNESDALE

Lake Joseph Centre, run by the Canadian National Institute for the Blind (CNIB), isn't hard to spot from the water. There's a long line of sandy beach, and a collection of neat brown buildings with white trim. There's also the hard, straight line of the railway embankment calling attention to itself on what's usually an irregular, green shoreline. The railway made this location a busy one in the early days. The Canadian Pacific and Canadian Northern ran side by side along this particular stretch, the CN being the one to set up a wharf-side station here.

The new CN line from Toronto to Parry Sound officially opened in the fall of 1906. The path of the spur, which connected the wharf station with the main line, is now used as a roadway to the CNIB wharf. There was also a stairway, and later a ramp, connecting the wharf with the main line. The depot was called Lake Joseph Station. The station superintendent lived in a cottage adjacent the wharf (that building is still being used today, the brown cottage with white roof and spruce tree).

At the time the railway came through, Mr. J.J. Barnes (sometimes spelled Barns) owned the surrounding property. He had established the Barnesdale Hotel on the point (in the vicinity of the CNIB gazebo). Unfortunately he did not live long enough to see the full effect of the transportation link on his business. He died a year after the rail line opened. The Bradys purchased the hotel. In the 1920s, when Mr. Ford's automobile was leaving the rail lines in its dust, the Barnesdale Hotel burned.

The steamer-train connection became less and less important and the CNR eventually sold 18 acres to the MacDonalds from Foot's Bay in 1952.

In 1960 the CNIB, pressed for space at a camp for the visually impaired in Ancaster, looked with interest at the old CNR property. Arthur Weir, CNIB business manager at that time, had a cottage nearby, and he arranged a meeting with the MacDonalds. In the spring the construction crews came in and built much of what you see today. Ninety percent of the work was funded by provincial Lions clubs, who continue to support the centre.

20 YOHO ISLAND

The southern tip of Yoho Island is one of Muskoka's chief points of interest, owing to its early prominence as a place to meet and exchange goods. Here William Robinson, Simcoe County's representative in the government of Upper Canada, set up one of his several trading posts, possibly as early as the 1820s. He got along well with the native people, and they trusted his traders to give them a fair price for furs.

Next the island became the domain of the Muskoka Club, a group of scholarly young men who'd been coming to Muskoka since the early 1860s to camp and explore the lakes. Having "found" Lake Joseph in 1862, they made their base of operations here, first at Chaplain's Island, and from 1872 on, at Yoho.

They purchased Yoho, Peggy, Burnt, Bungay and Gitchie islands. Bungay Mena and Gitchie Mena meant Little Huckleberry and Big Huckleberry, respectively, in the Ojibway language. Peggy is named after Chief Pegemegahbo, whom they met in 1863.

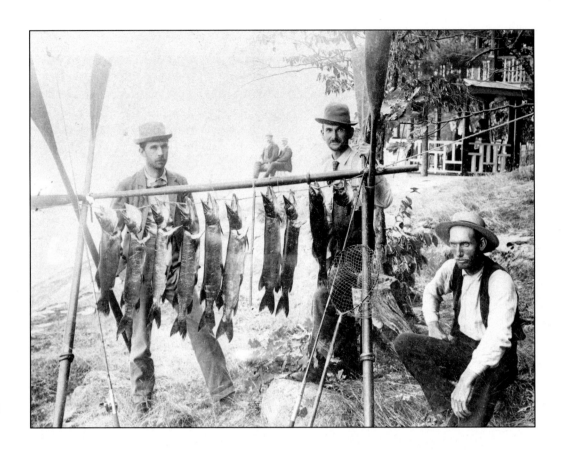

A *day's catch*.
(Muskoka Lakes Museum)

The *Northern Lake of Canada* (1886) mentions the Yoho group this way: "And then comes the Yohocucaba Group. A thoroughly Indian intonation would appear to attach to this name, with its constantly repeated vowel sounds, and one wonders as to what may be its native meaning. It is a revelation to be told that it was framed from the first syllables of the names of the first occupants of the largest island."

Yo: Professor George Paxton Young
Ho: W.H. Howland
Cu: Montgomery Cumming
Ca: Professor John Campbell
Ba: James Bain.

Campbell married Mary Playfair in 1875, and they purchased Yoho two years later (the Playfair name is attached to a similar long, thin island just north of Yoho). D.H.C. Mason, in his book *The First Islanders*, describes John and Mary Campbell this way: "There every Sunday he donned his 'blacks' and his Glengarry bonnet, betook himself to the wharf and greeted each boat and canoe as it arrived for the morning service. There in a little hemlock grove he preached his inimitable sermons, stories and legends, drawn from his amazing memory without reference to any book. There his wife ruled the household with a firm hand and a heart of gold. She ran the post office to the great benefit of the neighbourhood because, she said, she would go to no one else for *her* mail."

Descendants of the Campbells still spend their summers on Yoho Island. The Campbell house itself dates to 1881 or '82.

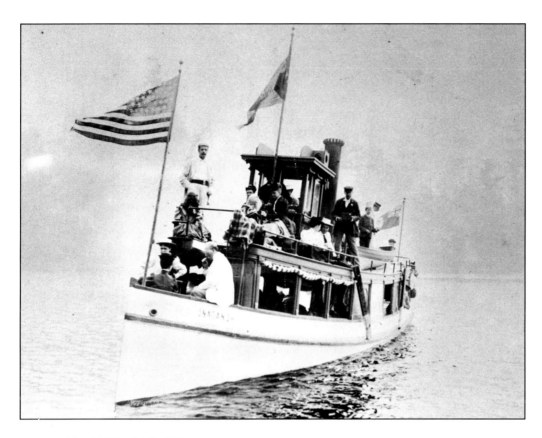

*Cruising the lakes
aboard the Onaganoh.*
(Muskoka Lakes
Museum)

21 CHIEF'S ISLAND

When the steamboats gained access to the upper lakes in the early 1870s, James Campbell, head of the publishing firm of James Campbell and Son, finally got to look at the country his son had been traipsing off to each summer. He, too, caught the Muskoka fever, and he bought Chief's Island in 1874. In *The First Islanders*, D.H.C. Mason says they called Campbell "The Chief," but whether the island took its name from James Campbell or vice versa is unclear.

The Chief enjoyed a decade of summer holidays on the island. When he died the property went to his daughter Elizabeth and her husband, J. Herbert Mason.

We get a glimpse of cottage life on Lake Joseph in the 1890s in the following excerpts from letters written from Chief's Island by Genevieve Canniff. She was staying with the Masons at the time. Her father, a doctor, owned nearby Canniff Island.

THE SUMMER BALL

. . . The dining room was all waxed to perfection. The piano was placed in the window, and oh! how pretty the room looked — beautifully decorated with green vines and golden rods — I made crinkled paper lamp shades ad lib — each lamp was shaded with red. On the north side of the veranda there was a table with claret cup and lemonade, all through the evening. The walks were all lit with lanterns and the sight of the evening was the supper room — the laundry. We worked all day Thursday at it — it was a perfect bower — green cedar and red bunting. The supper was grand — cakes of all kinds — candies, ices, fruit — of course salads and sandwiches to start off. The programme consisted of 18 dances and 12 extras. Oh! I did have a glorious time — the very nicest partners. I danced with Mr. W. McMurrich, Jack McM, a Mr. Macdonnell from their house, Fred Campbell, Mr. Playfair, Casey Wood (lots), Willie Morris, Jimbo McMurray, Mr. Spotton, Mr. Frazer, Ross Hayter and Mr. Hall . . . But fancy just as they were going home, it started to pour! Theo Watson and her sister-in-law had to stay all night. Thirty, all night and for breakfast. The McMurrichs came over on their steam

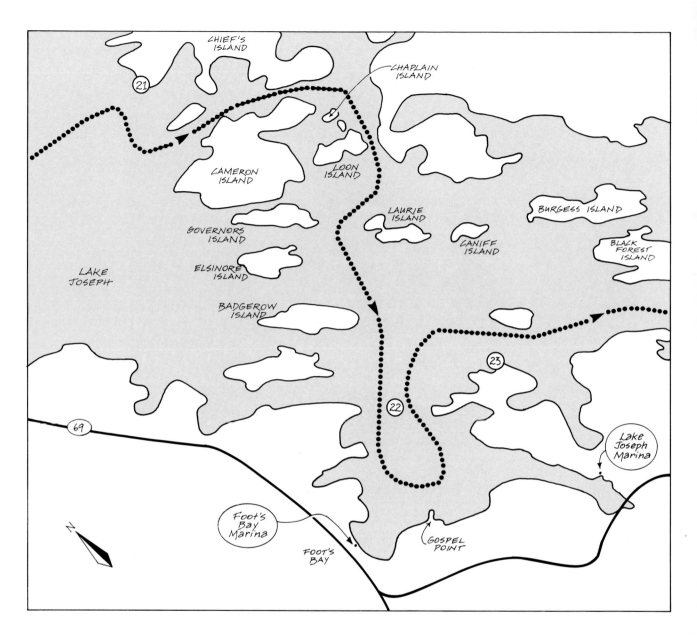

launch for the Watsons this morning and Nor Playfair brought back a lot of wraps and coats they had borrowed so we had quite a reception again this morning. There were 93 in fancy dress. Can you imagine the sight!

CATERPILLARS AND CRUISES

My Dear Mother . . . Since I last wrote we have been very gay. Our party has been added to nearly every evening. Sir Casimir Gzowski, Mr. Mason, Morton Jones and some children all came in one day. Did you ever hear of Sir Casimir? We are all in love with him . . .

This afternoon I paddled, all by myself, Mr. Muntz down to our island and we explored everything. Tell Papa the island looks frightful. Like every other island around it has been visited by a plague of caterpillars — which destroyed every hemlock in the place. Consequently the island looks like a forest of dead trees . . .

Yesterday Mr. Mason chartered the Onagonah for the day and we went all over Rosseau and Joseph. Sir Casimir, Mrs. Mason, Dr. and Mrs. Hoskin, besides ten of us young people made up the party. We had lunch on board and two maids to wait on us so you can imagine the style of us.

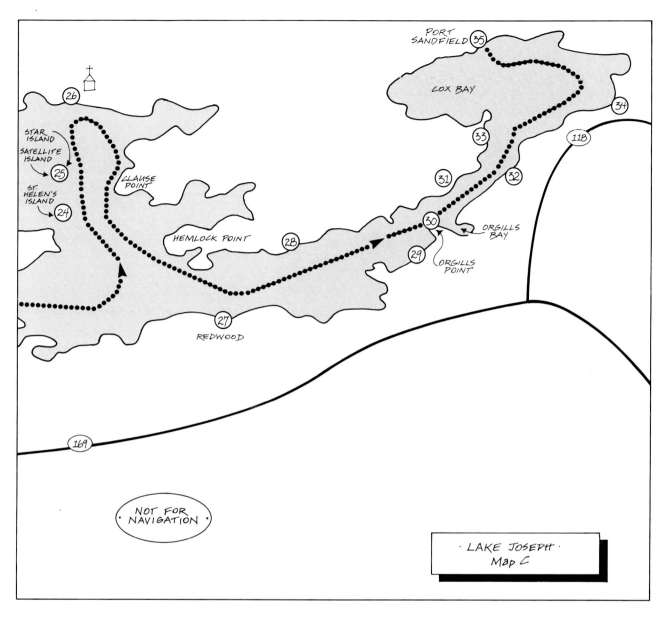

PORT
SANDFIELD 35

COX BAY

34

118

33

26

31 32

STAR
ISLAND

SATELLITE
ISLAND 25

ST.
HELEN'S
ISLAND 24

CLAUSE
POINT

30

ORGILLS
BAY

29

ORGILLS
POINT

HEMLOCK POINT 28

27

REDWOOD

169

NOT FOR
NAVIGATION

· LAKE JOSEPH ·
Map C

22 FOOT'S BAY

It's not uncommon for the names of bays and islands to change when new owners come along, but the name Foot's Bay has persisted in spite of the fact the Foots' tenure here was both brief and ineffective, as homesteading goes.

William Edward Foot, his wife, Jane, and seven children left Dublin, Ireland, headed for Muskoka in 1871. As his descendant W.W. Foot says in the family's genealogy, "These were not rough, hardy settlers. They were refined, cultured, gentle people; literary, musical, religious, accustomed to the city amenities of Dublin society."

The Foot family held some standing in Ireland. William's great-grandfather was Lundy Foot, a tobacco and snuff manufacturer of some note in Dublin. William himself held a substantial position with the Great Southern & Western Railway. Indeed the railway officials were loathe to let him leave and gave him quite a send-off party, pressing upon him a bag containing 64 gold sovereigns.

But times were hard in Ireland and Foot apparently felt he had to leave if he hoped to provide for his large family. And so they arrived in Bracebridge and from there arranged to move their things to Lake Joseph.

Sunrise, Foot's Bay

According to Seymour Penson, who described Foot as witty, naturally brilliant and "every inch the gentleman," Foot seemed to really enjoy his new life in Canada, but his family did not. Bad luck dogged them. First the boat carrying their furniture capsized, dispatching most of their goods to the bottom of the lake. Then their house burned down the first time they put a fire in the kitchen stove (they hadn't put the legs on the stove, to lift it off the floor). Winters were a hardship such as they'd never endured. One morning they awoke and found their clergyman dead on their doorstep, where he'd fallen trying to reach them in a snowstorm.

Enough was enough. They moved to Bracebridge. There William found convivial interests in the cricket club, the Masonic Lodge and theatre group. He became the secretary of the Agricultural Society and held the position of fishery inspector. But it seems his wife never forgave him for dragging her to such a backwoods part of the country. They separated in 1880. William later headed out west to join his son. He lasted two years, finding life on the Prairies worse than life at Foot's Bay. He returned and settled in Parry Sound, where he took the job of deputy registrar of deeds in 1892.

As to the spelling of Foot's Bay, family historian W.W. Foot says: "The spelling of our name has varied from Foot to Foote from one generation to another." The family chronicler favours the spelling without the 'e', even though maps have spelled it Foote for many years. In 1974 W.W. Foot began lobbying to get the name changed. Officially, the community is recognized as Foot's Bay, without the 'e'.

23 HAMILL'S POINT

Today the drawing cards at Hamill's Point are the pretty little islands — Faith, Hope and Charity — whose cottages and boathouses are indeed worth a frame or two of film. The original hotel that once commanded the point is gone, but its foundation supports a pretty white cottage, owned by Arthur Brackley. Some of the furniture from the hotel stayed with it when the Brackleys purchased this property in 1950. The cribs of the steamer wharf are still there, too.

Behind the cottage is the cleared land of the original Hamill farm. Thomas Hamill settled here in the 1870s. He supplemented his income by guiding sportsmen and renting boats.

According to Brackley, the Hamills built the hotel in 1896, and it burned the same year. They rebuilt in 1897, living in the small basement through the winter. The four-storey hotel had 50 bedrooms, a dining room and kitchen. The nearby annex (now used as a summer home) offered an additional 16 rooms.

Ownership of the hotel passed to J.D. Williams who quoted rates of $2 a day, or $10 to $16 a week in 1908. Advertisements claimed: "A commodious, airy, well-lighted building, surrounded by wide and shady verandahs, amply supplied with comfortable chairs. It is lighted throughout with acetylene gas and is equipped with hot and cold baths. Each room has its own window looking out on lake and island. In fact, the situation of the hotel is such that there is not a window in the whole building but looks upon the water and island scenery. Hay fever sufferers find ready relief here, in fact hay fever is almost unknown in this locality."

Another owner of the property was Rev. L.S.D. Coxon, who would have been unaware when he boarded a steamer here on October 6, 1934, that the ship would perish in a sudden storm, taking Coxon and Capt. Thompson down with her to the bottom of Lake Muskoka (see the Wreck of the *Waome*, Chapter 2).

The hotel was known as the Lantern Hotel when Brackley took it over.

24 ST. HELEN'S ISLAND

Early maps show this bit of land as Scadding's Island, after Henry Simcoe Scadding, a member of a prominent Toronto family. He purchased it in 1875. When Toronto's Holy Trinity Church was built in 1847, Bishop John Strachan, of Family-Compact fame, appointed Scadding as rector. Scadding remained a loyal supporter of Strachan, despite the feelings of the common people that Strachan's influence on the politics of the day led to unjust and corrupt government in Upper Canada. Scadding took a great interest in the history of the Toronto area and wrote several articles about the city. Scadding House, next to Holy Trinity Church, is a historic point of interest in Toronto.

The name St. Helen's came from the island's next owner, Louis Martin, who named it for his first wife (which seemed a very odd thing to do when he was bringing his second wife to the island).

It is in the Winslow era, however, that the island's history becomes really interesting. The story has it that Mrs. Harriet Winslow left New York State one summer in the 1890s, looking for an escape from the heat. She hired a boat at Port Carling and got two men to row her around the lakes. On seeing this part of Lake Joseph she announced, "This will do," and purchased a set of islands, including St. Helen's. Another island was for the captain of her steamboat. If she wanted the launch brought round, she'd signal the captain by raising a flag on her wharf.

The Winslows did not lack for money. John Winslow was a head man at Albany Iron Works and, as such, had a private rail car to take the family to Muskoka.

A 1984 *Port Carling Museum Quarterly* says, "A day on the island started with communal prayers and a hymn (led by Mrs. Winslow) before breakfast. Mrs. Winslow was confined to a wheelchair but her son built a broad path that completely encircled the island. The family

was expected to attend every meal on time and fully attired, the men in stiff collars and ties." On Sundays she allowed no games and no swimming. She had four summer houses on the island so there'd always be one where the wind was right for afternoon tea.

Like her great summer friend, Lady Eaton, Harriet Winslow had a philanthropic disposition. To the Presbyterian congregation she was most generous, first making sure Rev. Kerr had a launch in which to get around his parish, then providing donations for the construction of the Lake Joseph Presbyterian Church.

25 STAR ISLAND

In the 1890s Sir Casimir Stanilaus Gzowski captured the attention of many Lake Joseph islanders. Certainly people were talking about him and inviting him to their parties and picnics. Sir Casimir, a Polish immigrant, won acclaim in his adopted country as a noted engineer. (His great-great-grandson is Peter Gzowski, the host of *Morningside* on CBC Radio.) It is Sir Casimir whom we have to thank for the prestigious Queen's Plate. Gzowski also built the first bridge across the Niagara River, paved Yonge Street, laid out much of the Grand Trunk Railway, and, for those and other contributions to his adopted land, was knighted by Queen Victoria.

For a time Sir Casimir owned Star, Sunshine and Zanzibar islands, as listed in the 1918 *Muskoka Lakes Directory*.

26 LAKE JOSEPH COMMUNITY CHURCH

If it is the object of churches to generate a sense of peace and awareness of the beauty of nature, none does a better job than the Lake Joseph Community Church on a *mid-week* day when you are alone in this very special spot. At such a time you can sit on the dock, listen to the waves plonking against the crib work, and admire the clarity of the water. The threshold of the church is a pad of grey Muskoka rock edged by wind-bitten scrub. The church itself peeks out from a palisade of tall white pines. It is a structure that is beautifully simple, humbly grand.

Until 1967 you could get to the church only by water, or by walking through the bush from District Road 7 at Gregory. In Canada's centennial year the congregation chipped in to build a road and parking area.

The church itself dates back to 1902, when the Mackenzie brothers from Foot's Bay started building it on land purchased by the Presbyterian congregation. Lake Joseph had a healthy Presbyterian contingent, both permanent settlers and cottagers. In fact the roster of landowners on the lake at that time read like a Scottish registry: Henry, Campbell, MacLennan, McMurrich, McFarlane, McKenchnie, Mackenzie, *et al.*

The first service, on August 9, 1903, was full to overflowing. A.P. Cockburn had offered the services of the *Islander* to pick up anyone who wanted to attend. The evening service saw larger crowds still, with fully 100 people standing outside. The *Presbyterian* (Aug. 12, 1903) notes: "After the evening service as the boat was leaving in the perfect moonlight, its 250 passengers united in singing Jesus Saviour Pilot Me, and while homeward bound the singing of Abide With Me, Nearer My God to Thee and God Be With You Till We Meet Again re-echoed from the mainland and island."

In 1925, following the union of some Presbyterian and Methodist churches, the Lake Joseph Church became a non-denominational church under the jurisdiction of the United Church.

27 REDWOOD

You recognize Redwood today by its collection of almost identical summer bungalows and boathouses. The name can be traced back to the 1870s, when the Ardagh family established a farm here called Redwood.

View of Lake Joseph from the Sherwood Inn.

Around 1880 John and Susan Nixon took over the Ardagh farm, moving from Glen Orchard. (The Nixons were the first settlers in the Glen Orchard area, settling at Ada, or Ida, Lake in 1868.) At their new location, they set up a post office, and the name Redwood started appearing on the maps. Susan was the closest thing to a doctor the early settlers had. She travelled many miles on a cold winter nights to help in times of sickness, or to deliver a baby. The Women's Institute history says she delivered over 400 babies, "never losing a baby or a mother."

In 1921 the Nixons moved to Macaulay Township, selling the farm to Martin Orchard and his wife, Ida Henshaw, Susan Nixon's niece. The Orchards carried on the postal service and operated a summer store.

28 KILLIECRANKIE

When it comes to unique cottages, you can't overlook Killiecrankie. Its octagonal design, and age, make it a striking point of interest on Lake Joseph.

William and Euphemia Mackenzie had the cottage built in the spring and summer of 1886. Euphemia suffered a condition brought on by heat and humidity, and her physician, Emily Stowe, suggested the best cure was to spend summers in Muskoka. Emily Stowe held a holistic approach to medicine and was an adherent to the philosophy that meditation can provide insight into divine nature, and that octagonal buildings helped focus the process of meditation. The Stowes lived in an octagonal building and no doubt their experience influenced the Mackenzies.

Euphemia Mackenzie spent several weeks with the Stowes the summer before she and William built Killiecrankie. Eight Scottish carpenters were brought in to work on the cottage (the number eight seems to be favoured in all aspects of this project). The cottage resembles Bracebridge's Woodchester Villa, which is of a similar vintage. Descendants of the Mackenzies still summer at Killiecrankie. Killiecrankie is the name of the pass where the Scots last defeated the English. Euphemia lived not far from the pass in her childhood years.

29 SHERWOOD INN

Sherwood Inn is an elegant retreat, very colonial-looking with its white siding, gables and green shutters. The inn provides the creme de la creme of vacation experiences in Muskoka. As the brochure says, it's "very intimate, very private."

The property's history goes back to the early days of settlement in Muskoka, when the James and Orgill families arrived. (Charlotte James had married Thomas Orgill.) The Orgills had been in Canada a while when the Jameses came out to join them, around 1877. At that time the Orgills had found a place at Redwood. The two families purchased Crown land, the Jameses taking the west half where the Sherwood Inn is today, and the Orgills the east. Mr. James was a bricklayer by trade. Philip James, the son, was seen by his neighbours as a recluse. He did sketching and painting, often working on fungus and birchbark when he ran out of canvas. Some of his lithographic sketches can be seen in the collection of the Gravenhurst Archives.

A lady known as "Miss James" operated a small tourist establishment called Edgewood on what is now the Sherwood Inn property. By the 1930s little remained of the Edgewood. On the foundation of the old hotel, there is now a new cottage, part of the Sherwood Inn complex.

30 ORGILL'S POINT

The pretty, white homestead on the point is the Orgill house, built around 1900. The Orgills came to Canada in 1870, settling in Toronto, and two other locations on Lake Joseph before moving to the point in 1882. The family returned to England for three years in the 1890s. When they came back to Muskoka, they set up a steam laundry, which they operated successfully in conjunction with a pick-up and delivery service, by boat.

The Orgills had a large family: Lillian, Idan, Phillip, Will, Fred and Charles. Phillip never married, nor did Idan nor Lillian. After their parents died, Phillip, Idan and Lillian lived in the white house. Brothers Fred, Will and Charles married and went their own ways, Charles to Glen Orchard, where he operated the post office for many years and also served as reeve of Medora and Wood townships.

Charles met his wife, Agnes Clark, when he came home from the Great War on sick leave, dangerously ill. Agnes had been visiting her sister at the time and spent many hours with the recuperating soldier. Charles and Agnes married in 1921 and lived on a farm by Ada Lake.

Around 1959 Charles and Agnes returned to the homestead and refurbished it. Donna Denison of Toronto recalls her visits to the house and the graciousness of its hostess: "Agnes never lost her Scottish accent. There was always silver on the table and linen napkins — afternoon teas. She brought to Muskoka a new cultural level. She played the organ in the church . . . was an avid reader. She encouraged, throughout the area, a level of refinement."

31 CROFT OF DOUNIE

Hunting jackets and jodhpurs would not look out of place at Croft of Dounie, nor would you be surprised if someone came around the corner with five hounds straining on their leashes. William Elliott must have had a Scottish hunting lodge in mind when he designed this timber-and-stone cottage. Elliott was a design contractor in Toronto and he had some of his craftsmen up to help with the project, including building the dining-room table and benches right in the house (which certainly solves the problem of how to move large pieces of furniture in once a house is complete.)

The dining-living room is a replica of the one at the Toronto Hunt Club, complete with a minstrels' gallery, a pipe organ and massive stone fireplace. Outside, the grounds are shady and spacious, and it's hard to believe each mature tree was planted by the Elliotts on what was once sheep pasture. The Elliotts' daughter, Louise, set out an extensive perennial garden, incorporating a pergola in the Edwardian fashion.

The Elliotts purchased the property from Iden Gobel, who settled here in 1865. Gobel had been a commercial fisherman and did his fishing on a larger scale than other Muskoka settlers. The little log hut at the foot of the Croft of Dounie wharf was the smoke hut for the fish. In the Elliotts' day, the smoke hut became the wash house. The Elliotts planted thyme on the lawn outside the wash house to make the sheets smell nice when laid on the lawn to dry. The thyme is still there.

The little boathouse to the right of the wharf functioned as a schoolroom for the children's lessons, and later the boys' sleeping quarters.

The steamers called in at the Croft of Dounie wharf, snubbing up at the white posts, which are still there. To signal the steamer, the Elliotts placed a flagpole in the top of the post.

Today the property belongs to William Elliott's grandson, John Gray.

32 MARY GROVE/GLEN HOME

On July 29, 1939, Mr. Lambert Love held opening ceremonies for his new hotel, Glen Home. This was a modern, clean-lined building with corner turrets built up in tiers like a wedding cake (the top tiers of the towers have since been removed).

Lambert Love had previously owned and operated Elgin House on the opposite shore. He married three times, losing his second wife in childbirth. Later he met and married another lady, much younger than he. Some years after he remarried, Lambert left the management of Elgin House to his son Bert and moved his second family to Glen Home. Lambert Love was about 70 years old when his son John was born, 75 when Paul was born.

Lambert's years of experience in the tourism business are reflected in the layout of Glen Home, both in terms of making a pleasant environment for the guests and in creating an efficient work area for the staff. Of particular interest are screened-in balconies off every suite (a convenience not found in other resorts of the era).

Every Sunday, services were held in the Glen Home chapel. Lambert Love, a staunch Methodist, insisted that his staff conduct themselves in a temperate manner. One staff member recalls, "In the morning, when you went into work, you all sat down at the kitchen table for Bible study and prayer. You never started your day otherwise. When all the work was done in the evening, we gathered around again. And if they ever heard a swear word or saw you smoking or drinking — there's the door. Out."

Lambert's wife, Alice, and son Paul continued to operate the resort after Lambert's death. Paul closed the resort on Labour Day 1974. When the resort came up for sale, the Sisters of St. Joseph, a Roman Catholic order, purchased it. They owned an island in Lake Rosseau (The Crag) but saw the advantage of a property accessible by car.

The sisters, who've renamed the hotel Mary Grove, come up for vacations or retreats. When on retreat, the sisters spend their time in meditation and are not allowed to speak. The facilities at Mary Grove are also lent to seminarians and novices for conferences and study sessions. Lambert Love's hotel chapel is still in use. The lovely hardwood floors throughout the building still provide a sharp echo when you walk on them. The pillars and art deco fixtures in the lounge remind you of a tasteful, cultured era.

33 ELGIN HOUSE

The waterfront is much changed from the early days, but the clear waters and sandy beaches of Elgin House are proof of the attraction this property held to Lambert Love when he moved here from Gravenhurst in 1885. A blacksmith by trade, Love switched to sawmilling — a clear choice of occupation with timber close at hand and the means of transport on your doorstep. The lakes were the commercial highways in those days.

The Loves, like other settlers, took in a few boarders, notably visiting clergymen, millhands and summer visitors. Apparently a trip to the Chicago World's Fair in 1893 impressed on Love

Pinelands

what a success the tourism business could be if properly done. In particular he carried back a memory of immaculate grounds (a characteristic which would become the hallmark of Elgin House). As the popularity of the Loves' accommodations grew, their home was soon "bulging at the seams," according to Bert Love. A proper hotel was what was needed, and what the Loves set out to build. The final touch on the new resort was a sprinkling of tanbark on the pathways from the wharf to the hotel: "We were now shipshape, Elgin House was now ready to open its doors. It was the year 1900," said Bert Love.

The lodge grew and expanded, each renovation or addition changing the look of the main building. Management of the resort passed to Lambert's son Bert, and then Bert's son, Victor. In 1969 Victor sold the resort to the Grise family, who continue to uphold the Elgin House reputation as a beautiful and hospitable resort.

34 PINELANDS

An interesting thing about Pinelands Resort is that it is not the original Pinelands, but Belmont House. Pinelands House, now torn down, sat adjacent the Belmont and the two were run as one from 1942 onwards.

John and Elizabeth Jones moved their family to this spot in 1895, although they'd been in Muskoka since 1880, living in and around Port Sandfield. Jones worked as a porter at Enoch Cox's Prospect House, then established a hotel of his own. Pinelands House also became the post office for this section of the lake.

William Fairhall, a sawmiller from the Lake Muskoka side of the peninsula, purchased property adjacent Jones in 1902. Perhaps his experience in the lumber business gave him an edge in designing buildings, for the Belmont House was, and still is, a very pleasing hotel to

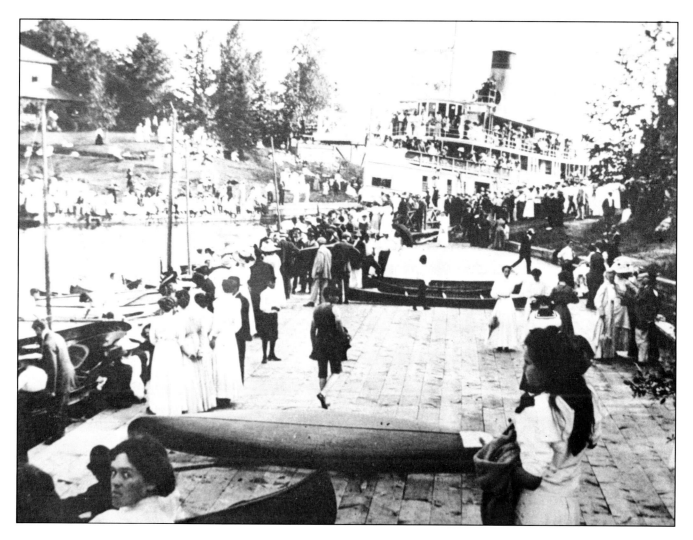

Port Sandfield (Muskoka Lakes Museum)

look at. There's something "complete" about the arrangement of the four towers and the second-storey sun porch. Certainly the Belmont had a lovely lookout on the beach — which just happens to be the prettiest stretch of sandy shoreline on Lake Joseph. The Belmont House was built in 1904.

In 1942 Clarence and Bert Jones (John's sons) purchased the Belmont and operated the resorts as Pinelands Lodges. The Lydans bought the resorts in 1961 and sold to the Revilles in 1970. The Revilles found they had to tear the old Pinelands House down, as it had fallen into such a state of disrepair as to be dangerous.

35 PORT SANDFIELD

On maps the strip of land separating Lake Rosseau and Lake Joseph in the Port Sandfield area is hardly visible. Although the Joseph River joins the two lakes further north, it had a rocky waterfall obstructing navigation. Early settlers chose instead to cross here, at what was called Sandy Portage.

The Foreman family took advantage of that fact and provided a transportation service, using a team of horses to haul boats from one lake to the other.

In looking for the easiest route for steamboats to ply between lakes Rosseau and Joseph, engineers decided to by-pass the Joseph River with a cut at Port Sandfield. There were scarcely

The canal at Port Sandfield

180 metres (590 feet) of land between the lakes at this point and a drop in water levels of only 45 centimetres (18 inches).

In September 1870 the Department of Public Works had the project under way when the premier himself came by to visit. Premier John Sandfield MacDonald and his entourage found 30 men busy at work cutting through the sand and embanking the channel with stone. With the premier on that visit was a man named Charles Marshall, who wrote down how the place came to be named after the premier: "In the morning a great plank was procured. In open block letters I inscribed on it the name newly decided on for the place. The plank was nailed up to a pine before the assembled party. In the name of Her Majesty Queen Victoria and of the Dominion of Canada, the Reverend Mr. Herring christened the place Port Sandfield."

The canal was to open in the autumn of 1871, but the steamship *Wenonah* got stuck during the hoopla, and the red-faced Public Works people had to bring the dredge in again to open the passage for the next year.

Meanwhile Mr. Enoch Cox had moved to the area, acquiring some free grant land and also buying some land from his friend Seymour Penson. Cox established Prospect House on the northeast side of the channel around 1882. The place thrived, and people raved about its facilities, which included rooms for 250 guests, bowling greens, tennis, ballroom, music room, express office and postal service. After catering to tourists for more than three decades, Prospect House burned down.

Reflections, Lake Rosseau

Author's Favourites . . .

— Most scenic lake
　　Lake Joseph
— Best sightseeing lake
　　Lake Rosseau
— Most intriguing ruins
　　German POW camp, Gravenhurst
— Favourite spots
　　Rock pool, Burnegie Bay, Lake Joseph
　　Hardy Lake Provincial Park
　　Eleanor Island Sanctuary, Lake Muskoka
　　Clark's Falls, Lake Rosseau
　　Rosseau Falls, Lake Rosseau
— Prettiest passage
　　Channel between Cliff Island and the mainland, Lake Joseph
— Most dramatic waterfalls
　　Bala Falls, Lake Muskoka
— Most impressive cliffs
　　Skeleton Bay, Lake Rosseau
　　Burnegie Bay, Lake Joseph
— Most neglected historic site
　　Muskoka Wharf
— Places you long to see, but can't
　　Natural Park, Little Lake Joe
　　Kawandag, Lake Rosseau
　　The Main Sanatorium, Lake Muskoka
　　The Royal Muskoka, Lake Rosseau
　　Whiting's Drug Store, Port Carling
　　Wigwassan Lodge, Lake Rosseau
　　Beaumaris Hotel, Lake Muskoka
— Favourite ghost village
　　Port Cockburn, Lake Joseph
— Favourite fading hotel
　　Rostrevor Resort, Lake Rosseau
　　Woodington House, Lake Rosseau
— Cutest church
　　The Church of the Kettles, Lake Muskoka
— Strangest public access
　　Carlingford Wharf, Lake Rosseau
— Best public swimming beach
　　Four-Mile Point, Lake Rosseau
— Favourite ice-cream stop
　　Beaumaris, Lake Muskoka
　　Windermere, Lake Rosseau

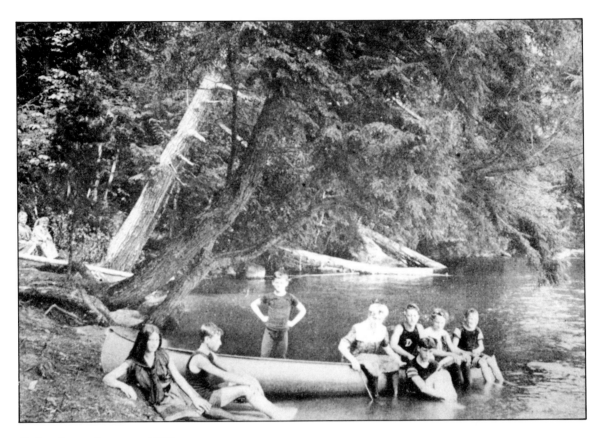

Swimming costumes, c. 1905.

Bibliography . . .

PRIMARY SOURCES

— Atlases, Maps, Gazetteers —

Gazetteer and Directory of the County of Simcoe and District of Muskoka 1872, East Georgian Bay
 Historical Foundation, Elmvale, 1985.
Hamilton, W.E. ed. *Guide Book and Atlas of Muskoka and Parry Sound Districts*. Toronto, 1879.
Marshall, G.W. *Map and Chart of the Muskoka Lakes*, Toronto, 1899, 1904.
Ministry of Fisheries and Oceans, hydrographic maps: lakes Muskoka, Rosseau and Joseph.
Rogers, John. *Muskoka Lakes Blue Book Directory and Chart*, Toronto, 1918.

— Government Reports —

Canada Census: 1871, 1881
Department of Public Works: *Engineer's Correspondence, Muskoka District*, 1903-1912.
Environment Canada: A *Review of Migratory Bird Sanctuaries in Ontario*, 1984.
Environment Canada: *Management Plan: Eleanor Island National Wildlife Area*, 1985.
Ministry of the Environment: *Lakes Muskoka, Rosseau and Joseph Progress Report*, 1988

— Lectures —

History of Muskoka District as presented by guest speakers on behalf of Georgian College
in Bracebridge, Gravenhurst and Huntsville, October and November 1974. Transcriptions revised
and edited by the Algonquin Regional Library System, Parry Sound, 1975.

History of Muskoka District as presented by guest speakers on behalf of Georgian College
in Bracebridge, Gravenhurst, Huntsville and Port Carling, September to November 1975. Tran-
scription revised and edited by the Algonquin Regional Library System, Parry Sound, 1976.

— Manuscripts and Journals —

A *Voyage in Search of Free Grant Lands*, by T. Robinson.
Bala Women's Institute Tweedsmuir History
Coate, F.W. *Dairies*, Ontario Archives
Canniff Papers, Ontario Archives
Fife Family Papers, Ontario Archives
Glen Orchard Women's Institute Tweedsmuir History
Betty Gordon letters
Mildred McCauley McLeod collection, Gravenhurst Archives
Orgill Family and Others on Orgills Point

S.R.G. Penson *Memoirs*, Ontario Archives
Redmond Thomas Scrapbooks, Bracebridge Library
Sandford Women's Institute Tweedsmuir History
Snider Collection, Gravenhurst Archives
Wadsworth Papers, *Narrative of Surveying Trips*, Ontario Archives
Windermere Women's Institute Tweedsmuir History

— Newspapers —

Bracebridge: *Herald*
Bracebridge: *The Herald-Gazette*
Bracebridge: *Muskoka Advance*
Bracebridge: *Muskoka Sun*
Bracebridge: *Muskokan*
Bracebridge: *Examiner*
Gravenhurst: *News*
Gravenhurst: *Banner*

— Periodicals and Brochures —

CMA Journal, "Tuberculosis in Canada: a century of progress," Vol. 126, March, 1982.
City and Country Home, "Muskoka: Croft of Dounie," June 1985.
Port Carling Museum Quarterly, 1984, 1985.
Muskoka Lakes Association Yearbook, 1985-1988.
Muskoka Lakes Association: handbook, 1987.
Muskoka Lakes Golf and Country Club: history pamphlet, 1980.
Muskoka Lakes Navigation and Hotel Company: brochure 1905.
Lake Joseph Community Church: history pamphlet 1988.

SECONDARY SOURCES

Ahlbrandt, Patricia Walbridge. *Beaumaris*. Erin, Ontario: The Boston Mills Press, 1989
Blackwood, Algernon. *Episodes Before Thirty*, 1950.
Boyer, Barbaranne. *Muskoka's Grand Hotels*. Erin, Ontario: The Boston Mills Press, 1987.
Boyer, George. *Early Days in Muskoka*. Bracebridge, Ontario, 1970.
Boyer, Robert J. *A Good Town Grew Here*. Bracebridge, Ontario, 1975.
Boyer, Robert J. *Early Exploration and Surveying of Muskoka District*. Bracebridge, Ontario, 1979.
Coombe, Geraldine. *Muskoka Past and Present*. Toronto: McGraw-Hill Ryerson, 1976.
Cope, Leila. *A History of the Village of Port Carling*. Bracebridge, 1956.
Colwill-Maddock, Marian Frye. *Diary of Fanny Colwill Calvert, Portrait of an Artist, 1848-1936*. 1981.
Cumberland, Barlow, ed. *Muskoka and the Northern Lakes of Canada*. Toronto: Hunter, Rose and Company, 1886.
Duke, A.H., and W.H. Gray. *The Boatbuilders of Muskoka*. Toronto: W.M. Gray and Company, 1985.
Duvernet, Sylvia. *The Muskoka Assembly of the Canadian Chautauqua Institution: Points of View and Possibilities*. Bracebridge, Ontario, 1985.
Foot, W.W. *What's My Line?* Waterloo, Ontario, 1978.
Fraser, Captain Levi R. *History of Muskoka*. Bracebridge, Ontario, 1946.

Gibson, David L. *Chronicles of Keewaydin Island with the Seven Sisters Islands*. Port Carling, n.d.

Gravenhurst Historical Committee, Porter, Cecil *et al. The Light of Other Days*. Gravenhurst, Ontario, 1967.

Hathaway, Ann. *Muskoka Memories: Sketches from Real Life*. Toronto: William Briggs, 1904.

Hosking, Carol. *Clevelands House: Summer Memories*, Erin, Ontario: The Boston Mills Press, 1988.

Jocque, Violet. *Pioneers and Late Comers*. Minett, Ontario, 1979.

Long, Gary. *This River the Muskoka*. Erin, Ontario: The Boston Mills Press, 1989.

Lucas, Gail, ed. *East Georgian Bay Historical Journal* Vol. II. Elmvale, Ontario: East Georgian Bay Historical Foundation, 1982.

Mason, D.H.C. *Muskoka: The First Islanders*, 1957

Murray, Florence. *Muskoka and Haliburton: 1615-1875*. Toronto: University of Toronto Press, 1963.

Pryke, Susan. *Explore Muskoka*. Erin, Ontario: The Boston Mills Press, 1987.

Schell, Joyce. *The Years Gone By: A History of Walker's Point and Barlochan, Muskoka, 1870-1970*. Bracebridge, Ontario, 1970.

Schell, Joyce. *Through the Narrows of Lake Muskoka*. Bracebridge, Ontario, 1974.

Scovell, Beatrice. *The Muskoka Story*, Bracebridge, Ontario, 1983.

Scott, Harley E. *More Tales of the Muskoka Steamboats*, Bracebridge, Ontario, 1980.

Scott, Harley E. *Steam Yachts of Muskoka*. Bracebridge, Ontario, 1978.

Scott, Harley E. *Tales of Muskoka Steamboats*. Bracebridge, Ontario, 1969.

Shea, Bert. *History of the Sheas and the Birth of a Township*. n.d.

Sutton, Frederick William. *Early History of Bala*. Bracebridge, Ontario, 1968.

Tatley, Richard. *The Steamboat Era in the Muskokas*, Vols. I and II. Erin, Ontario: The Boston Mills Press, 1984.

Thomas, Redmond. *Reminiscences*. Bracebridge, Ontario, 1969.

Index